PRINCETON AND THE GOTHIC REVIVAL

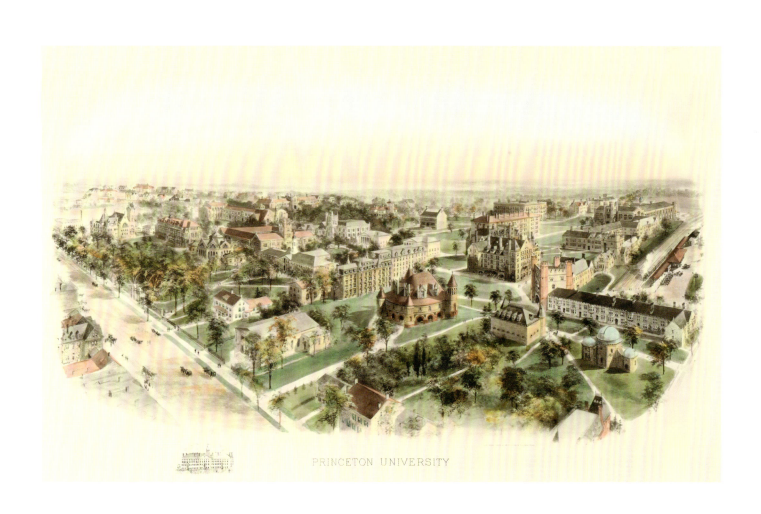

PRINCETON UNIVERSITY

PRINCETON AND THE GOTHIC REVIVAL

1870–1930

Johanna G. Seasonwein

PRINCETON UNIVERSITY ART MUSEUM

Distributed by Princeton University Press

Princeton and the Gothic Revival: 1870–1930 is published by the Princeton University Art Museum and distributed by Princeton University Press.

Princeton University Art Museum, Princeton, New Jersey 08544-1018

artmuseum.princeton.edu

Princeton University Press, 41 William Street

Princeton, New Jersey 08540-5237

press.princeton.edu

This book is published on the occasion of the exhibition *Princeton and the Gothic Revival: 1870–1930*, on view at the
Princeton University Art Museum from February 25 through June 24, 2012.

Princeton and the Gothic Revival: 1870–1930 has been made possible by the generous support of Christy Eitner Neidig and William Neidig, Class of 1970,
in memory of Lorenz E. A. Eitner, Graduate School Class of 1952; and by Christopher E. Olofson, Class of 1992; the Kathleen C. Sherrerd Program Fund
for American Art; the Allen R. Adler, Class of 1967, Exhibitions Fund; the Andrew W. Mellon Foundation; and the Barr Ferree Foundation Fund for
Publications, Princeton University. Additional funding has been provided by the Herbert L. Lucas Jr., Class of 1950; Exxon-Mobil Corporation;
and the Partners and Friends of the Princeton University Art Museum.

Managing Editor: Jill Guthrie

Project Editor: Sharon Herson

Designer: Bruce Campbell

Printer: Brilliant Graphics, Exton, Pennsylvania

Library of Congress Control Number: 2011931253

ISBN: 978-0-691-15401-5

Cover: Graduate College, Princeton University, interior of Procter Hall

Frontispiece: After a watercolor by Richard Rummell, American, 1848–1924, commissioned and published by Littig & Co.:
Princeton University, 1906. Colored photogravure, 42.7 x 75.3 cm. Princetoniana Collection, Graphic Arts Collection,
Department of Rare Books and Special Collections, Princeton University Library

Page 6: detail of figure 6, p. 35; page 10: detail of figure 28, p. 104; page 26: detail of figure 3, p. 16

The book was typeset in Bembo and Perpetua display and printed on Scheufelen PhoeniXmotion Xantur 115 lb. Text.

Printed and bound in the United States of America.

10 9 8 7 6 5 4 3 2 1

Contents

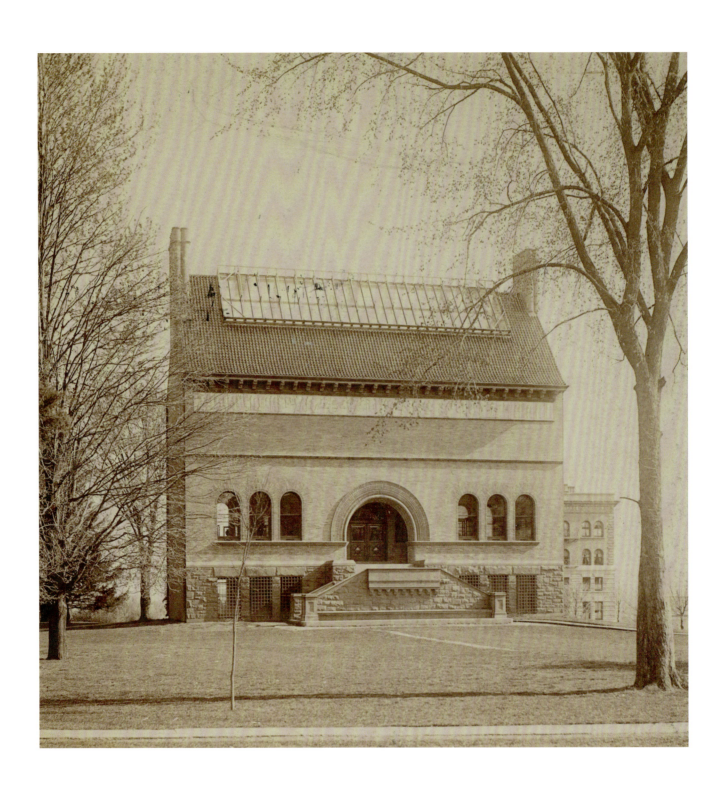

Foreword

In the spring of 1896, at the celebration of its sesquicentennial, the College of New Jersey officially became Princeton University. This occasion marked not only the changing of the institutional moniker but also a change in the University's architectural practices, for it was in that year that the Board of Trustees endorsed the Collegiate Gothic style for all new campus buildings going forward. From that point on, Princeton University became synonymous with its Collegiate Gothic buildings, most notably the residential quadrangles that tumble down the campus hillside toward Lake Carnegie and the resplendent University Chapel, at the time of its construction the second-largest collegiate chapel in the world. Even as the campus has embraced new architectural styles and a more wide-ranging aesthetic in the ensuing decades, for most people, these Gothic Revival buildings continue to embody Princeton's physical essence.

Princeton and the Gothic Revival: 1870–1930 investigates how the former College of New Jersey constructed a sense of its own identity as a new type of American university by looking to the past—specifically embracing the language of Britain's "ancient" universities, Oxford and Cambridge—and communicating this identity through architectural language. Conceived and organized by Johanna G. Seasonwein, the Museum's Andrew W. Mellon Curatorial Fellow for Academic Programs, the exhibition builds upon another recent Museum exhibition, *Inner Sanctum: Meaning and Memory in Princeton's Faculty Room at Nassau Hall*, which also explored the relationship between place, architecture, and institutional identity. These two exhibitions and their accompanying catalogues deepen our appreciation of the ways in which Princeton University became the institution that it is today, and focus particular interest on the self-conscious decisions taken late in the nineteenth century that led to becoming a "modern" university—by both looking to the past and adopting some of the most progressive European practices of the time. Without overlooking the importance of the University's Georgian "front campus," Princeton can be seen as being synonymous with its Gothic Revival buildings, and one would be hard-pressed to consider a Princeton without these buildings and the values they embodied when the Gothic Revival language was adopted.

This exhibition also advances our understanding of the role the arts have played at the University from its earliest days, dating to the first acquisition of works of art for the

young College in the 1750s. Under the leadership of President Shirley M. Tilghman, the arts have received renewed attention as a core component of a twenty-first-century academic institution. The belief that the study and the making of art are not only compatible with but integral to a research-based curriculum dates from the joint founding of what was then known as the Museum of Historic Art and the Department of Art and Archaeology—entities that remain conjoined both intellectually and spatially to our own day. One of the goals of the exhibition and the essays in this catalogue is to chart the connections between the study of authentic art objects—specifically medieval art—and the larger changes taking place on campus as the College of New Jersey transformed itself into Princeton University. *Princeton and the Gothic Revival* also continues our tradition as a teaching museum, serving as the focal exhibition for the Museum's annual freshman seminar, which provides first-year students with an intimate look behind the scenes of the Art Museum, exposing them to some of the methodologies and pedagogies of the twenty-first-century museum.

The majority of the objects in *Princeton and the Gothic Revival: 1870–1930*, many on view for the first time or the first time in decades, come from the Museum's own collections and those of the Princeton University Libraries, most notably the Princeton University Archives, housed at the Seeley G. Mudd Manuscript Library. We especially thank Ben Primer, associate university librarian for Rare Books and Special Collections, and his staff for their enthusiastic and unwavering support of this project, most notably Daniel Linke, university archivist and curator of public policy papers; Don Skemer, curator of manuscripts; Julie Mellby, graphic arts librarian; and Sandra Brooke, librarian, Marquand Library of Art and Archaeology. The core group of objects has been enriched by select loans from area institutions, and we thank the Metropolitan Museum of Art, the Glencairn Museum, the Winterthur Museum and Library, and Willet Hauser Architectural Glass for their generosity.

The Andrew W. Mellon Foundation has had a longstanding leadership commitment to art museums in academic settings and has been a sustained benefactor in support of our work at Princeton. Its particular commitment to fostering close ties between university museums and our partners in the arts and humanities led to the establishment at Princeton of a post-doctoral fellowship that would focus on deepening the Museum's engagement with the University's teaching and research missions and on fostering new scholarship. To the Mellon Foundation, and to the Museum's current Mellon Curatorial Fellow for Academic

Programs, Johanna G. Seasonwein, we owe a great debt; without them, much of what we do—including this exhibition and catalogue—would not be possible.

Princeton and the Gothic Revival: 1870–1930 comes to fruition at a time when the Museum has specifically sought to build renewed and strong bridges between its academic and popular missions, stemming from the belief that deep scholarship and broad accessibility need not be mutually exclusive. On a campus whose historic architecture and landscape are among the most welcoming attributes for both prospective students and general visitors, such an exhibition embodies our hope to enable every Princeton student, as well as visitors from around the world, to view the Museum's galleries and to discover and share the origins and meanings of our buildings and of the modern University itself.

James Christen Steward
Director

Acknowledgments

There are many individuals whom I would like to thank for their assistance and guidance with this project. First and foremost, I would like to thank director James Steward for his encouragement and support for both the exhibition and the accompanying publication. At his urging, what began as an idea for a relatively small exhibition has grown in scope and in depth, and I thank him for the opportunity to conduct what has become a larger investigation into the ways in which Princeton University—and by extension, the American academy at the turn of the last century—has created a sense of self and history through a specific architectural language.

Caroline Harris, curator of education and academic programming, has been an exceptional mentor throughout the project. Her deep knowledge of the collection and curatorial practices, as well as her skill as an educator, has improved the project immensely. I also want to thank Juliana Ochs Dweck, Andrew W. Mellon Curatorial Fellow for Collections Engagement, for her guidance with all interpretive materials as well as the mobile interactive tour, the first of its kind for the Art Museum. For their assistance and support, I am grateful to my other colleagues in the department of education: Brice Hall, manager of youth, family, and school programs, and Jessica Popkin, student outreach coordinator.

At the Princeton University Art Museum, I thank Rebecca Sender, former associate director, and Mike Brew, business manager, for logistical support. Francesca Williams, associate registrar, guided me through the complex process of securing loans and provided help with conservation issues. Manager of Exhibition Services Michael Jacobs and his staff, along with Gary Bloomer, Museum designer, created an elegant ambience for the exhibition. Nancy Stout, director of institutional advancement, and Jennifer Alexander-Hill, former manager of corporate, foundation, and governmental relations, were instrumental in securing funding for both the exhibition and the publication. Rebecca Adamietz-Deo, manager of marketing and public relations, oversaw all marketing efforts for the exhibition. Janet Strohl-Morgan, director of information technology, and her staff managed all things technological; I particularly am grateful for the work of Cathryn Goodwin, manager of collection information and access, for directing the development of the mobile website and interactive

tour. Careful oversight of the exhibition is provided by security manager Albert Wise, lead officer Tracy Craig, and the security staff of the Museum. For their advice and assistance, I also thank Lisa Arcomano, manager of campus collections; curators Calvin Brown, Karl Kusserow, and Betsy Rosasco; and conservator Norman Muller. Jill Guthrie, managing editor, guided the production of the exhibition catalogue, from inception to publication. Bruce Campbell prepared the book's elegant design, and Brilliant Graphics, under the supervision of Bob Tursack, is responsible for the expert printing. Jeff Evans, Bruce M. White, and Denise Applewhite provided photographs, as did a number of amateur photographers who graciously shared their images of medieval and modern architecture and stained glass with me, and who are named individually in the photography credits. I thank reader Mary Shepard for her insightful comments and editorial suggestions, and Sharon Herson for her careful and thorough copyediting.

The exhibition would not have been realized without loans from both inside and outside the University. At the Princeton University Libraries, I thank Ben Primer, associate librarian for rare books and special collections; Sandra Brooke, librarian, Marquand Library of Art and Archaeology; Stephen Ferguson, assistant University librarian for rare books and special collections and curator of rare books; Daniel Linke, University archivist and curator of public policy papers; Julie Mellby, graphic arts librarian; Don Skemer, curator of manuscripts; and their staffs, including Charles Greene, AnnaLee Pauls, Amanda Pike, and Jessica Hoppe Dagči. Beyond Nassau Street, I thank Thomas P. Campbell, Constance McPhee, and Kit Basquin, Metropolitan Museum of Art; Richard McKinstry and Helena Richardson, Winterthur Museum and Library; Stephen Morley and Bret Bostock, Glencairn Museum; and Michael Hauser and Amy Pulliam, Willet Hauser Architectural Glass.

Staff, students, and alumni from across the University enthusiastically provided me with advice and ideas from the gestation of this exhibition to its completion, and I sincerely appreciate their generosity with their time and expertise. Among them are: Alison Boden, dean of religious life; Robert Cullinane, Class of 1970, assistant director, office of the vice president for development; Alice Cooney Frelinghuysen, Class of 1976, Anthony W. and Lulu C. Wang Curator of American Decorative Arts, the Metropolitan Museum of Art; W. Barksdale Maynard, Class of 1988; Ron McCoy, University architect; Matthew Milliner, Graduate School Class of 2011; William Neidig, Class of 1970; Jeff Nunokawa, professor of English and master of Rockefeller College; and David Williamson, Class of 1984. I was

fortunate to be able to contact a number of descendants of the artists discussed in the exhibition, including Crosby Willet and Anne Yarnall, grandchildren of William Willet; Laurie Engel, granddaughter of Oliver Smith; and Dana Stewardson and his mother, Elizabeth S. Ford, son and widow, respectively, of William Emlyn Stewardson, Class of 1958, the grandnephew of John Stewardson. They graciously shared with me personal stories and cherished works of art by their family members. For their assistance with my research, I also thank Ethan Anthony, principal, HDB/Cram and Ferguson, Architects; Kim Tenney and the late Janice Chadbourne, Boston Public Library, Fine Arts Division; Karen Lightner, Philadelphia Free Library, Art Division; Susan Anderson, Philadelphia Museum of Art Archives; the staff of the Archives of American Art, Smithsonian Institution; and the stained-glass scholars and enthusiasts who post on the H-Stained Glass list-serv, managed by Michigan State University. For his unwavering support of this project, I also thank my husband, Davis Ozdogan.

Princeton and the Gothic Revival: 1870–1930 has been made possible by the generous support of Christy Eitner Neidig and William Neidig, Class of 1970, in memory of Lorenz E. A. Eitner, Graduate School Class of 1952; and by Christopher E. Olofson, Class of 1992; the Kathleen C. Sherrerd Program Fund for American Art; the Allen R. Adler, Class of 1967, Exhibitions Fund; the Andrew W. Mellon Foundation; and the Barr Ferree Foundation Fund for Publications, Princeton University. Additional funding has been provided by Herbert L. Lucas Jr., Class of 1950; Exxon-Mobil Corporation, and the Partners and Friends of the Princeton University Art Museum.

Johanna G. Seasonwein
Andrew W. Mellon Curatorial Fellow for Academic Programs

Figure 1. Frank Miles Day and Brother (renamed Day Brothers & Klauder in 1911 and Day & Klauder in 1912), architects, Philadelphia, 1893–1927: Princeton University, Holder Hall quadrangle, 1908–12. Originally part of the freshman quadrangle, these buildings now form part of Rockefeller College.

INTRODUCTION
SPIRES AND GARGOYLES

Evening after evening the senior singing had drifted over the campus in melancholy beauty, and through the shell of his undergraduate consciousness had broken a deep and reverent devotion to the gray walls and Gothic peaks and all they symbolized as warehouses of dead ages.

The tower that in view of his window sprang upward, grew into a spire, yearning higher until its uppermost tip was half invisible against the morning skies, gave him the first sense of the transiency and unimportance of the campus figures except as holders of the apostolic succession. He liked knowing that Gothic architecture, with its upward trend, was peculiarly appropriate to universities, and the idea became personal to him.

—F. Scott Fitzgerald, *This Side of Paradise* (1920)

In *This Side of Paradise*, F. Scott Fitzgerald's first novel, the protagonist Amory Blaine enrolls at Princeton University and is immediately entranced by the campus, in particular its Gothic Revival buildings.[1] In chapter two, aptly titled "Spires and Gargoyles," Amory reflects upon the effects of the night mist as it rolls in across the campus, creating "lofty" peaks out of the spires and rendering the "Gothic halls and cloisters infinitely more mysterious" than during daylight hours. Fitzgerald himself had been an undergraduate at Princeton, having arrived on campus in 1913, just three years after the completion of the first portion of the new Gothic Revival freshman dormitories, the very buildings referred to in Amory Blaine's reverie (fig. 1).

If one can use Blaine—and by extension, Fitzgerald—as a guide, these new buildings made a lasting impression on the imaginations of the students who slept, ate, and studied within their walls. Yet Blaine's romantic and intensely personal response to the mist and its effect on the "spires and gargoyles" is intertwined with a more academic understanding of the purpose of these buildings—that they are specifically appropriate for a university setting. This idea that the

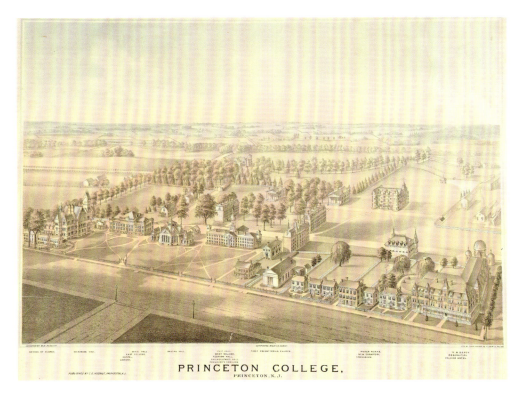

Figure 2. Lithographed by Thomas Hunter, American, fl. 1875, after a design by W. M. Radcliff and published by Charles O. Hudnut: *Princeton College, Princeton, N.J. (Hudnut's Aerial View)*, 1875. Lithograph, ca. 76.2 x 87.6 cm. Princetoniana Collection, Graphic Arts Collection, Department of Rare Books and Special Collections, Princeton University Library.

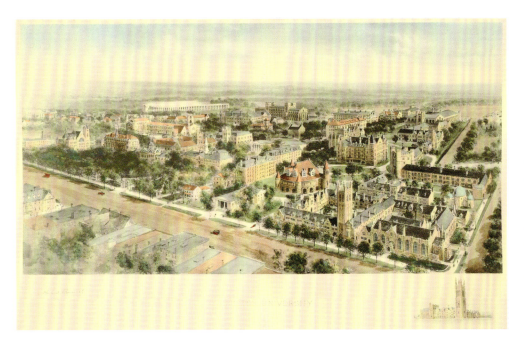

Figure 3. After a watercolor by Richard Rummell, American, 1848–1924, commissioned and published by Littig & Co.: *Princeton University*, ca. 1920. Colored photogravure, 42.3 x 69.5 cm. Princetoniana Collection, Graphic Arts Collection, Department of Rare Books and Special Collections, Princeton University Library.

Gothic style could communicate aspects of the purpose and heritage of an academic institution appealed to the men who commissioned, designed, and paid for the many Gothic Revival buildings that were built on Princeton's campus around the turn of the twentieth century. For administrators and alumni such as Woodrow Wilson, Andrew Fleming West, and Moses Taylor Pyne, Gothic was not a catch-all designation that could be used to refer to anything that seemed vaguely medieval in a romantic sort of way, as had been the case in decades past, but a specific architectural style with a defined vocabulary that could communicate precisely the goals and values of a new American model of higher education.

Why and how this transformation occurred is the focus of the exhibition *Princeton and the Gothic Revival, 1870–1930*, which investigates Americans' evolving attitudes around 1900 to the art and architecture of the Middle Ages, using Princeton University as a case study. Princeton's campus changed radically during this time, as two different prints depicting aerial views demonstrate (figs. 2 and 3). The lithograph (1875) includes the High Victorian Gothic buildings that had recently been constructed, yet it still privileges the colonial-era core of the campus, represented by Nassau Hall at the center of the composition. By contrast, the artist of the later view (1920) focuses on the new Collegiate Gothic freshman quad formed by Holder, Hamilton, and Madison Halls, which are shown at the lower right corner, closest to the viewer. (The artist, Richard Rummell, also sketched the Graduate College campus in the lower margin of the print, which enabled him to show the other great Collegiate Gothic tower of the Princeton campus in his view, even though in reality it was located about an eighth of a mile to the southwest of the freshman quad.)

For several reasons, Princeton also provides a useful lens for the broader study of American architecture and interior design during this period. First, the town is situated halfway between Philadelphia and New York, the two major centers of taste in late-nineteenth-century America. The influence of these two cities is evident in the choice of predominantly Philadelphia- and New York-based architects and artists for Princeton commissions. Second, the growing number of alumni, particularly in the fields of industry and finance, devised new funding opportunities for the College's expansion, and the generosity of these men helped to create lavish new libraries, dormitories, a chapel, and academic buildings, many of which boasted interior furnishings by the most sought-after artists of their day. The exhibition asks the following questions: How did a style that was first used in this country in the creation of picturesque mansions of the wealthy evolve into an architecture that was

understood as "peculiarly appropriate to universities?" And, what connections can be made between the changing academic environment at Princeton during this time and its embrace of a very specific type of Gothic Revival architecture, the Collegiate Gothic style?

The term Gothic was coined during the Italian Renaissance to refer to the "bad" architectural style of the north (i.e., Germany and France) from the mid-twelfth through early sixteenth centuries and to distinguish that architecture from the "good" Classical architecture of the south.[2] In the eighteenth and early nineteenth centuries, Europeans, particularly in Great Britain, "rediscovered" their own Gothic buildings, many of which had been destroyed in the Reformation, the French Revolution, and the aftermath of the creation of the Church of England under Henry VIII and the resultant dissolution of British monasteries in the 1530s and 1540s. This resurgent interest led to a "revival" of Gothic style, particularly in ecclesiastical and domestic architecture and furnishings, although many of the buildings that contemporaries labeled as "Gothick" were only very loosely based on medieval precedents. Instead, they took what might be considered a picturesque or romantic approach to the Gothic style, one championed by antiquarians and literary men such as the novelist and art collector William Beckford (1760–1844).

Beckford's Fonthill Abbey, his fantastical home built in the "Gothick" style, embodied the era's romantic interpretation of the Gothic, which strove for atmospheric effects rather than archaeological verisimilitude. The "abbey" was an immense, sprawling structure centered on a massive tower from which long arms extended in each direction, not unlike a monumental church building (fig. 4). The goal was maximum scenic effect, with grand vistas of the soaring tower available to the viewer from across the property. The resulting building was "all that the eighteenth century demanded from Gothic—unimpeded perspective, immense height, the sublime."[3] The demand for the sublime, however, did not equate with an interest in historical authenticity. The genesis for Fonthill, as imagined by Beckford and his architect, James Wyatt (1746–1813), was supposedly a once-great convent that had fallen into ruin on the property. In fact, the property had not been the home of a monastic institution but rather of Beckford's own family; Beckford had inherited it from his father, whose home was nearby.

Wealthy Americans who traveled to Europe to see homes like Fonthill, as well as authentic medieval sites, appreciated the picturesque qualities of English "Gothick" and upon their return home were eager to commission their own medieval mansions. The preeminent designer of Gothic Revival homes of the mid-nineteenth century was Alexander

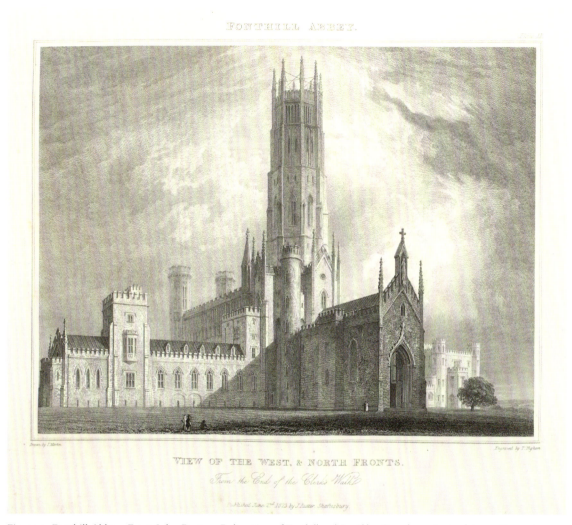

VIEW OF THE WEST, & NORTH FRONTS.

From the End of the Clerks Walk

Published June 2nd 1823 by J.Rutter Shaftesbury

Figure 4. Fonthill Abbey. From John Rutter, *Delineations of Fonthill and Its Abbey* (London, 1823), plate 11. Engraving, 28 x 22 cm. Rare Book Collection, Marquand Library of Art and Archaeology, Princeton University.

Jackson Davis (1803–1892), an artist-turned-architect. Davis particularly liked the Gothic mode for domestic architecture, for it afforded him more opportunities than any other style to indulge his love of the picturesque. In 1832, he was commissioned by Robert Gilmor III to design a Gothic Revival villa outside of Baltimore. Gilmor III, nephew of the renowned art collector and antiquarian Robert Gilmor Jr., had taken the Grand Tour to Europe, where he visited the Gothic Revival mansions of Horace Walpole and Sir Walter Scott, Strawberry

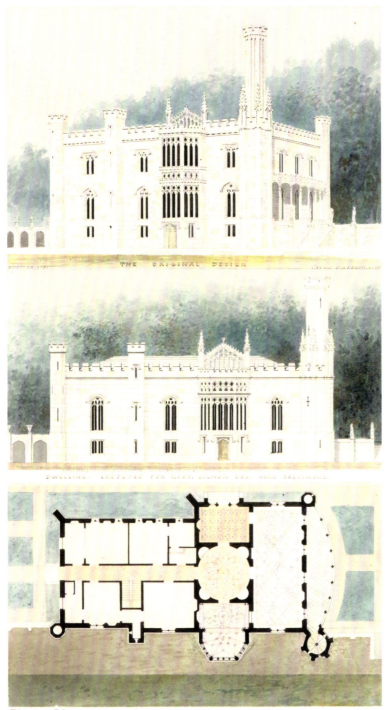

Figure 5. Alexander Jackson Davis,
American, 1803–1892: Glen Ellen:
perspective, elevation, plan, 1832–33.
Watercolor, ink, and graphite
on paper, 55.2 x 39.7 cm. The
Metropolitan Museum of Art,
Harris Brisbane Dick Fund, 1924
(24.66.17).

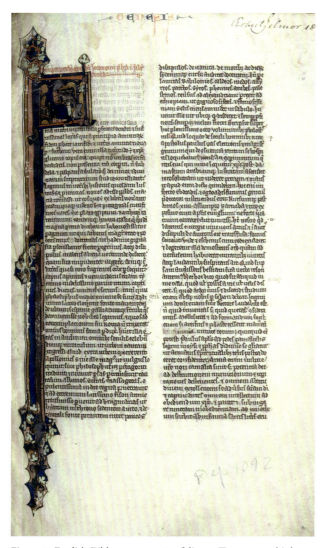

Figure 6. English Bible, ca. 1270–80, folio 1r. Tempera and ink on parchment, ca. 24 x 34 cm. Robert Garrett Collection of Medieval and Renaissance Manuscripts, no. 28, Manuscripts Division, Department of Rare Books and Special Collections, Princeton University Library. Gift of Robert Garrett, Class of 1897.

Hill and Abbotsford, respectively.[4] So inspired was he by what he had seen that he commissioned the firm of Town & Davis to build him a home in a similar style. The home, named Glen Ellen in honor of his wife, no longer stands, but a detailed watercolor of the design survives in the collections of the Metropolitan Museum of Art (fig. 5).[5] Gilmor III was the favorite nephew of his uncle, who was also interested in medieval architecture and collected authentic medieval objects, including a thirteenth-century Bible now in the Princeton University Library (fig. 6).[6]

Even though Gilmor III was exposed to authentic medieval objects and architecture through his uncle and the Grand Tour, his home is a picturesque Gothic fantasy, with a pseudo-cruciform plan adjusted to the needs of a domestic interior and an exterior encrusted with fake buttresses, a crenellated roofline, a slim tower decorated with pinnacles, and "Gothic" window tracery. Just as in Great Britain, then, American interest in the Gothic Revival or the desire to collect authentic medieval objects at this time did not necessarily lead to an archaeologically correct approach to the Middle Ages.

The mixing of authentic and picturesque elements inspired by the Middle Ages was a trend not just in domestic architecture but also in institutional settings, and one finds this

lack of interest in following correct medieval models in the first Gothic Revival buildings on Princeton's campus as well. The first essay in this book, "Princeton and the Changing Face of Gothic," provides an overview of the various phases of Gothic—or more broadly, medieval—Revival architecture on the Princeton campus, charting the development of campus architecture from these early "eclectic" buildings to the more uniform Collegiate Gothic, a style used for almost every campus building between 1896 and 1930. The second essay, "'That Ancient and Most Imperishable of the Arts': The Role of Stained Glass in the Development of the Gothic Revival at Princeton," examines these developments through case studies of three Princeton buildings and their stained-glass windows: Marquand Chapel, Procter Hall at the Graduate College, and the University Chapel.

In these two essays, I argue that the University administration, trustees, and alumni deliberately selected the Collegiate Gothic mode as a way to make a statement not only about the growing importance of Princeton University but also about its role in upholding the Protestant values that were perceived as under attack in the broader culture. As noted by historian T. J. Jackson Lears, the sixty-year span covered by the exhibition and these three case studies was a time of great change in America, particularly in the northeast and mid-Atlantic regions. Members of the old-stock Protestant bourgeois and upper classes embraced medievalism and other "anti-modern" sentiments as a way to combat their growing unease with the changes wrought by industrialism, immigration, and later, war.[7] The later Middle Ages were seen as a purer, more child-like, and more moral time that could provide a model for reviving the ethic of work and self-control that Protestants embraced.

The language of medieval architecture was also employed as a Protestant response to a perceived crisis of cultural authority. One way to lessen the threat of a growing Catholic immigrant population was to co-opt the symbols of Catholicism and refashion or reinterpret them to align with Protestant values. An example at Princeton of the growing Protestant comfort with architectural forms previously seen as reserved for Catholicism is the embrace of the cruciform shape for the campus's successive chapel buildings, which I discuss in the second essay. When the architect John Notman (1810–1865) proposed a cruciform shape for the first purpose-built chapel in the 1840s, the trustees responded vehemently that such a "popish" architectural form was inappropriate for a Presbyterian institution.[8] By the 1880s, with the construction of the second chapel building, Marquand Chapel, there was more concern about the acoustical properties of a cross-shaped space than about its religious

symbolism. In the 1920s, when the current chapel was designed and constructed, there was still much discussion about the appropriateness of the Gothic style, but there were far more supporters than dissenters for Ralph Adams Cram's Collegiate Gothic design.[9]

This wholehearted embrace of an architecture that in its original form had strong ties to Catholicism underlines the desire on the part of the Protestant elite to create a symbolic language of its own, one that would communicate its self-perceived role in modern American society. Princeton University specifically chose the language of English Gothic Revival architecture to proclaim itself the successor to the well-established academic institutions of Oxford and Cambridge. Princeton may not have been the first to adopt the Collegiate Gothic style (and by the time it did so, the style had largely fallen out of fashion in larger architectural circles), yet the continued commissioning of Collegiate Gothic buildings even after architectural trends had moved on in the broader cultural sphere speaks more eloquently than any written document to the administration's fervent desire to cement the University's place in academe.

A final note: The reader who is familiar with the Princeton campus will notice that not all the buildings constructed during the period receive equal attention. Some buildings are discussed in detail, while others are mentioned briefly or not at all. This is on account of space limitations (in the book as well as in the exhibition galleries) as well as the vagaries of history. Many of the design documents related to Princeton's Gothic Revival buildings have deteriorated over time because they were created as working documents and not intended to be permanent works of art in their own right. Many other buildings are not represented among the design archives, suggesting that the working documents were discarded. These include Alexander Hall, the only example of Richardsonian Romanesque on the Princeton campus, and Blair and Little Halls, the first true examples of Collegiate Gothic architecture at Princeton. It is with that caveat in mind that I (knowing full well the strong emotions that Princeton architecture can raise in students, alumni, and visitors) request the forgiveness of the reader whose personal favorite may have been left out.

1. F. Scott Fitzgerald, *This Side of Paradise* (New York: Random House, 2001), 54.

2. In his biographies of Italian Renaissance artists, the sixteenth-century artist and author Giorgio Vasari described the state of affairs in medieval Italy: "There came to arise new architects, who brought from their barbarous races the method of that manner of buildings that are called by us today German [*maniera tedesca*, lit. German manner]; and they made some that are rather a source of laughter for us moderns than creditable to them, until better craftsmen afterwards found a better style, in some measure similar to the good style of the ancients." See *Lives of the Most Excellent Painters, Sculptors and Architects*, trans. Philip Jacks (Westminster, Md.: Random House Adult Trade Publishing Group, 2006). For a more in-depth exploration of the changing fortunes of the term "Gothic," see Paul Frankl's magisterial *The Gothic: Literary Sources and Interpretations through Eight Centuries* (Princeton: Princeton University Press, 1960).

3. Kenneth Clark, *The Gothic Revival: An Essay in the History of Taste* (New York: Charles Scribner's Sons, 1929), 108. Clark's book is the classic text on the Gothic Revival. Recent publications that provide overviews of the genre include: Megan Brewster Aldrich, *Gothic Revival* (London: Phaidon, 1994); Chris Brooks, *The Gothic Revival* (London: Phaidon, 1999); Michael J. Lewis, *The Gothic Revival* (New York: Thames and Hudson, 2002); and Elizabeth Feld and Stuart P. Feld, *In Pointed Style: The Gothic Revival in America, 1800–1860* (New York: Hirschl and Adler Galleries, 2006).

4. To distinguish between uncle and nephew, I refer to Robert Gilmor Jr. as "Gilmor Jr." and to his nephew, Robert Gilmor III, as "Gilmor III."

5. Davis wrote that his partner Ithiel Town and Gilmor were responsible for the plan and that he had designed the Gothic ornamentation. See "Alexander J. Davis: Glen Ellen for Robert Gilmor, Towson, Maryland (perspective, elevation, and plan) (24.66.17)," in Heilbrunn Timeline of Art History (New York: The Metropolitan Museum of Art, last modified May 10, 2011), accessed May 23, 2011, www.metmuseum.org/toah/works-of-art/24.66.17.

6. Gilmor Jr.'s library in his home in Baltimore had a "painted window" in the "Gothic style," and his letters to his brother William while he was on the Grand Tour indicate a great interest in the medieval buildings he visited, some of which he drew in his sketchbook. See Elizabeth Bradford Smith, *Medieval Art in America: Patterns of Collecting, 1800–1940* (University Park: Pennsylvania State University Press, 1996), 25. A note pasted on the interior of the book by a later collector, Robert Garrett Jr., specifies that the Bible was previously in the collections of "William Gilmor (son of Robert Gilmor, Jr.)," and the flyleaf is inscribed with the signature of Robert Gilmor Jr. It is possible that Gilmor Jr., upon his death, left the Bible to his nephew Gilmor III, who then passed it on to his son, William. It is unclear, however, which William Gilmor was the owner of the book, since Gilmor Jr., who died in 1848 without any heirs, had both a brother and a nephew named William. Gilmor III also had a younger brother named William, further complicating the matter. It is unlikely that Gilmor Jr.'s own brother owned the Bible, since William predeceased Gilmor Jr. by nineteen years. Gilmor Jr. was very close with his brother's son, Robert Gilmor III; thus, it is reasonable to assume that he would have bequeathed a cherished object such as the Bible to his nephew, who then might have bequeathed it to his own son William, who later became president of the Maryland Central Railroad.

7. T. J. Jackson Lears, *No Place of Grace: Antimodernism and the Transformation of American Culture, 1880–1920* (Chicago: University of Chicago Press, 1994). Ryan K. Smith also discusses Protestant unease with immigration, noting that the Catholic population of the United States had grown to 1.75 million by 1850, making it the largest religious group in the country. See his *Gothic Arches, Latin Crosses: Anti-Catholicism and American Church Designs in the Nineteenth Century* (Chapel Hill: University of North Carolina Press, 2006), 9.

8. July 1847, Minutes of the Board of Trustees, vol. 3, 483–84.

9. For more on the controversy surrounding the University Chapel's Gothic Revival design, see W. Barksdale Maynard, *Princeton: America's Campus* (University Park: Penn State University Press, forthcoming May 2012).

PRINCETON AND THE
CHANGING FACE OF GOTHIC

Like Amory Blaine in *This Side of Paradise*, many modern visitors to the Princeton campus are enchanted by the Collegiate Gothic dormitories, academic buildings, and chapel, all built in the first three decades of the twentieth century.[1] These buildings signify a change in the University's approach to campus architecture beginning in 1896, the date of the University's sesquicentennial. The earlier campus had expanded around the colonial-era core (with Nassau Hall as its "Inner Sanctum"[2]) to include a wide variety of buildings, some of which were considered "Gothic" at the time. By the end of the century, however, such eclecticism was rejected in favor of a more uniform approach that would appropriately convey the educational ideals of a prestigious, world-class academic institution such as the new Princeton University.

The changing nature of Gothic Revival architecture on the Princeton campus coincided with significant changes that were taking place at the administrative level as the formerly small-town college strove to compete first at the national and then at the international level. Under the leadership of President James McCosh (president, 1868–88), Princeton incorporated modern, "scientific" approaches to learning; under his successors, the University sought to balance its role as an institution of progressive education with its desire to proclaim its roots in the English model of education as epitomized by the colleges of Oxford and Cambridge Universities. This struggle to define exactly what a modern American university should be is mirrored in the changing architectural styles of both academic and residential buildings. The new disciplines added to the curriculum during the McCosh presidency, including biological sciences and art history, necessitated buildings that would allow for the collection and study of objects. These buildings were constructed in the rather plain (and inexpensive) Romanesque Revival style. With the celebration of the sesquicentennial in 1896, the transformation of the College of New Jersey into Princeton University resulted in a transformation of the campus into a collection of "spires and gargoyles," as described by F. Scott Fitzgerald. Functionality gave way to a new kind

of romanticism, one that was steeped in the study of medieval monuments and that sought to provide the "new" University with a specifically English pedigree.

This focus on English roots had racial undertones, as articulated by the University's supervising architect, Ralph Adams Cram (1863–1942). Cram gave voice to the concerns of the American Protestant elite, who believed that their values and even their way of life were under attack, both at home, with the ever-increasing numbers of immigrants from Europe—particularly Jews and Catholics—and abroad, with the threats of socialism and bolshevism made real by war.[3] At Princeton, the changing composition of the student body and administration, with an increasing number of Episcopalians versus old-line Scottish Presbyterians, also encouraged an interest in connecting with English roots.

Princeton's campus provides a unique opportunity to trace the changing approaches to the art and architecture of the Middle Ages, from the nineteenth-century embrace of the picturesque, romantic, and aesthetic qualities of medieval architectural styles to a more archaeological, nationalistic, or even racial interpretation of the Gothic style around the turn of the twentieth century. In the following sections, the discussion encompasses the three main campus architectural campaigns of the late nineteenth and early twentieth centuries that embraced the Gothic style in some fashion: the High Victorian Gothic of the 1870s and 1880s; a subgenre of Victorian Gothic of the late 1880s and early 1890s known as the Romanesque Revival; and the Collegiate Gothic of the late 1890s to the late 1920s.

High Victorian Gothic: Chancellor Green Library

Directly influenced by the theories of the author and art critic John Ruskin, High Victorian Gothic architecture reached its peak in England in the middle of the nineteenth century.[4] Buildings such as the Museum of Natural History in Oxford (designed by Thomas Newenham Dean and Benjamin Woodward in 1855) reflect Ruskin's particular love of Venetian Gothic (fig. 1). The building's exterior is composed of two arcades of pointed arches articulated in two colors; the two-colored banded arch is also used extensively throughout the interior, supported by carved foliate capitals. This style did not become popular in the United States until the 1860s and 1870s and was promoted by the architectural firms of Ware and van Brunt, who designed Harvard's Memorial Hall (1877–78); Frank Furness, architect of the Pennsylvania Academy of Fine Arts building in Philadelphia; and Edward Tuckerman Potter, who had studied with Richard Upjohn, designer of Trinity Church on Wall Street in New

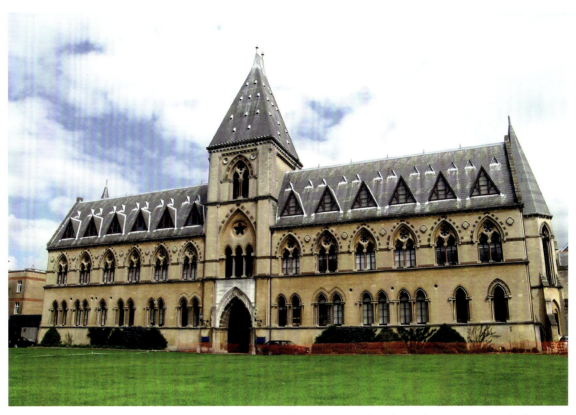

Figure 1. Thomas Newenham Dean, British, 1828–1899, and Benjamin Woodward, British, 1816–1861: Oxford University, Museum of Natural History, Oxford, England, 1854–60.

York (completed in 1846). In addition to the specific influence of Ruskin, this aesthetic derived from the growing number of design manuals, books, and other printed materials devoted to the improvement of taste in interior furnishings in the mid- to late nineteenth century: for example, Augustus Welby Northmore Pugin's publications on furniture (1835) and metalwork (1836), and Owen Jones's *The Grammar of Ornament* (1856).[5]

The first High Victorian Gothic building at Princeton was Chancellor Green Library, designed by William Appleton Potter (1842–1909), half-brother of the New York architect Edward Potter, and built between 1871 and 1873. The building was named by the donor, John C. Green, in honor of his brother, Henry W. Green, a College trustee and chancellor of the state of New Jersey (fig. 2).[6] Potter designed the building, the first purpose-built library on the campus, as a centralized octagon with stacks radiating out from the rotunda.

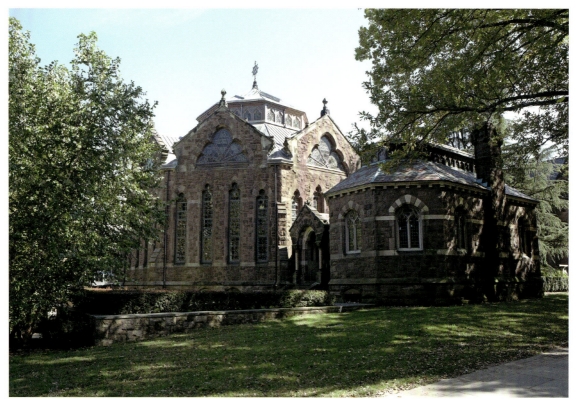

Figure 2. William Appleton Potter, American, 1842–1909: Princeton University, Chancellor Green Library, northwest exterior, 1871–73.

Chancellor Green reflects William Potter's close study of his brother's interpretation of the High Victorian Gothic style, which was characterized by the use of various colors of stone to achieve polychromatic effects, richly carved ornaments on both exterior and interior, and elaborately carved wooden architectural elements on the building's interior.[7] Although one historian has called the design "restrained" compared to some of Potter's commissions for other institutions, when compared to the warm ochre stone of Nassau Hall, Chancellor Green is a riot of color, with polychrome slate roof shingles, stained-glass windows, and an interior decorated with highly stylized foliate and tracery forms.[8]

The library's plan also suggests that William Potter was using his brother's designs for inspiration. The centralized plan had been suggested by a faculty member, but it also closely resembles Edward Potter's design of Nott Memorial Hall at the brothers' alma mater, Union

College, in Schenectady, New York (1858–79; fig. 3).[9] William Potter might also have had in mind the form of an English Gothic chapter house, many of which are octagonal and have star-shaped lierne vaults, the motif of the library ceiling.[10] A chapter house is a space attached to a monastic complex where monks (the chapter) gathered to discuss organizational matters and read from the chapter's rule book and the Bible. Perhaps it was the function of communal gathering and study that made the octagonal form so attractive for adaptive use as a library.

Potter's combination of historicizing and modern styles also represents an academic response to a popular domestic movement in craft and design at the time known as Aestheticism. The Aesthetic movement became fashionable first in England and then America in the 1870s and 1880s and took many of its cues from the Arts and Crafts movement. Whereas the latter focused on the moral nature

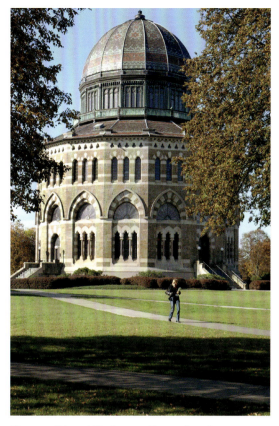

Figure 3. Edward Tuckerman Potter, American, 1831–1904: Union College, Nott Memorial Hall, Schenectady, N.Y., 1858–79.

of craft, Aestheticism emphasized beauty as the most worthy goal for artists—"art for art's sake." Its supporters strove to raise the decorative arts to the same level as the fine arts, and many of the artists associated with the movement were painters and sculptors who also accepted interior design commissions. Aesthetic interiors could be found in many new mansions lining the avenues of the Upper East Side of Manhattan and in Newport cottages.[11] Some of the owners of these mansions were also patrons of lavish buildings that were in construction on college campuses. At Princeton, the wealthy banker and railroad magnate Henry Gurdon Marquand commissioned and paid for a new chapel in the early 1880s. It was decorated by many of the artists who also decorated his homes in Manhattan and Newport, and it will be discussed in greater detail in the next essay.

The Romanesque Revival: Alexander Hall, the Museum of Historic Art,
and the Class of 1877 Biological Laboratory

Three of the High Victorian Gothic buildings that were constructed on the Princeton campus fall into a subgenre known as Romanesque Revival, which in American architecture dates as early as the 1840s. At that time, it was used primarily for church buildings, particularly by Protestant denominations, which deemed the Gothic Revival style appropriate only for Catholics or High Church Anglicans.[12] These church patrons took their inspiration from Germany, where the style was known as *Rundbogenstil* ("round-arch style"), but in later decades, American architects would transform what had been a plain, simple style into something more lavish and exuberant.

The lavish version of Romanesque is epitomized by Boston-based architect Henry Hobson Richardson's Trinity Church in Copley Square (1872–77; fig. 4). Richardsonian Romanesque buildings exhibit round arches, the massing of cylindrical and other geometric forms around the building's core, and a robust, rusticated exterior, yet one could hardly say that they are re-creations of any twelfth-century French models. At Princeton, William Potter was given the commission to design a new convocation hall in the Richardsonian Romanesque style. Alexander Hall (1891–94; fig. 5), the only Richardsonian Romanesque building commissioned by the College, was the last one to be designed in a style other than Gothic, but it was not the only campus building constructed in what was referred to as the Romanesque Revival style. Alexander Hall's singular status is the result of campus demolitions of the mid-twentieth century, when two other Romanesque Revival buildings constructed in the 1880s

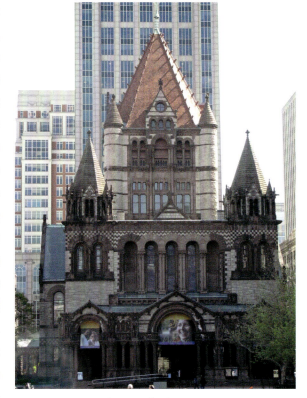

Figure 4. Henry Hobson Richardson, American, 1838–1886: Trinity Church, Boston, 1872–77.

32

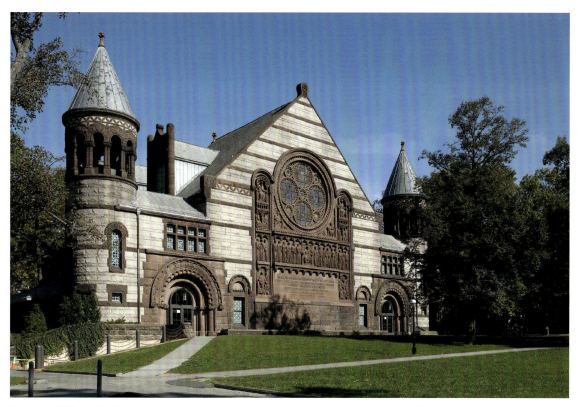

Figure 5. William Appleton Potter, American, 1842–1909: Princeton University, Alexander Hall, 1891–94. The southern exterior features sculptures by J. Massey Rhind and stained-glass windows by the Tiffany Glass Company.

were torn down: the Class of 1877 Biological Laboratory (1887–88, razed 1946) and the Museum of Historic Art (1886–89, razed 1964).

Both the Biological Laboratory and the Museum were designed by the New York–based architect A. Page Brown (1859–1896) and displayed a much more sober (and therefore less expensive) approach to the Romanesque Revival. Their demolition in the twentieth century speaks to the changing needs of academic departments as well as changing tastes; even when these two buildings still stood, however, they were not always regarded as worthy of attention. Writing in 1910, the eminent architectural critic Montgomery Schuyler stated: "There was no very notable or 'architecturesque' addition to the architecture of Princeton between 1881, the year of the Marquand Chapel, and 1892, the year of Alexander Hall."[13] Schuyler then moved on to the buildings that made Princeton what he called "the most

attractive architectural Mecca in the United States": the Collegiate Gothic, represented by Blair and Little Halls.[14] He thus skipped an entire stage (albeit a brief one) in the architectural history of the campus in order to create a sense of continuity between the eras he found worthy: the Ruskinian Victorian Gothic of the 1870s and the Collegiate Gothic of the late 1890s, with a brief interlude represented by Alexander Hall, in a style that was never repeated on the Princeton campus.

Nevertheless, omission of these Romanesque Revival buildings in a historical review of the Princeton campus would ignore a period that provides insight into the way the College viewed its changing academic programs and their relationship to architecture.[15] Unlike decision-making for the High Victorian Gothic buildings constructed during the McCosh presidency, determinations about the way money was to be spent were made by the College's administration, although the new academic buildings were often financed in part by private donors.[16] True to its (thrifty) roots in Scottish Presbyterianism, the administration chose not to spend precious dollars on decorative buildings but to focus on the needs of the departments to be housed in these structures and the manner in which the form might serve the function.

The decision to build an art museum dates to the early 1880s, when James McCosh commissioned William Cowper Prime, an art collector, trustee of the Metropolitan Museum of Art, and a member of the Class of 1843, and George B. McClellan, a general in the Civil War and the governor of New Jersey from 1878 to 1881, to investigate the possibility of establishing a "department of art instruction" at the College.[17] Prime and McClellan published a pamphlet in May 1882 that outlined their recommendations not only for the creation of a department but also for a museum: "The foundation of any system of education in Historic Art must obviously be in object-teaching. A museum of art objects is so necessary to the system that without it we are of [the] opinion it would be of small utility to introduce the proposed department."[18]

For the new building, to be called the Museum of Historic Art, Brown designed a three-story functional structure that included space for collections display and an office for the director, the two primary needs of the fledgling Museum (fig. 6). The focus on function did not mean that all decorative details were renounced; the decorative motifs, however, were not necessarily consistent with the Romanesque Revival aesthetic. As with Richard Morris Hunt and William Potter before him, Brown felt free to incorporate elements from a variety

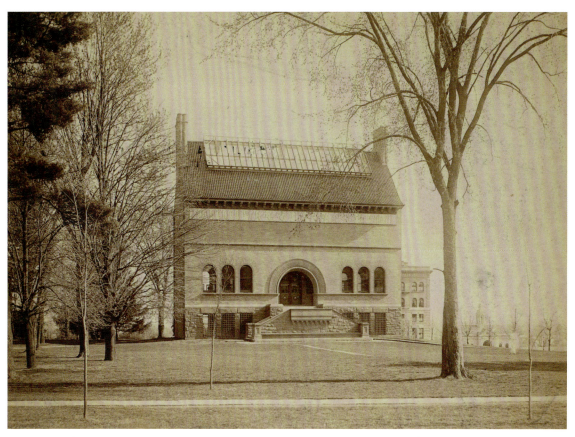

Figure 6. A(rthur) Page Brown, American, 1859–1896: Princeton University, Museum of Historic Art, ca. 1890. University Archives, Department of Rare Books and Special Collections, Princeton University Library.

of artistic periods. Brown took an eclectic approach for aesthetic as well as practical reasons; the more styles he could master, the more clients might be interested in hiring him to fulfill commissions according to their personal tastes. Brown's sketchbook contains designs for furniture in a variety of styles for the Cyrus McCormick Jr. family, who were donors to Princeton and helped to finance McCormick Hall and, later, the collections of the Museum of Historic Art (see Checklist of the Exhibition).

For both the Museum of Historic Art and the Biological Laboratory, Brown referred to Romanesque architecture in the heavy brick arches that delineated the main doors of the buildings, yet the decorative details were Classical, Gothic, or even Beaux-Arts. For the Biological Laboratory, Brown alleviated the heaviness of the brick exterior with roundels of

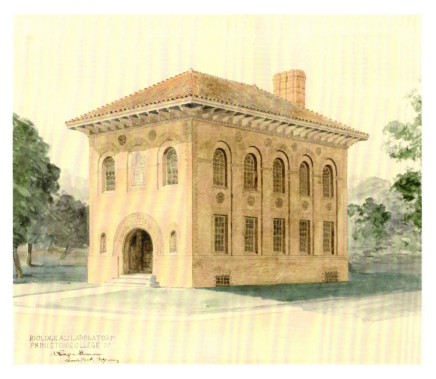

Figure 7. A(rthur) Page Brown, American, 1859–1896: Princeton University, Class of 1877 Biological Laboratory, proposed exterior, 1887. Watercolor on paper, ca. 45.7 x 50.8 cm. University Archives, Department of Rare Books and Special Collections, Princeton University Library.

Gothic tracery that pierced the wall between the lower and upper windows and between the spandrels beneath the eaves of the roof (fig. 7). The most elaborate decorative detail was a Beaux-Arts terracotta plaque commemorating the Class of 1877, installed above the entry door at the level of the second floor (this plaque is now located on an exterior wall of Firestone Library). For the Museum, classically inspired ornament included a terracotta copy of the eastern frieze from the Parthenon, manufactured by the Perth Amboy Terracotta Company, and a mosaic pavement for the entry porch.[19]

The use of a copy of a masterpiece from Classical antiquity on the exterior of the Museum building hinted at the nature of the collections inside. The foundation of the collection was the Trumbull-Prime collection of pottery and porcelain, named for the donor, William Prime, and his wife, Mary Trumbull. To this collection were gradually added works of ancient and medieval art, early Italian and Northern Renaissance painting, a "hall of casts" in the basement, and a collection of gold and silver coins on loan from alumnus and trustee Moses Taylor Pyne.[20] The use of casts in museum collections was common in the seventeen through nineteenth centuries as a way to survey the great monuments of history without

traveling far from home.[21] Most important was that students be able to engage directly with three-dimensional objects, whether casts of great works of sculpture or architecture or authentic examples of the "minor arts" (e.g., ivories, cameos, and other small-scale decorative objects), which were more affordable for the new Museum's budget.

The object-based approach to the study and teaching of history reflected a desire on the part of American educators to incorporate new academic disciplines and scientific approaches into the college curriculum. James McCosh, whose own theological understanding accepted Darwinian teachings and attempted to reconcile them with Calvinist doctrine, was particularly interested in adding science and the arts to the Princeton curriculum. In 1882, McCosh wrote: "I believe that the Fine Arts should have a place, along with Literature, Philosophy and Science, in every advanced College."[22] The enthusiasm for the "scientific" approach extended beyond the sciences; for example, a letter dated 1894 from Professor Westcott of the Classics Department stated: "We need a 'laboratory' where our 'apparatus' can be gathered together, where our students can be shown their 'tools' and taught how to use them."[23]

The inclusion of these new fields of study reflected the new model of the German research institution, which placed a premium on subject specialization, scientific study, and laboratory-based learning.[24] The guiding principle of this educational philosophy was the German concept of *Anschauung*, which described a face-to-face encounter with the world. This could include the natural physical sciences and the historical disciplines, and could be summarized as "object-based learning."[25] The first American institution to emulate this model was The Johns Hopkins University in Baltimore, Maryland, established in 1876.

Johns Hopkins provided a way for more established academic institutions, such as Princeton, to embrace the German model by hiring their new American doctoral graduates to lead new departments of study. The school granted the Ph.D. of Allan Marquand, Princeton's first professor of art history and the first director of the Art Museum,[26] as well as of two other early professors in the department, Arthur Frothingham and Frank Jewett Mather Jr. Marquand was initially hired by James McCosh to teach philosophy, the subject of his graduate study, but the president soon found Marquand's approach to the material to be unorthodox. McCosh instead suggested that the young professor teach courses on the philosophy of art; according to Marquand, he declined but agreed to focus on the history of art.[27]

The study of art history was a relatively new field in American academe, having been "invented" in the nineteenth century by German scholars, who were in large part influenced by trends in German history and philosophy as well as by discoveries in the natural sciences.[28] Art history was termed both *Kunstgeschichte*, the history of art, and *Kunstwissenschaft*, the science of art. The study of art was therefore not only the study of peoples but also a scientific investigation of something that could be categorized and dissected. Marquand's rejection of McCosh's suggested course of inquiry into the philosophy of art thus reflects the German-influenced training he had received at Johns Hopkins, where the study of history and other liberal arts was rooted in object-based inquiry and the examination of source material.[29] When he changed course from philosophy and logic, Marquand discussed art history as a field worthy of "systemic study," whereby one would gain knowledge of humankind's past through observation and correct classification of its monuments.

> *There is little question that the historical or scientific method, which has accomplished so much for other sciences[,] will prove equally productive here. If architectural, sculptural or other forms are to be studied in groups or families, their characteristics noted and their sequence traced, we have before us very similar problems concerning the origin and evolution of artistic species to these which have figured so (prominently) in biological science in recent years. The analogy between the methods of biology and of art history are [sic] very striking. Embryology finds its analogue in prehistoric archaeology, morphology and comparative morphology in a similar study of artistic forms, and physiology in the interpretation and significance of art.[30]*

In order to undertake such a rigorous, scientific method of study, Marquand agreed with the earlier assessments by William C. Prime and George McClellan that a collection of objects was necessary. He asserted that "one of the first requirements . . . is a museum or laboratory, which should contain a class or classes of monuments arranged in historic sequence."[31] The collection should contain not only casts and examples of the minor arts but also photographs and prints, which could also be classified.

Marquand's analogy between the methods of biology and those of art history sheds some light on the possible reasons for the similarity in style of Princeton's Art Museum and the Biological Laboratory. It cannot be attributed to a penchant on the part of the architect A. Page Brown for one style. He was comfortable working in multiple styles, as demonstrated

by his own sketchbook as well as by the other two buildings he designed for the Princeton campus at this time, the Neoclassical Whig and Clio Halls (1887–92). Instead, the relatively inexpensive Romanesque Revival idiom may well have been specifically chosen as particularly appropriate for buildings meant to house departments that reflected the German academic model (as filtered through schools like Johns Hopkins). Daniel Coit Gilman, the first president of Johns Hopkins, had rejected the notion that American universities needed "splendid architecture" and had proposed that they should instead spend their funds on recruiting faculty and students.[32] At Princeton, the design of the two new buildings in a similar Romanesque Revival style suggests that Brown deliberately created a visual link that echoed the methodological connections between art and science as practiced by Marquand and his colleagues and as supported by the administration.

The Creation of Princeton as a University and the Collegiate Gothic Style
The connection between architectural style and educational reform culminated at Princeton at the 1896 sesquicentennial, or 150th anniversary, of the founding of the College of New Jersey. The three-day celebration featured an international roster of lecturers on a variety of academic topics, Woodrow Wilson's keynote address on "Princeton in the Nation's Service," and a torch-lit procession that was reviewed by former United States president Grover Cleveland, by then a Princeton resident.[33] The pomp and circumstance was to celebrate not only the institution's past but also its future, for it was on this occasion that the College officially renamed itself Princeton University and undertook a new building campaign that would radically alter the appearance of the campus.[34]

The renaming of the College of New Jersey as Princeton University was meant to signify the school's growing prominence, not only nationally but also internationally. This change was acknowledged by the editor of *Harper's New Monthly Magazine*, whose breathless description of the event reads: "It was the first formal recognition of the brotherhood of learning and research between the great educational institutions of the world. It was the first time that America has asserted her place in this hierarchy of learning."[35] A key element in the campaign to demonstrate Princeton's place in this hierarchy was the adoption of the Collegiate Gothic style for the growing campus.

Broadly speaking, "Collegiate Gothic" refers to the architectural style used in the construction of the fifteenth- and early-sixteenth-century colleges of Oxford and

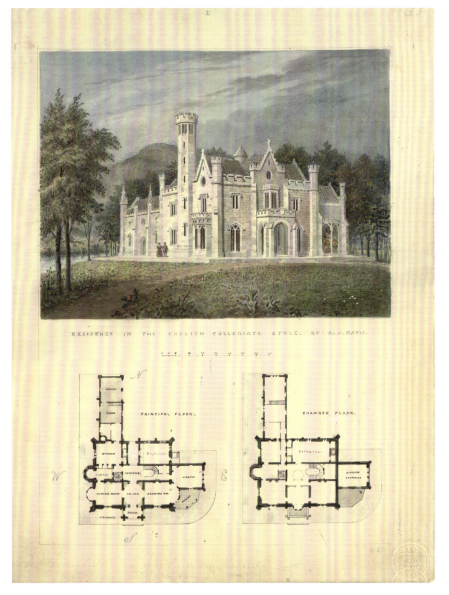

Figure 8. Alexander Jackson Davis, American, 1803–1892: villa for Robert Donaldson, Fishkill Landing, New York (perspective and plans), 1834. Watercolor, 33 x 25.4 cm. The Metropolitan Museum of Art, Harris Brisbane Dick Fund, 1924 (24.66.865).

Cambridge, although it could include references to fourteenth-century or even earlier models. Sometimes called "Tudor Gothic," the style is characterized by heavy crenellations, oriel windows, and the so-called Tudor arch, which is wider and flatter than the pointed arches of the twelfth through fourteenth centuries. Although in the United States the term is usually associated with late-nineteenth-century Gothic Revival buildings, in

fact the term was used earlier in the century by the preeminent Gothic Revival architect of the early nineteenth century, Alexander Jackson Davis, to describe some of his domestic designs. For example, Davis labeled his design for a villa in Fishkill Landing, New York, as "English Collegiate" (1834), and it does indeed exhibit some of the same characteristics as the later buildings, including an oriel window and crenellations (fig. 8). This design, however, was for a residence, not an academic building, and thus there is not as clear a link between stylistic choice and symbolic meaning as there would be with the later academic commissions built in the Collegiate Gothic mode.

The driving force behind both the sesquicentennial celebration and the move toward a unified campus in the Collegiate Gothic style was Andrew Fleming West, Giger Professor of Latin (and future dean of the graduate school). West was secretary of both the committee in charge of the sesquicentennial festivities and the committee responsible for securing gifts in honor of the celebration, and in these roles he was uniquely positioned to influence the decisions made by the committee as well as the choices of the donors of new buildings. West was also able to influence decisions of the Board of Trustees through his friend Moses Taylor Pyne, one of the board's wealthiest and most influential members—and a member of the same two sesquicentennial committees as West.[36] (West and Pyne would also work together closely on the creation of the new Graduate College campus, which is discussed in the following essay.)

The first commission under the post-sesquicentennial stylistic guidelines was for an extension to Chancellor Green Library, named Pyne Library in honor of the donor, the mother of trustee Moses Taylor Pyne.[37] William Potter, the de facto in-house architect for the school, had completed Alexander Hall only two years before, but the trustees no longer desired Richardsonian Romanesque. Pyne personally directed the design of the structure by Potter in the Tudor Gothic style and submitted the completed plans to the Board of Trustees for approval (fig. 9).[38] Writing in *Harper's Weekly*, Andrew Fleming West praised the building as "a splendid richly decorated example of English collegiate building of the later fifteenth century. In watching its rising walls and towers one cannot help thinking of Magdalen College in Oxford and the battlemented walls overlooking the gardens of St. John's in Cambridge."[39] Indeed, the west clock tower of Pyne Library is reminiscent of the late-fifteenth-century tower in the cloister quadrangle of Magdalen College, Oxford (fig. 10).

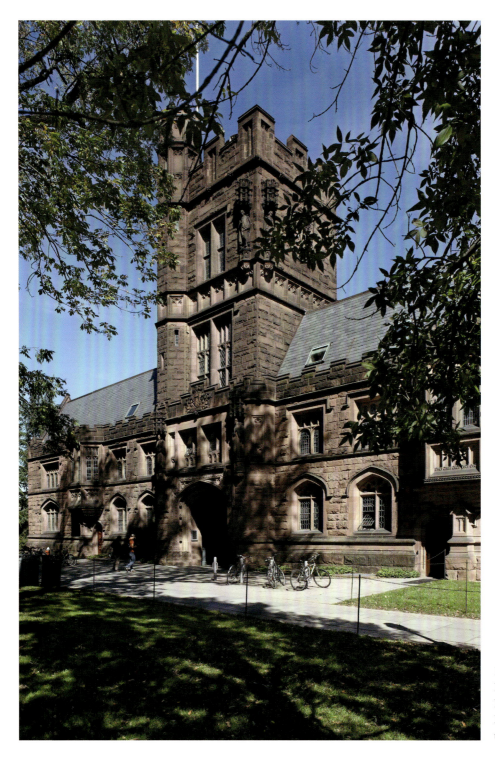

Figure 9. William Appleton
Potter, American, 1842–1909:
Princeton University, Pyne
Library, west entrance and
tower, 1896–97.

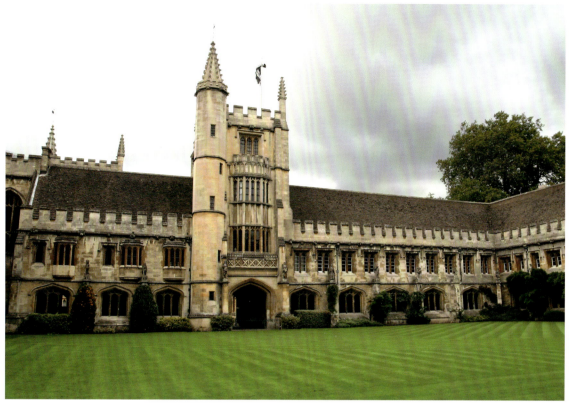

Figure 10. William Orchard, English, 1468–1504: Oxford University, Magdalen College, view of cloister, 1474–80 (with later renovations).

Although West was pleased with Potter's design for the library, the architect was not retained by the University for the next building campaign in Collegiate Gothic style, which would focus on dormitories for the growing number of students. Instead, the University hired the Philadelphia-based architectural firm of Cope and Stewardson. Partners and childhood friends Walter Cope (1860–1902) and John Stewardson (1858–1896) had already established themselves as masters of the Collegiate Gothic style with their designs for buildings on the campuses of Bryn Mawr College and the University of Pennsylvania.

Cope and Stewardson's initial work in the Collegiate Gothic style at Bryn Mawr was directed by the college's president, M. Carey Thomas, whose recent, transformative trip to England had convinced her that English Gothic architecture was the only appropriate style for a college campus.[40] John Stewardson's own English vacation of 1894 inspired a specifically

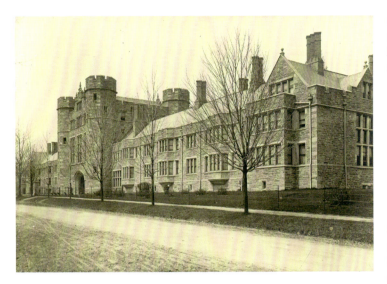

Figure 11. Cope and Stewardson, architects, Philadelphia, 1885–1912: Bryn Mawr College, Pembroke Hall, 1892, Bryn Mawr, Pennsylvania.

Figure 12. William Swayne, English, active early 16th century: Cambridge University, St. John's College, Main Gate, completed 1516.

Oxbridge approach to Tudor Gothic. Stewardson made a number of watercolors of English collegiate buildings, including St. John's College of Cambridge, which he shared with his partner upon his return.[41] Pembroke Hall, the first building the firm designed for Bryn Mawr after Stewardson's trip, is a clear reference to the Main Gate, the entrance to the first court of St. John's and the oldest part of the college (1511–20; figs. 11 and 12).

Pembroke Hall proved to be an attractive model at Princeton for both West and John Insley Blair, a railroad magnate, trustee of the University, and the donor of its new dormitory, Blair Hall.[42] West had visited Bryn Mawr and was impressed with Cope and Stewardson's work there; he then encouraged Blair to visit the campus and

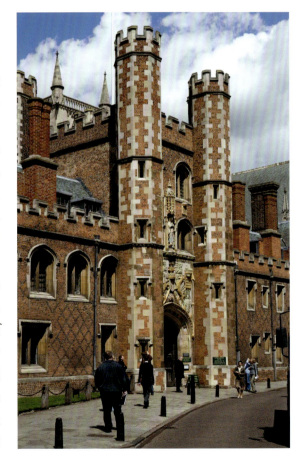

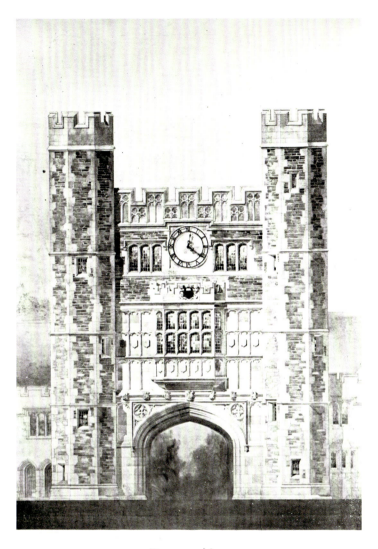

Figure 13. Cope and Stewardson, architects, Philadelphia, 1885–1912: Princeton University, Blair Hall, entrance tower, December 1896. From *Plans and Sketches of the New Buildings Erected or Proposed for Princeton University, July 1897* (Philadelphia: G. H. Buchanan, 1897), pl. 8. University Archives, Department of Rare Books and Special Collections, Princeton University Library.

Figure 14. Cope and Stewardson, architects, Philadelphia, 1885–1912: Bryn Mawr College, Rockefeller Hall, 1903–4, Bryn Mawr, Pennsylvania.

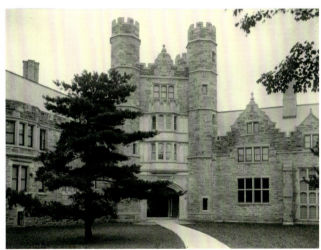

ENTRANCE TOWER TO BLAIR HALL PRINCETON UNIVERSITY
ELEVATION TOWARDS CAMPUS

discuss possible designs for his new building with the two architects.[43] Although John Stewardson died shortly thereafter, Walter Cope carried on with the approach already established at Bryn Mawr (fig. 13).[44] While Blair Hall was not a direct copy of Pembroke Hall, the similarities were enough for Carey Thomas to request that the firm's design for a new library in 1903 remain "an individual feature of Bryn Mawr."[45] The library, however, named for benefactor John D. Rockefeller, bears a striking resemblance to Blair Hall,

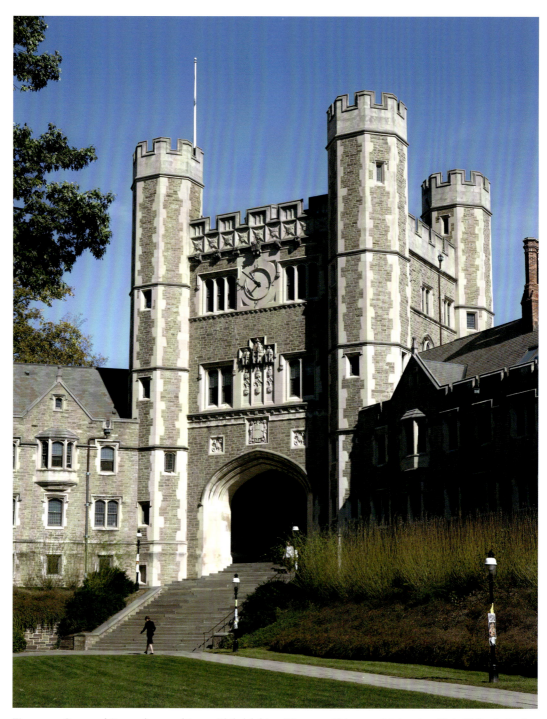

Figure 15. Cope and Stewardson, architects, Philadelphia, 1885–1912: Princeton University, Blair Hall, 1896–98.

suggesting aesthetic reciprocity between the firm's designs for Bryn Mawr and those for Princeton (fig. 14).

Blair Hall was completed in 1898 and was joined by a second Cope and Stewardson-designed dormitory, Stafford Little Hall, by 1899, and the adjoining University Gymnasium by 1903. (The gym burned down in 1944 and was replaced by Dillon Gymnasium, constructed between 1945 and 1947.) Together, these three buildings served to welcome and impress the visitor arriving by train, with Blair Hall acting as a monumental gateway from the railroad station to the campus, as well as functioning as a screen to shield the undergraduate population from the noisy and industrialized world beyond (fig. 15).

In an essay written in 1947 on the campus architecture, Donald Drew Egbert noted that although the Collegiate Gothic designs of Cope and Stewardson, as well as those of their successors, certainly looked like their Oxbridge models from the outside, they departed radically in both overall plan and interior layout. Unlike the English colleges, which were constructed as a series of quadrangles, Blair and Little Halls instead meander along the campus border—F. Scott Fitzgerald referred to Little as a "black Gothic snake."[46] At St. John's College in Cambridge, the Main Gate serves as an entry portal to the first court, marking the entrance to the rarified space of academe contained within. Blair Arch, however, is not an entrance to the space reserved for student life but rather a marker of the boundary between the campus and the outside world. Students reach the interior living spaces not through a quadrangle or centralized entry portal but through a series of separate entryways that mark the length of the dormitory buildings.

Egbert attributed the use of separate doors to the greater degree of social freedom afforded the Princeton student, but they are also the embodiment of Woodrow Wilson's belief that students learned best from close contact with their peers and elders—what he called mind-and-mind interaction. This conviction was the product of his own happy undergraduate days, when he formed close friendships with his dorm-mates at Seven West Entry on the second floor of Witherspoon Hall.[47] The division of the dormitories into vertical slices certainly provided a greater degree of privacy for the students, yet it also encouraged them to get to know their neighbors on other floors and to congregate not in the hallways but in each other's rooms.[48]

The continuing interest in the Collegiate Gothic also reflects Woodrow Wilson's own love of the English university model and its architectural style. Wilson, an alumnus of both

Princeton (Class of 1879) and Johns Hopkins (Ph.D., 1885), was hired by Princeton as professor of jurisprudence and political economy in 1890 and was elected to the presidency in 1902. He had enjoyed an idyllic four years of undergraduate study at Princeton, but had found graduate study at Hopkins to be "irksome" and the school's focus on the German model to be merely technical, not inspirational.[49] Wilson graduated from Hopkins with a strong dislike for the Germanic model of education and an even stronger desire to mold Princeton in the image of Oxford University, which he had visited during a trip abroad in 1896.[50] Wilson returned to Oxford in the summer of 1899; a letter to his young daughter Jessie illustrates the romantic views he held of Oxford's medieval buildings and his desire to emulate them at Princeton:

> *Oxford, you know, is England's great university town. We hope Princeton will be like it some of these days, —say about two hundred years from now. It is full of buildings like Blair Hall by the station and the University Library. Only the Oxford buildings are more beautiful than ours. They have been standing so long that they look, not new, but venerable. Their old stone is of such soft colours, and they are covered over so often with ivy—like the front of Old North. And then, behind them and about them, are beautiful gardens, with great trees and shady lawns and inviting cool places to sit and read, or fancy how all the great Oxford men who have made England's history, and all the great writers who studied at Oxford must have fared when they were here. It would be hard <u>not</u> to study, wouldn't it, when so many people have been studying for almost a thousand years?*[51]

As University president, Wilson felt very strongly that the best way to make mind-and-mind interaction occur was within the English collegiate quadrangle model. In 1906, Wilson and the Board of Trustees retained Ralph Adams Cram, the preeminent Gothic Revival architect, to create a master plan that would re-imagine the entire campus.[52] Unlike the newer University of Chicago or Stanford University, which were built from scratch and could therefore exhibit a singular architectural vision,[53] Princeton had to contend with what Cram derided as McCosh's "pleasure park" campus, which featured buildings scattered willy-nilly, with no thought to regularity.[54]

The new master plan called for the creation of a series of quadrangles based on the colleges of Oxford and Cambridge. In order to create these quads, however, Cram noted that a number of pre-existing buildings would have to be either demolished or moved, a

wish that was never granted.[55] Ultimately, Wilson's desire for the quad plan to the exclusion of all other campus priorities—including the Graduate College—would be his downfall. Andrew Fleming West would outmaneuver Wilson in his quest for a new graduate school campus, and Wilson would depart the University in 1910 without ever having seen his "quad plan" come to fruition. Cram's opportunity to create a Gothic quadrangle from scratch came the next year with the commissioning of the new Graduate College on a site far removed from the central campus.[56]

Although the quad plan was not realized at Princeton during Wilson's tenure, a new freshman dormitory quadrangle, designed by the Philadelphia-based firm of Frank Miles Day (1861–1918) and Charles Z. Klauder (1872–1938), began to take shape toward the end of his presidency.[57] The complex is actually two quadrangles: the first, formed by Holder Hall (1908–10), was expanded when Madison Hall (1915–17) was added to enclose the space outlined by Hamilton Hall (1909–10; fig. 16). As with Cope and Stewardson's Blair Hall, the buildings are generally inspired by the architecture of Oxford's colleges, but they also contain references to other English models—Holder Tower (1910–11), for example, is almost a copy of the crossing tower at Canterbury Cathedral, completed in 1498 (fig. 17).[58]

In an article on Princeton architecture, penned in 1909, Ralph Adams Cram surveyed the current state of affairs of Princeton campus architecture and presented the University's master campus plan, with its strong focus on Collegiate Gothic architecture and the use of the quadrangle. The article was an opportunity for Cram to discount the earlier High Victorian Gothic buildings, which he derided as a "variety show," and present the Collegiate Gothic as the only suitable style for an American institution of higher education. Cram wrote that all future buildings would be designed in "the style fixed forever by Oxford and Cambridge, Winchester and Eton; the style that education and learning had made their own and held for two centuries a bulwark against the tide of the secular Renaissance; the style hewn out and perfected by our own ancestors and become ours by uncontested inheritance."[59]

Cram's article repeated an argument he had made elsewhere about the racial roots of Gothic architecture. In an appreciation from 1904 of the work of Cope and Stewardson, for example, Cram equated the "poetry" of their designs with "indestructible race fealty and religious continuity."[60] Gothic—and specifically English Gothic—was an inheritance dictated by "our own blood and temper."[61] Cram's words echoed those of Wilson two years before, when he announced to a gathering of New York alumni:

Figure 16. Day & Klauder, architects, Philadelphia, 1893–1927: Princeton University, Holder Tower, 1910–11.

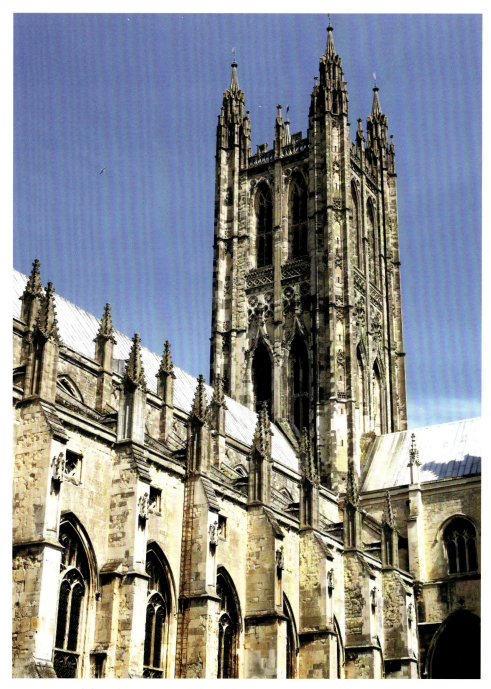

Figure 17. English, 15th century: Canterbury Cathedral, crossing tower (Bell Harry Tower), completed 1498.

By the very simple device of building our new buildings in the Tudor Gothic style we seem to have added a thousand years to the history of Princeton by merely putting those lines in our buildings which point every man's imagination to the historical traditions of learning in the English-speaking race. We have declared and acknowledged our derivation and lineage; we have said, "This is the spirit in which we have been bred," and as the imagination, as the recollection of classes yet to be graduated from Princeton are affected by the suggestions of that architecture, we shall find the past of this country married with the past of the world and shall know with what destiny we have come into the forefront of nations.[62]

The appropriateness of English Gothic for America was therefore not only a question of aesthetics but of racial heritage. For Cram, Wilson, and their compatriots, America was at its core an English country, and therefore the most befitting architectural style was the Gothic of late medieval England. By claiming their status as the heirs to Oxbridge, Princeton's administration and alumni not only made a direct link to longstanding educational traditions but also made a racial connection between modern American Protestant culture and its Anglo-Saxon roots. This interest in defining Princeton's academic and racial heritage in architectural terms accords with T. J. Jackson Lears's argument that a key reason for modern medievalism was a deep-seated anxiety on the part of those who saw themselves as arbiters of culture and taste.[63]

Princeton's desire to create a campus filled with buildings that would reflect actual medieval models coincided with the growing interest among the art history faculty in collecting and studying authentic medieval works of art.[64] The growing financial strength of the Art Museum, Marquand's own personal financial security, and the largesse of donors meant that Marquand and his colleagues could acquire more original works of art and not rely solely on the use of casts for teaching and research. Marquand's earliest purchases for the Museum, often made with his own funds, were mostly small objects, including a fifteenth-century English alabaster plaque of the Coronation of the Virgin and a fifteenth-century Italian bone-and-wood casket (see Checklist of the Exhibition), but later purchases and gifts brought larger sculptural works into the collection, including a fifteenth-century Champenois relief of an angel (see Checklist) and an early-sixteenth-century limestone sculpture of a female saint (fig. 18), both purchased in 1908 from the art dealer Georges Demotte.[65] The

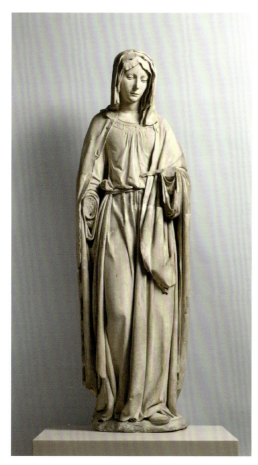

Figure 18. French, Champagne School,
The Princeton Saint (Saint Martha?), ca. 1515–25.
Limestone, 117 x 30 cm. Gift of Allan Marquand,
Class of 1874, in 1908 (y47).

sculpture of the female saint was particularly prized by the department, which labeled it "the best French Gothic piece in the country" in 1926.[66]

The growing professionalism of the discipline of art history as practiced at Princeton, with its roots in the German academy, might seem to have been at odds with the goals of the men who were directing the development of the campus along the lines of the English collegiate model. Certainly, Woodrow Wilson was not reserved in his distaste for the German university model. I would suggest, however, that these two groups—"medievalists" and "revivalists"—found Princeton to be an effective crucible for melding what could have been disparate approaches to the Middle Ages. At Princeton, the art and architecture of the Middle Ages became the language through which a new model of American higher education was articulated. This new American university combined the research-based model of academic inquiry, as pioneered in continental Europe, with the English collegiate paradigm. The combination provided a rigorous education using the latest pedagogical techniques within an idyllic setting meant to both inspire the student body and remind them of their own heritage and their status among the elite. Gothic Revival architecture, and in particular the Collegiate Gothic examples, thus became a symbol for the University as a whole. Beginning with the December 13, 1916, issue of the *Princeton Alumni Weekly*, the cover represented this symbolic "self-portrait" by depicting the two Collegiate Gothic towers on campus: Holder Tower and Cleveland Tower at the Graduate College (fig. 19). The two towers served as metonyms for the two student populations, the undergraduate body (represented by Holder Tower) and the graduate student body (represented by Cleveland Tower).

Figure 19. Cover of the *Princeton Alumni Weekly*, December 13, 1916. University Archives, Department of Rare Books and Special Collections, Princeton University Library. This was the first cover to feature images of the campus's two Gothic Revival towers, Holder Tower and Cleveland Tower.

Even with the growth in development on and around the campus in the following decades, these two towers continue to dominate the surrounding area, rising above the tree line to proclaim Princeton's stature to the town and countryside beyond. While a tower may be a building's most visible structure, it is but one element in a Gothic Revival building, which, like its medieval predecessors, was designed and constructed holistically—architecture worked together with interior furnishings, sculpture, and stained glass to present an entire work of art.

The next essay presents three major stained-glass commissions for three medieval revival buildings at Princeton— Marquand Chapel, Procter Hall at the Graduate College, and the University Chapel—to examine the ways in which an art form closely associated with medieval architecture communicated changes in the role of Princeton as an academic institution and in what was considered Gothic by artists and patrons around the turn of the last century.

Notes

1. The exception is Whitman College, completed in 2007, making it a modern revival of the Gothic Revival style.

2. Karl Kusserow, ed., *Inner Sanctum: Memory and Meaning in Princeton's Faculty Room at Nassau Hall* (Princeton: Princeton University Art Museum, 2010).

3. "Bolshevik" was often equated in the first half of the twentieth century with "Jews." (In 1922, an anti-Semitic pamphlet titled "The Jewish Bolshevism" was published in England, helping to spread the concept.) It was also during this period that Ivy League schools instituted measures to limit the number of Jews admitted. See Jerome Karabel, *The Chosen: The Hidden History of Admission and Exclusion at Harvard, Yale, and Princeton* (Boston: Houghton Mifflin Co., 2005).

4. Ruskin's *The Stones of Venice* was influential in both British and American circles, in particular Part Two, Book IV, "The Nature of Gothic." See *The Stones of Venice*, ed. J. G. Links (Cambridge, Mass.: Da Capo Press, 1960), 157–90.

5. A. W. N. Pugin, *Gothic Furniture: In the Style of the 15th Century* (London: Ackermann & Co., 1835); Pugin, *Designs for Gold and Silver Smiths* (London: Ackermann & Co., 1836); Owen Jones, *The Grammar of Ornament* (London: Day and Son, 1856). For more on the Aesthetic movement in England and abroad, see Lionel Lambourne, *The Aesthetic Movement* (London: Phaidon Press, 1996). For more on the Aesthetic movement in America, see Doreen Bolger Burke, ed., *In Pursuit of Beauty: Americans and the Aesthetic Movement* (New York: The Metropolitan Museum of Art, 1986).

6. For more on Potter, see Lawrence Wodehouse, "William Appleton Potter, Principal 'Pasticheur' of Henry Hobson Richardson," *Journal of the Society of Architectural Historians* 32 (May 1973): 175–92, and Sarah Bradford Landau, *Edward T. and William A. Potter: American Victorian Architects* (New York: Garland, 1979).

7. Sarah Bradford Landau, "Potter (ii)," in *Oxford Art Online*, accessed April 13, 2011, www.oxfordartonline.com/subscriber/article/grove/art/T069036pg1.

8. The ceiling originally had floral designs stenciled on plaster between the wooden ribs, and the bookcases featured pointed arches. See Cathy J. Brown, "Victorian Architecture on the Princeton Campus: 1868–1888: An Exhibition at the Princeton University Art Museum, 11 May–13 June 1976" (B.A. thesis, Princeton University, 1976), 49.

9. Brown, "Victorian Architecture on the Princeton Campus," 47. Sadly, none of Potter's original designs for the library survive; according to his brother Frank, William had made arrangements to ship his belongings to Europe for an extended visit, and the ship sank en route. Among the lost designs was an entry for a competition to design the new Cathedral of Saint John the Divine in the Morningside Heights neighborhood of Manhattan, where a third brother, Henry, was bishop. The firm of George Lewis Heins and Christopher La Farge (eldest son of John La Farge) was the eventual winner of this competition. See Frank Hunter Potter, *The Alonzo Potter Family* (Concord, N.H.: Rumford Press, 1923), 59.

10. Landau, *Edward T. and William A. Potter*, 258–59.

11. Elizabeth Aslin, *The Aesthetic Movement: Prelude to Art Nouveau* (London: Elek, 1969); Burke, *In Pursuit of Beauty*.

12. Kathleen Curran, *The Romanesque Revival: Religion, Politics, and Transnational Exchange* (University Park: Pennsylvania State University Press, 2003), and Curran, "The Romanesque Revival, Mural Painting, and Protestant Patronage in America," *Art Bulletin* 80, no. 4 (1999): 693–722.

13. Schuyler continued: "This, again, is very likely as well, since any additions that had been made in that decade would probably have been made in the Richardsonian Romanesque, which at best, would have introduced another refractory and incongruous element into the architecture of the university, and at the worst would have imposed upon it some very crude and clumsy works." See Montgomery Schuyler, "Architecture of American Colleges: III. Princeton," *Architectural Record* 27 (February 1910): 152.

14. Schuyler, "Architecture of American Colleges," 154.

15. For a discussion of the connections between the Romanesque Revival and the growing influence of the German educational model in the United States, see Curran, *The Romanesque Revival*, especially chaps. 4 and 6.

16. For discussions of the beginning and completion of the Art Museum building, see records from February 10, 1887, and November 14, 1889, Board of Trustees Minutes and Records, vol. 7, 4, 295, University Archives, Department of Rare Books and Special Collections, Princeton University Library.

17. For a thorough investigation of the creation of the Museum and its architectural history, see Sara E. Bush, "The Architectural History of the Art Museum," *Record of the Art Museum, Princeton University* 55, nos. 1/2 (1996): 77–106. The building was expanded with an addition designed by Ralph Adams Cram in 1921–23 in what Professor Howard Crosby Butler referred to as a Sienese Gothic style. The expansion originally housed the School of Architecture, and now forms part of McCormick Hall, the home of the Department of Art and Archaeology, the Art Museum, and the Index of Christian Art. See Butler, "McCormick Hall and the School of Architecture," *Princeton Alumni Weekly*, November 2, 1921, 99–102.

18. William C. Prime and George B. McClellan, "Suggestions on the Establishment of a Department of Art Instruction in the College of New Jersey" (Princeton, 1882), Department of Art and Archaeology Records, box 11, University Archives, Department of Rare Books and Special Collections, Princeton University Library.

19. Marilyn Aronberg Lavin, *The Eye of the Tiger: The Founding and Development of the Department of Art and Archaeology, 1883–1920* (Princeton: Princeton University Art Museum, 1983), 15.

20. Princeton Fund Committee, "The Department of Art and Archaeology of Princeton University and Its Endowment" (Princeton, 1926), Department of Art and Archaeology Records, box 11, folder "History of the Department." Casts of medieval and ancient sculptures were donated by the Class of 1881, while Marquand purchased casts of medieval ivories from the Arundel collection in England; these were used by Professor Frothingham in a class on medieval industrial art. See Lavin, *The Eye of the Tiger*, 16. Many of the casts of ancient monuments were catalogued and conserved in the 1980s. See the booklet published in conjunction with the 1989 exhibition on casts: H. Meyer and K. Evans, eds., *Casts in Perspective* (Princeton: Princeton University Art Museum, 1989).

21. Examples of other museums founded with extensive cast collections include the Victoria and Albert Museum in London, known in the 1880s as the South Kensington Museum, and the Metropolitan Museum of Art in New York.

22. James McCosh, "An Art Building for Princeton College" (Princeton, 1882), Department of Art and Archaeology Records, box 11.

23. June 11, 1894, Board of Trustees Minutes and Records, vol. 8, 10.

24. The prototype, the University of Berlin, was founded in 1810 by the educational reformer Wilhelm von Humboldt. The university is now known as the Humboldt-Universität zu Berlin.

25. Curran, *The Romanesque Revival*, 137.

26. For more on the founding of the Department of Art and Archaeology and the Art Museum, see Lavin, *The Eye of the Tiger* and Betsy Rosasco, "The Teaching of Art and the Museum Tradition: Joseph Henry to Allan Marquand," *Record of the Art Museum, Princeton University* 55 (1996): 7–52.

27. Allan Marquand, "Remarks on the History of the Study of Architecture at Princeton," dedication of McCormick Hall, June 16, 1923, Department of Art and Archaeology Records, box 11.

28. See Kathryn Brush, *The Shaping of Art History: Wilhelm Vöge, Adolph Goldschmidt, and the Study of Medieval Art* (Cambridge: Cambridge University Press, 1996).

29. Johns Hopkins faculty adopted the "scientific" approach to history first championed by the German historian Leopold von Ranke, who emphasized the study of primary sources as an essential part of historical inquiry. See Craig Hugh Smyth, "The Princeton Department in the Time of Morey," in *The Early Years of Art History in the United States: Notes and Essays on Departments, Teaching and Scholars*, ed. Craig Hugh Smyth and Peter M. Lukehart (Princeton University: Department of Art and Archaeology, 1993), 37–42.

30. Allan Marquand, "The History of Art as a University Study" (unpublished manuscript, July 1891?), Allan Marquand Papers, box 9, folder 6, Department of Rare Books and Special Collections, Princeton University Library.

31. Ibid.

32. Paul Venable Turner, *Campus: An American Planning Tradition*, 2nd ed. (Cambridge, Mass.: MIT Press, 1995), 163.

33. For a contemporary overview of the sesquicentennial, see *Memorial Book of the Sesquicentennial Celebration of the Founding of the College of New Jersey and of the Ceremonies Inaugurating Princeton University* (New York: Charles Scribner's Sons, 1898). This and other materials related to the celebration are located in the Princeton University Archives at the Seeley G. Mudd Library.

34. The first recommendation to the Board of Trustees to change the name of the institution from the College of New Jersey to Princeton University was made on November 8, 1894. The Committee on the Sesquicentennial noted that the public had already begun using this name informally, and if the change were not made, Princeton would suffer in terms of prestige as well as finances. The change was officially announced on October 22, 1896, "Sesquicentennial Day," in a ceremony at Marquand Chapel. See November 8, 1894, and October 22, 1896, Board of Trustees Minutes and Records, vol. 8, 71–72 and 369–70.

35. Charles Dudley Warner, "Editor's Study," *Harper's New Monthly Magazine*, February 1897, 481.

36. Donald Drew Egbert, "The Architecture and the Setting," in *The Modern Princeton*, ed. Charles Osgood et al. (Princeton: Princeton University Press, 1947), 86.

37. Officially, the gift was made anonymously by a "friend" working through the agency of Moses Taylor Pyne. See April 10, 1896, Board of Trustees Minutes and Records, vol. 8, 86.

38. Ibid.

39. Andrew Fleming West, "The New University Library at Princeton," *Harper's Weekly*, June 12, 1897, 591–92.

40. Edith Finch, *Carey Thomas of Bryn Mawr* (New York: Harper, 1947), 163.

41. William Emlyn Stewardson, "Cope and Stewardson, the Architects of a Philadelphia Renascence" (B.A. thesis, Princeton University, 1960), 72.

42. Egbert, "The Architecture and the Setting," 87.

43. Stewardson, "Cope and Stewardson," 80; Egbert, "The Architecture and the Setting," 90.

44. Stewardson died on January 6, 1896, in a skating accident on the Schuylkill River in Philadelphia. His younger brother Emlyn was hired by the firm and became partner in the following year. See "A Philadelphia Architect Drowned," *New York Times*, January 7, 1896.

45. "Collegiate Gothic—Cope and Stewardson," in *"The Very Best Women's College There Is"*: M. Carey Thomas and the Making of the Bryn Mawr Campus*, last modified September 2001, accessed March 21, 2011, www.brynmawr.edu/library/exhibits/thomas/gothic.html.

46. F. Scott Fitzgerald, *This Side of Paradise* (New York: Random House, 2001), 42.

47. W. Barksdale Maynard, *Woodrow Wilson: Princeton to the Presidency* (New Haven, Conn.: Yale University Press, 2008), 4–5.

48. Earlier dormitories, such as West College, also featured separate entryways, although here the intention was for less, not more, freedom. The separate entries divided the long hallways found in Nassau Hall, where students had taken to rolling hot cannonballs down the corridors. See Egbert, "The Architecture and the Setting," 99.

49. Maynard, *Woodrow Wilson*, 28–29.

50. Ibid., 83. See also Ray Stannard Baker, *Woodrow Wilson: Life and Letters*, vol. 2, *Princeton, 1890–1910* (Garden City, N.Y.: Doubleday Books, 1927; New York: Greenwood Press, 1968), 80–81. Citations refer to the Greenwood edition.

51. Woodrow Wilson to Jessie Wilson, July 30, 1899, Jessie Wilson Sayre Papers, box 2, folder 5, Public Policy Papers, Department of Rare Books and Special Collections, Princeton University Library. My thanks to Robert Cullinane, Class of 1970, who graciously alerted me to this letter, which is also available online through the Woodrow Wilson Presidential Library's eLibrary, www.woodrowwilson.org/index.php/library-a-archives/wilson-elibrary. Wilson expressed similar sentiments in a letter to his wife dated just four days earlier, referring to Cambridge as "a place full of quiet chambers, secluded ancient courts, and gardens shut away from intrusion,—a town full of coverts for those who would learn and be with their own thoughts." See Baker, *Woodrow Wilson: Life and Letters*, 92–93.

52. For Cram's own discussion of his plan, see his article on "Princeton Architecture," *American Architect* 96 (July 21, 1909): 21–30.

53. Turner, *Campus: An American Planning Tradition*, 169.

54. See David Williamson III, "The Pleasure Park vs. The University Plan," *Princeton Campus: An Interactive Computer History, 1746–1996*, last modified 1996, accessed March 22, 2011, http://etcweb.princeton.edu/Campus/text_parkplan.html.

55. The biggest offender was Dod Hall, which Cram disliked both for its location (which disrupted his envisioned main axis from Nassau Hall and down the sloping lawn through Whig and Clio to the site he

proposed for a new chapel) and its style, a sort of Romanesque-Byzantine hybrid. Cram never got his wish to move Dod, and it remains today on the same site where it was built in 1889–90 by Boston-based architect John Lyman Faxon.

56. For a detailed account of the battle between Wilson and West, see Maynard, *Woodrow Wilson*, parts 3 and 4.

57. The firm was established as Frank Miles Day & Bro. but was changed to Day Bros. & Klauder in 1911 and then Day & Klauder in 1913. Klauder continued to use that name, even after the death of Day in 1918, until 1927, when he used only his name. See Sandra L. Tatman, "Charles Zeller Klauder," American Architects and Buildings database, accessed March 18, 2011, www.americanbuildings.org.

58. Egbert, "The Architecture and the Setting," 92.

59. Cram, "Princeton Architecture," 23.

60. Ralph Adams Cram, "The Work of Messrs. Cope & Stewardson," *Architectural Record* 16 (November 1904): 411.

61. Cram, "Princeton Architecture," 25.

62. Baker, *Woodrow Wilson: Life and Letters*, 174.

63. See "Introduction: Spires and Gargoyles," n. 7.

64. For more on the development of the collections in tandem with the teaching goals of the faculty, see Rosasco, "The Teaching of Art and the Museum Tradition."

65. Marquand kept a record of his purchases in his "day book," which is now stored in the archives of the Princeton University Art Museum.

66. Princeton Fund Committee, "The Department of Art and Archaeology of Princeton University and Its Endowment."

Figure 1. Princeton University, Marquand Chapel (undated), view of the west entrance. University Archives, Department of Rare Books and Special Collections, Princeton University Library.

"THAT ANCIENT AND MOST IMPERISHABLE OF THE ARTS"*
THE ROLE OF STAINED GLASS IN THE DEVELOPMENT OF THE GOTHIC REVIVAL AT PRINCETON

Shortly after 11 p.m. on Friday, May 14, 1920, a fire broke out on the top floor of Dickinson Hall, one of the academic buildings on the east side of the campus of Princeton University.[1] Sparks leapt to the roof of the neighboring Marquand Chapel, and several blazes started in the interior. Students and other onlookers joined together to save anything that could be carried out of the chapel, but it soon became clear that the building could not be saved. By morning, all that remained was a charred shell, which continued to send up sparks and smoke well into the following night.

The chapel, completed in 1882, had been one of the architectural highlights of the Princeton campus (fig. 1). Designed by Richard Morris Hunt (1827–1895), the first American architect to train at the École des Beaux-Arts in Paris, it had contained works by some of the most famous American artists of the late nineteenth and early twentieth centuries, such as Augustus Saint-Gaudens (1848–1907) and Louis Comfort Tiffany (1848–1933). A few days after the fire, the student newspaper, *The Daily Princetonian*, reported that the fire chief declared it the worst fire he had ever seen in Princeton, and that the loss of the interior decorations in particular was "most keenly felt."[2]

Within a year, the Boston architectural firm of Cram and Ferguson had produced plans for a new chapel, to be built just to the north of the site of the destroyed chapel. This new chapel was to be in the Collegiate Gothic style, which had become the sanctioned style of the University's building program at the time of the school's sesquicentennial in 1896 (and was the favored style of Ralph Adams Cram, senior partner of the firm and the University's supervising architect). Even though the school had made a conscious decision to build the new chapel in an architectural style different from the former one, the sense of loss of

Marquand Chapel persisted. President John Grier Hibben inquired of Cram whether the stained-glass windows, which were destroyed in the fire, could be replicated in the new chapel's north transept, known as the Marquand Transept. This request did not fall on sympathetic ears. After reviewing photos of the destroyed windows, Cram replied, "The old windows were certainly pretty bad. I cannot imagine anything much worse. It is fortunate that they were destroyed."[3]

What had been considered appropriate elements of a "Gothic," or at least medievalizing, interior in the 1880s was considered by the 1920s not only passé but in poor taste. The windows for the new chapel expressed a radically different approach to the art of the Middle Ages and a desire on the part of artists and patrons to return to what they believed were the authentic methods and style of the thirteenth and fourteenth centuries. This essay explores changes in attitude toward the arts of the Middle Ages as epitomized by developments in stained-glass design and technique from the late nineteenth to the early twentieth century. It presents three case studies of Princeton buildings with major stained-glass windows commissioned between the 1880s and the 1920s: the memorial windows of Marquand Chapel, the great window in Procter Hall at the Graduate College, and the windows made for the Marquand Transept in the University Chapel. These case studies serve as markers not only of changing attitudes toward the Gothic at Princeton, but also as a measure of the larger shifts in art and style taking place in the United States at this time.

The change can be charted broadly as a turning away from the Aesthetic movement's eclectic approach to the Middle Ages, an approach that could include references to a wide variety of buildings and styles from eastern and western Europe as well as the Middle East, from the twelfth through the sixteenth century (as epitomized by Marquand Chapel), to a much more direct interpretation of the Gothic: architecture from France and England in the thirteenth and fourteenth centuries (as represented by the University Chapel). This move away from Aestheticism toward a "true" Gothic Revival was not a clean break, however, and there were moments when proponents of the two camps were in direct conflict, as was the case with the commission for the great window in Procter Hall at the Graduate College in the 1910s.

Why focus these case studies on stained glass? Stained glass in America "paralleled the artistic and cultural developments across the decades," particularly in the nineteenth and early twentieth centuries and especially in the New York region.[4] At Princeton, the same

could not always be said of the buildings that contained stained-glass windows. True to its conservative Scottish Presbyterian roots, Princeton was usually late to adopt the newest architectural styles, and did so sometimes even after they had passed their peak elsewhere. While the buildings may have on occasion been *retardataire*, the art that was commissioned to decorate them came from the studios of some of the most trend-setting decorative and fine artists of their time.

Stained glass experienced a renaissance in the United States and Europe in the late nineteenth and early twentieth centuries. Stained-glass windows were a popular way to memorialize a deceased family member and served as the generator of many ecclesiastical commissions, yet windows were also created for private residences and secular public buildings. Stained glass also became the focus of debates over artistic authenticity versus invention. Should American stained-glass artists experiment and develop their own forms of glass, as did John La Farge (1835–1910) and Louis Comfort Tiffany? Or should they honor the medieval roots of stained glass by close study of the methods used by thirteenth-century craftsmen? These issues were debated on the Princeton campus over the course of more than four decades, as the commissions for Gothic Revival buildings required stained glass to fill the many large windows.

Marquand Chapel: Medieval Eclecticism
When James McCosh arrived in Princeton in 1868 from Queens College, Belfast, to become president of the College of New Jersey, he was troubled by the state of the campus buildings.[5] Enrollment was increasing, and students did not have the proper facilities for their study or worship. At that time, the chapel was a simple, cruciform-shaped building that could seat 325—far more than the number of students at the College when it was completed in 1847, but by the 1870s already too small to accommodate the growing student body.[6] McCosh was also concerned about the behavior of the students, whose constant pranks during religious services made clear that compulsory chapel attendance did not necessarily result in a sense of spiritual commitment.[7] Believing that buildings could "at best [be] as outward expressions and symbols of an internal life,"[8] McCosh reported to the Board of Trustees in 1873 that a new chapel was needed.[9]

The College found a willing donor in Henry Gurdon Marquand, a wealthy New York banker and railroad owner whose success in business allowed him to indulge his interest in

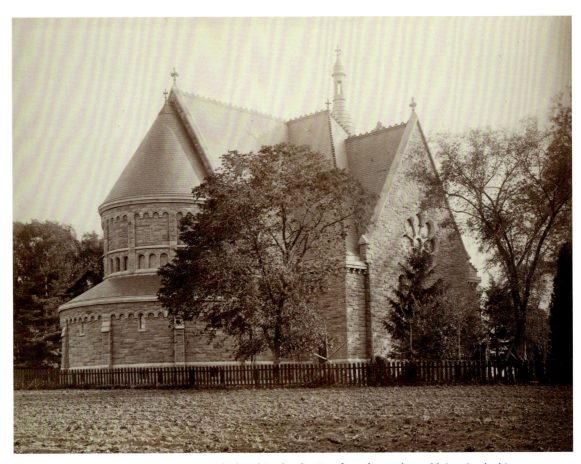

Figure 2. Princeton University, the Marquand Chapel (undated), view from the southeast. University Archives, Department of Rare Books and Special Collections, Princeton University Library.

the arts.[10] An 1897 *Harper's Weekly* article described him as a "noble example of enlightened citizenship, . . . proving that a love of art and an active interest in all that beautifies and refines existence are not incompatible with the pursuit of a successful business career."[11] Marquand had already established himself as an important patron of the College with his donation of a new gymnasium building in 1869. Although Marquand was not an alumnus of the College, his three sons—Harry, Frederick, and Allan—had all graduated from Princeton, and his ties were to grow deeper with the appointment of Allan as lecturer in logic in 1881.[12]

Richard Morris Hunt, the architect whom Marquand selected for the chapel, is today better known for the façade and wings he designed for the Metropolitan Museum of Art and

many mansions for the leading families of the Gilded Age.[13] Yet in the 1880s, Hunt was employed on a number of projects in Princeton, including Murray Hall, the Lenox Library at the Princeton Theological Seminary (see fig. 5), and two adjacent faculty houses.[14] Hunt had already designed Marquand's Newport home, Linden Gate, in 1873 and would later design his Manhattan mansion, which stood at the northwest corner of East 68th Street and Madison Avenue.[15]

As a group, Hunt's buildings cite a wide range of historical styles, from Moorish to Classical to Renaissance, and his work in Princeton likewise exhibited eclectic tendencies. Historic photographs as well as Hunt's original presentation drawings of Marquand Chapel reveal a building that referred to the architecture of twelfth-century Europe, with its rounded arches, crocket-capital columns and rugged masonry of freestone quarried from nearby Newark (fig. 2). Other details, such as the pointed arches embedded in the exterior masonry, recalled Gothic architecture, while many of the decorative details seemed more Middle Eastern or Byzantine.

For all the eclecticism of its decorative details, Hunt's design also displayed a sense of geometrical regularity based on the massing of forms around the building's core. Hunt composed a closed exterior combining geometric shapes and volumes: the triangle, the rectangle, the semicircle, the cube, the cylinder, and the cone. These shapes and volumes were arranged around a Greek-cross plan, with four shallow bays extending from a central square of sixty feet. On the exterior, the steeply pitched roof resulted in walls that appeared as equilateral triangles separated from rectangular bases by a stringcourse. The north and south walls were identical, with large wheel windows above five round-arched windows (fig. 3), but the western entrance was visually more complex (fig. 4). Here, the triangle-rectangle combination was broken up by a series of repeating arches—three for the windows above and three for the windows below, with three more triangles serving as gables above the portal arches. A staircase tower to the right and the larger tower to the left were cylindrical and rectangular volumes, respectively, that were appended to the façade. In the rear, the apse was formed by another appendage—here, two concentric cylinders that were covered with a cone (see fig. 2; in the construction phase, the tower and staircase were switched, so that the staircase was on the left and the tower on the right, as in fig. 1).

The only irregular element of the exterior was the tower, with its turban-like dome. The addition of a tower was essential to McCosh, who wished to make the chapel the focal point

Figure 3. Richard Morris Hunt, American, 1827–1895: Marquand Chapel, side elevation, 1882. Ink on linen(?), 86.3 x 101.6 cm. University Archives, Department of Rare Books and Special Collections, Princeton University Library.

of the campus, with "a tower 'as high as the tower of Babel,' so as to be seen from the railroad."[16] It is doubtful that McCosh's comparison to biblical Babylon directly influenced Hunt's design, however, since the tower closely resembled one Hunt had designed just a few years earlier for the new library at the Princeton Theological Seminary (fig. 5).

The tops of these towers resemble the dome of the basilica of Sacré-Coeur on Montmartre, designed by Paul Abadie (1812–1884) in 1874 (fig. 6).[17] Abadie, like Hunt a graduate of the École des Beaux-Arts, was both a designer of new buildings and a restorer of a number of Romanesque and Gothic churches across France, and his designs often display the direct influence of his restoration projects. Abadie's design for Sacré-Coeur recalls the church of Saint-Front in Périgueux, which he restored in the 1850s and 1860s (fig. 7). Saint-Front, with its distinctive multiple cupolas, had already been published in Félix Verneilh's *L'Architecture byzantine en France* of 1851; perhaps Hunt, who was still in Europe at the time

66

Figure 4. Richard Morris Hunt, American, 1827–1895: Marquand Chapel, front elevation, 1882. Ink on linen(?), 89.9 x 89.9 cm. University Archives, Department of Rare Books and Special Collections, Princeton University Library.

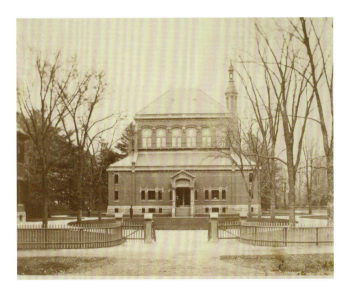

Figure 5. Richard Morris Hunt, American, 1827–1895: Princeton Theological Seminary, New Lenox Library (undated). Photograph Collection, Archives, Princeton Theological Seminary.

Figure 6. Paul Abadie, French, 1812–1884: Basilica of Sacré-Coeur, Paris, 1875–1919.

Figure 7. French, 1120–1173: Cathedral of Saint-Front, Périgueux, France; restored by Paul Abadie and others, 1852–1901.

of publication, was familiar with the book and its many reproductions of the building's exterior and plan.

Hunt found inspiration for American architectural design in these French "Romanesque Byzantine" buildings, Saint-Front in particular. In a speech he gave to the Fourth Church Congress in the fall of 1877, Hunt described for his audience "The Church Architecture That We Need" (the speech was reproduced as a two-part article in the *American Architect and Building News*). In part one, published in November 1877, Hunt specifically referred to Saint-Front as worthy of study, an "almost exact repetition in form and dimension of St. Mark's" in Venice.[18] In part two, published in December, Hunt went into more detail regarding the specific forms and style that were most appropriate for Protestant churches. He

concluded that the cruciform shape, and specifically the Greek cross form, was preferable, "as the length of the nave is thereby reduced, and the worshippers are brought nearer the chancel. This symbolic form, so appropriate and so universal, affords also the advantage of great variety of perspective effect, and permits endless modes of treatment both with the rectangular and apsidal termination of the arms of the cross. . . . In fact, the Byzantine church, without doubt, presents superior advantages over all other types for Protestant worship."[19]

This idea of finding the most appropriate form for the function of a building was one of the key tenets taught at the École des Beaux-Arts. According to Paul Baker in his book on Hunt: "At the École, the principles of composition taught were those of unity, proportion, scale, and balance of architectural forms, but above all, the working out of a logical solution to the particular problems encountered in a structure."[20] The plan was of primary importance, for it was the part of the design that most clearly communicated the logic of the solution— what the French referred to as the *parti*. The school also placed emphasis on the mass of the building, with a well-defined base, middle, and roofline, and on the relationship between the interior spaces and how one would move logically through them. All these elements are present in the design of the chapel, from the geometric plan to the massing of forms on the exterior, to the logic of the interior space and its relationship to its function. Although such a hybrid Romanesque-Byzantine-Gothic building would have been stylistically abhorrent to Hunt's instructors, the design—in terms of theory and planning—reflected admirably the principles of architectural composition Hunt had learned in Paris.

Hunt may have felt that the Greek-cross plan was the most appropriate form for a Protestant church, yet correspondence between Henry Marquand and his son Allan reveals that President McCosh was initially opposed to this plan. Allan wrote to his father that McCosh was concerned the Greek-cross plan would "preclude such a voice as (the chaplain) Dr. Murray's from being heard";[21] it is also possible that there were concerns over the appropriateness of what was seen as a "popish" form for a Protestant building. John Notman's cruciform design for the "Old Chapel" in 1846–47 had led to an argument among the trustees about the appropriateness of the cross shape. A special committee formed to evaluate the situation reported to the board that "in (our) judgment the form of <u>a Cross</u> is not the form for a Presbyterian chapel. Cruciform architecture is so identified with popery that it becomes us to beware of adopting its insignia."[22] Although no correspondence between

Figure 8. Interior of Marquand Chapel (undated). University Archives, Department of Rare Books and Special Collections, Princeton University Library.

McCosh and the elder Marquand survives to document the disagreement over the plan for Marquand Chapel, Allan's advice to his father to "remain firm" in his design choice seems to have been followed, for the Greek-cross plan stayed.

Hunt's eclectic mix of Romanesque, Byzantine, and Middle Eastern styles continued on the interior, which boasted decorative work by some of the most sought-after artists of the late nineteenth century (fig. 8). These decorations included a glittering apse mural by Frederic Crowninshield (1845–1918) of Saint Michael flanked by angels; stained-glass windows on all four sides of the building by John La Farge, Francis Lathrop (1849–1909), and Louis Comfort Tiffany; and a large brass chandelier, reminiscent of a Byzantine *polykandelon*, which hung in

the crossing space.[23] Memorial sculptures of famous Princetonians by well-regarded Beaux-Arts sculptors were installed over the course of the next eight years. The most notable of these was a life-size bronze sculpture in high relief by Augustus Saint-Gaudens of President James McCosh, commissioned in 1889 by the Class of 1879 and placed immediately to the left of the pulpit (fig. 9). After the sculpture was destroyed in the fire, a replacement copy, cast from the original molds, was commissioned by the Class of 1879 on the occasion of its fiftieth reunion and installed in the Marquand Transept in the University Chapel.[24] Other sculptures included a marble tablet by A. Page Brown and Louis St. Gaudens in honor of scientist and professor Joseph Henry, and a bronze plaque by Olin Levi Warner of geology professor Arnold Guyot, which was installed on a slab of rock cut from a boulder at Neuchâtel, Switzerland, Guyot's birthplace.[25]

Hunt's eclectic interpretation of the architecture of the Middle Ages was well received by the Princeton community, even if

Figure 9. Augustus Saint-Gaudens, American, 1848–1907: *James McCosh*, 1889, as installed in Marquand Chapel (undated). Although the sculpture was badly damaged in the fire of 1920, the University was able to salvage the head, which was mounted on a marble base and is usually on view in the Rare Books reading room of Princeton University Library. University Archives, Department of Rare Books and Special Collections, Princeton University Library (see Checklist of the Exhibition).

viewers seemed at a loss to categorize it. An article in the *Daily Princetonian* of October 1881 stated: "The Marquand Chapel cannot be considered as belonging to any distinctive style of architecture, or exhibiting any leading architectural idea. . . . It embodies the rounded apse of the Roman basilica, the transept of the Gothic cathedral, the minaret of the Turkish mosque and the floor of the modern audience-room." The article continued to propose the labels of "Norman," "Gothic," "Norman-Gothic," and "Romanesque" before declaring that the building was "essentially a style of Transition, mingled, perhaps, with some of the

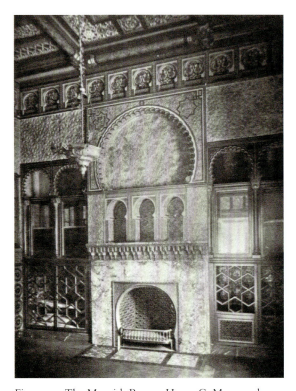

Figure 10. The Moorish Room, Henry G. Marquand residence, New York. From Harry Desmond, *Stately Homes in America* (New York: D. Appleton & Company, 1903). Marquand Library of Art and Archaeology, Barr Ferree Collection, Princeton University.

architect's own ideas of what would produce a handsome building."[26] One year later, the author of an article in the *New-York Tribune* wrote that "outside the building seem(ed) to be a conglomeration of different styles of architecture," but that "the prevailing type (was) Gothic."[27]

The mix of styles typified the Aesthetic movement, which was embraced by Henry Marquand for his own domestic interiors. His Madison Avenue mansion, for example, featured a series of theme rooms, which included a Greek music room, a Japanese room, a Moorish room (fig. 10), and a late medieval/Renaissance great hall. These were decorated by many of the same artists who had worked on the chapel—Crowninshield, La Farge, Lathrop, and Tiffany.[28] Stained-glass windows formed one of the elements of a successful Aesthetic interior.[29] The Arts and Crafts movement had encouraged a return to the arts of the Middle Ages, including the craft of stained glass, and wealthy patrons enthusiastically commissioned windows for their homes and as gifts for religious institutions. Two artists who spearheaded the growth of interest in stained glass were John La Farge and Louis Comfort Tiffany, both of whom executed commissions for Marquand's homes in Newport and Manhattan.

For Linden Gate, Marquand's Newport mansion, La Farge created *Peonies Blown in the Wind*, a vertical window with the central image of peach, pink, and red peonies against a blue background, framed by successive borders of decorative motifs (fig. 11). La Farge used opalescent glass, a technique he invented but for which his rival Tiffany is now better known.[30] La Farge's window is a riot of colors not found in medieval glass—pale peach, olive green, goldenrod, turquoise—and the ripples and irregularities of the opalescent glass enhance

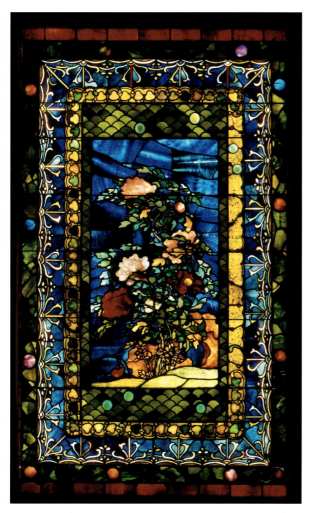

Figure 11. John La Farge, American, 1835–1910: *Peonies Blown in the Wind*, ca. 1880. Leaded opalescent glass, 190.5 x 114.3 cm. The Metropolitan Museum of Art, Gift of Susan Dwight Bliss, 1930 (30.50).

the sense of wind blowing across the flowers.[31] Displayed in a museum, La Farge's window is a singular masterpiece, but in Marquand's home, it was one element in a densely packed interior that also featured tapestries, sculpted ceilings, paneled walls, carpets, and Marquand's extensive collection of art and artifacts. (Linden Gate was so jam-packed that it was nicknamed Bric-a-Brac Hall.[32]) Indeed, the goal of Aesthetic domestic design was to create a harmonious whole out of disparate parts, which would then serve as a backdrop to the patron's own collection of art and artifacts.

In Marquand Chapel, the religious nature of the building demanded a more dignified aesthetic. Aside from the memorial sculptures, the large brass chandelier, and Frederic Crowninshield's apse mosaic, the interior walls were left bare of decoration, allowing the windows to command the viewer's attention. When the chapel was dedicated in May 1882, only the rose windows on the north and south walls by Louis Comfort Tiffany's studios and the twelve smaller arched windows in the half-dome of the apse by John La Farge were in place.[33] No detailed images of La Farge's windows for Marquand Chapel survive, but general views of the chapel suggest that the windows alternated between images of crosses and wreaths. The three large round-arched windows (one on the western façade and one below each rose window on the north and south sides) were glazed only with glass tinted the same pink color as the interior walls.[34]

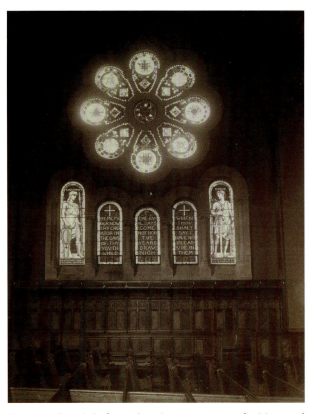

Figure 12. Francis Lathrop, American, 1849–1909: the Marquand memorial window, installed in Marquand Chapel in 1890 (destroyed 1920). University Archives, Department of Rare Books and Special Collections, Princeton University Library.

The large round-arched windows were likely left devoid of ornamental glass as an opportunity for the College to tap the generosity of its alumni. The second half of the nineteenth century saw an increase in the building of churches, and one way to distribute the costs of construction was to encourage individuals to donate portions of the buildings as memorials to deceased family members.[35] Stained-glass windows were the most popular form of private memorials, and it is probable that the College hoped that alumni or their families would embrace the opportunity to memorialize their loved ones in such an important new religious building.

The College's expectations came to fruition, and within a decade, three major memorial windows filled the north, south, and western walls of the chapel.[36] The Marquand and Dodge memorial windows, which were installed in the north and south walls, respectively, were designed and manufactured by Francis Lathrop, while the western window, the Garrett memorial window, was designed by Frederick Wilson (1858–1932) for Tiffany Glass Company. The first of the windows to be installed was the Marquand memorial window, given by Mrs. Henry Marquand in memory of her son, Frederick A. Marquand, who died at the age of thirty (fig. 12). The window was installed in the north wall in January 1890, seven and a half years after the dedication of the chapel. The scheme consisted of a cluster of five round-arched windows, with the tallest panels on the far left and right measuring about eight feet in height.[37] These end panels depicted the Old Testament figures of Jonathan and David, a common motif for the theme of friendship. An inscription running across the three central

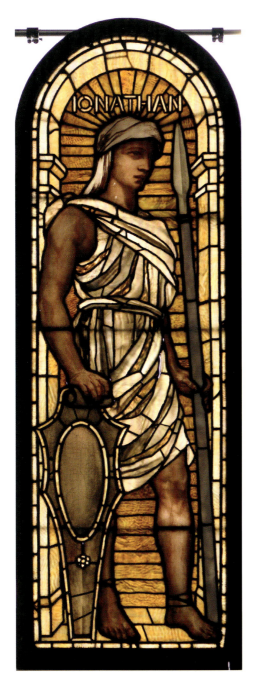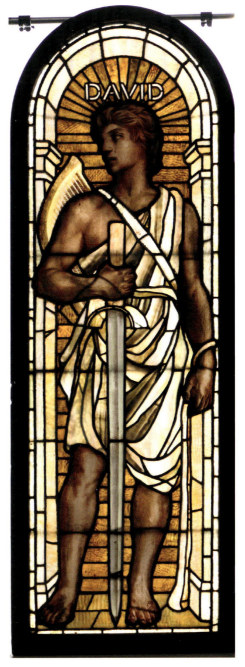

Figure 13. Francis Lathrop, American, 1849–1909: *Jonathan* and *David* (models for the Marquand memorial window), 1889. Leaded opalescent glass, each 171 x 61.5 cm. Gift of The Museum for the Arts of Decoration, The Cooper Union for the Advancement of Science and Art, New York, 1958 (y1958-112 and -113).

panels quoted Ecclesiastes: "Remember now thy Creator in the days of thy youth, while the evil days come not, nor the years draw nigh, when thou shalt say, I have no pleasure in them" (12:1). Lathrop's design was thus a meditation on friendship and the fleeting nature of youth—a fitting subject to commemorate the life of a man who died so young.

Although Francis Lathrop was not of the same stature as Tiffany or La Farge, in the late nineteenth century he was a sought-after designer and painter, as well as an art collector in his own right. His earliest works were based on the principles of the Pre-Raphaelites, and his mentor, James Abbott McNeill Whistler, sent him to England to study with the founder of the Arts and Crafts movement, William Morris. Upon his return to the United States, Lathrop was hired by John La Farge to assist with the interior decoration of Trinity Church in Boston. Lathrop then set up a studio in New York, where he made paintings and stained-glass windows to decorate churches and private residences, such as Saint Bartholomew's Church in New York and the home of the railroad magnate and art collector Collis P. Huntington.[38]

When Lathrop died in 1909, he bequeathed his art collection (of mostly English and Japanese art) to the Metropolitan Museum of Art. The terms of his bequest were so restrictive that the museum declined the gift, and Lathrop's estate, including all of his designs, cartoons, and papers, was auctioned at the Anderson Art Galleries in New York in April 1911.[39] The dispersion of the contents of his studio has resulted in the lack of archival material to study Lathrop's design process as well as his innovations in stained glass.

Surviving models of the David and Jonathan panels of the Marquand memorial window, however, demonstrate Lathrop's experiments with the form as well as the color of glass (fig. 13). Unlike La Farge, Lathrop deployed a restricted palette, a common feature of Aesthetic glass, which favored the same yellows, olive greens, and ambers used in other arts of the period. He also exploited the malleable nature of glass by modeling thicker areas to mimic the folds of drapery, a technique perfected at the Tiffany Glass Company and a departure from the mouth-blown sheets of pot-metal glass used in medieval windows.[40] The author of a *New-York Tribune* article, dated 1889, noted that the drapery of the figures was "corrugated glass, which represents the folds of the cloth admirably." The same individual also commented that the window was "unlike most others, in that pronounced colors, such as crimson and strong blues, do not appear in them. The only colors used are gray, yellow, brown and a pale flesh color, all of them in subdued tints." Such a neutral scheme lent "dignity" to the windows, which also "admit(ted) a flood of light," unlike "ordinary" (i.e.,

Figure 14. Francis Lathrop, American, 1849–1909: the Dodge memorial window, installed in Marquand Chapel in 1895 (destroyed 1920). University Archives, Department of Rare Books and Special Collections, Princeton University Library.

medieval) stained-glass windows.[41] Prior to its installation, Lathrop had exhibited the window in the first exhibition of the Philadelphia Museum and School of Industrial Art in the fall of 1889, where it won the gold medal in its class.[42]

Five years later, the industrialist William E. Dodge Jr., one of the founders of the mining company Phelps, Dodge and Company, commissioned Lathrop to create a similar window for the south wall (fig. 14). This window was given in memory of Dodge's eldest son, W. Earl Dodge, a member of the Class of 1879, who had died in 1884 at the age of twenty-six.[43] The window depicted two angels, representing Hope and Triumph, standing to the left and right of the central inscription from Psalm 148: "Praise ye the Lord; praise ye the Lord from the heavens; praise Him in the heights; praise ye Him all his angels; praise ye Him all his hosts." In this window, Lathrop expanded his color range, using mauve, blue, and olive glass that would harmonize with the Tiffany rose window above.[44]

The pairing of a rose window above a series of lancet windows on the west, north, and south façades is found in Gothic cathedrals, yet Lathrop's windows for Marquand Chapel

Figure 15. Frederick Wilson, British, 1858–1932, manufactured by the Tiffany Glass and Decorating Co., 1892–1902: the Garrett memorial window in Marquand Chapel, installed in 1898 (destroyed 1920). University Archives, Department of Rare Books and Special Collections, Princeton University Library.

depart from any medieval precedent. Unlike Gothic rose windows, which usually present a theme through the depiction of figures or narrative scenes, the Tiffany rose windows in the chapel were nonfigural. Instead, the artists used translucent and semi-opaque pieces of glass to mimic the look of jewels set in geometric shapes, a technique for which the studio was renowned. And unlike the lancets under the rose windows at Chartres, which present monumental figures standing in frontal views beneath elaborate architectural canopies, the Lathrop windows frame panels of inscriptions with monumental figures in profile or three-quarter view and without canopies.

The last of the three major windows was the Garrett memorial window, installed in January 1898 (fig. 15).[45] The window was given by Alice Whitridge Garrett, the widow of the wealthy Baltimore railroad magnate T. Harrison Garrett, in memory of her son, Horatio Garrett, a member of the Class of 1895. Like the Marquand and Dodge sons, Horatio died young, at the age of twenty-three. The window was designed by Frederick Wilson, one of the most popular and prolific stained-glass artists working for the ecclesiastical department of the Tiffany Glass & Decorating Company. Wilson's broad study of the history of art—his papers include sketches after the designs of the English Gothic Revivalist Augustus Welby Northmore Pugin, and he collected and copied works by Venetian, Italian, Flemish, and German masters, as well as the Pre-Raphaelite painters—provided the young artist with a rich visual vocabulary for his increasingly complex designs.[46]

Unlike the Lathrop windows, where each window was conceived as a separate, self-contained two-dimensional plane, Wilson's design formed a continuous scene set against the backdrop of the heavenly city of Jerusalem. The tripartite window measured twenty feet high by fifteen feet wide and depicted the "Glorification and Triumph of the Incarnation," according to a contemporary account.[47] In the center, Saint John the Evangelist held a chalice in his cloth-covered left hand. To the left stood the archangel Gabriel, holding a stalk of lilies; to the right was the archangel Michael, holding a sword and banner. Above, a host of angels lifted a crown aloft and played musical instruments. Wilson's angels were simultaneously powerful and elegant—monumental figures, clothed in broad swaths of drapery, who were also beautiful and courtly, with delicately painted faces. The artist was particularly known for his angels' wings, which he based on close study of heron and flamingo wings.[48] The monumental figures of the saint and archangels hovered in front of backgrounds of opalescent glass that gave depth to the landscape. Inscriptions below the archangels quoted Christian Scripture: the one beneath Michael was from 2 Timothy 4:17

Figure 16. Frederick Wilson, British, 1858–1932, manufactured by Tiffany Studios, 1902–32: *Angel* (from the Erskine and American Church, Montreal), ca. 1904–5. Colored and leaded glass, 190 x 63 cm. Collection of the Montreal Museum of Fine Arts, purchase, 2008 (2008.431b).

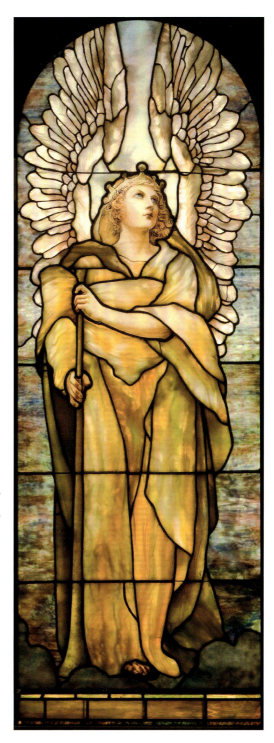

("Notwithstanding the Lord stood with me and strengthened me"); and the one under Gabriel cited Peter 2:20 ("But if, when ye do well and/suffer for it, ye take it patiently, this is acceptable with God.")

Wilson often reused portions of favored designs for multiple commissions, and this seems to have been the case with the Garrett window. The figure used for the archangel Gabriel reappears in a window dated to about 1904–5 of an angel, possibly also Gabriel, now in the collection of the Montreal Museum of Fine Arts (fig. 16). The Montreal window gives a sense of the brilliancy of color and the quality of the opalescent glass used in the Garrett window, which survives only in fuzzy black-and-white photographs. Even with its smaller scale and simpler design, the Montreal window hints at the loss of what was surely the crown jewel of Marquand Chapel's many decorative works.

The windows and other lavish interior decorations combined with the architectural framework of the chapel to create an inspiring space. President McCosh acknowledged the inspirational quality of the chapel in his farewell address at his retirement in 1888, stating that the chapel was "the most beautiful in America, and there the members of the college will worship on Sabbath and on week days for ages to come, and draw down blessings on the college and its students in all future time."[49] In an *Architectural Record* article in 1891, Allan Marquand wrote: "The growth in the religious attitude of the college may also be measured to some extent by the different character of the old chapel and the new. The old chapel, still standing on the campus, is as dismal as it is commonplace. Were it not for its cruciform character, it might be mistaken for a country school-house. The new chapel, exclusively devoted to religious purposes, and itself a monument of art, has had a marked effect in fostering a spirit of reverence for all that is beautiful and good."[50] Marquand went on to describe the various decorative elements of the chapel, including the sculptural tablets and the stained-glass windows, indicating that he believed that the art inside the building at least was instrumental in the improvement in students' comportment during chapel services.

Perhaps the best measure of the campus's deep fondness for the chapel was the extent to which both students and administrators attempted to re-create the sense of the lost "monument of art" in the building that was to replace it. Hibben's request to re-create the lost windows, the Class of 1879's gift of a new Saint-Gaudens sculpture to replace the damaged one—these gestures suggest that the eclectic mix of architectural and artistic styles was

pleasing and ultimately found worth commemorating. The inability to classify the building as one particular style was irrelevant, for it was the mixture of elements, shapes, and textures that made the building so successful.

This acceptance and even embrace of the eclectic was to change with the College's sesquicentennial in 1896, when the Board of Trustees endorsed Collegiate Gothic as the architectural style for all future buildings. The Aesthetic approach to the arts of the Middle Ages did not fade away completely, however, as is evidenced by the design process for the great stained-glass window in Procter Hall on the new Graduate College campus.

Procter Hall: A "Star for All Eternity"

The Graduate College campus, designed by the Boston firm of Cram, Goodhue and Ferguson, is arguably one of the most coherent and lovely specimens of Collegiate Gothic architecture at Princeton. Designed to evoke the residential colleges of Oxford and Cambridge, the complex continues to provide dormitories and dining and social facilities for Princeton's graduate students. Although its most visible element is the monumental tower, named in memory of Princeton resident and former United States president Grover Cleveland, the heart of the campus is its dining hall, Procter Hall. The hall is also the most lavish of the public interior spaces at the College, with oak paneling, hand-carved hammer-beam ceiling and stone fireplace, and stained-glass windows.

Procter Hall was named for William Cooper Procter, a member of the Class of 1883, whose monetary donation to the Graduate School was a major factor in the development of the school and in the choice of the location of its campus. Procter, known to his friends as Cooper, was the grandson of the founder of Procter and Gamble Company and served as its president. The battle between Woodrow Wilson, then president of the University, and Andrew Fleming West, dean of the Graduate School, over the location of the Graduate School campus has been told in great detail elsewhere, and it will suffice to summarize it briefly here.[51] West, a corpulent and epicurean Latin scholar who was extremely adept at currying favor with wealthy alumni, envisioned a graduate school removed from the main campus that would act as a cloister, albeit a luxurious one, for his hand-picked scholars-in-training. Wilson feared that West's plan would result in a school filled with dilettantes formed in West's image and insisted that the college be built at the heart of the campus, so that the graduates not only would be fully integrated into University life but also would

serve as a positive example for the rowdy undergraduate population. Although Procter had never exhibited much attachment to his alma mater, West managed to convince him to give $500,000 toward the creation of the new Graduate College, provided that it was located on a site to the donor's satisfaction. The site, of course, was West's favored location, a golf course twenty minutes' walk from Nassau Hall.[52] West got his way, and Wilson, having lost the support of the Board of Trustees, soon resigned as president.

Although in theory all decisions regarding the plans and overall design aesthetic for the new Graduate College were made by the Faculty Committee on the Graduate School in conjunction with the Committee on Grounds and Buildings, in truth there were five men who made all the major decisions: John Grier Hibben, who replaced Wilson as the president of the University; Andrew Fleming West, dean of the Graduate School; Henry Burling Thompson, chair of the Board of Trustees' Committee on Grounds and Buildings; Moses Taylor Pyne, chair of the Trustees' Committee on the Graduate School; and Ralph Adams Cram, the University's supervising architect.

Moses Taylor Pyne's involvement with the Graduate College project illustrates the changes that had occurred at Princeton since the days of James McCosh and Henry Marquand. Pyne, known to his friends as Momo, was perhaps the most powerful member of the Board of Trustees at this time and certainly one of the wealthiest (his estate, Drumthwacket, now serves as the governor's mansion for the state of New Jersey). Pyne was an Episcopalian and a parishioner of Trinity Church, a Gothic Revival building on Nassau Street that had been significantly enlarged and altered by Cram. Like Cram, himself a High Church Anglican, Pyne was an admirer of English Gothic architecture and strongly believed that it was the most beautiful and appropriate style for his alma mater.

No longer was the University run solely according to what was appropriate for a university founded by Scottish Presbyterians who found the "popish" Gothic style to be inappropriate for their religious buildings. Nor could a powerful donor or alumnus impose his preferences without the administration's approval when it came to selecting an architect or a design for the building he funded. Now, a single style—Gothic, and specifically Collegiate Gothic—was embraced wholeheartedly by the University as well as by its most powerful and generous benefactors.

Cram's first project for the University in 1907 had been a plan for the redevelopment of the campus, which he reorganized based on the English model of the college quadrangle.

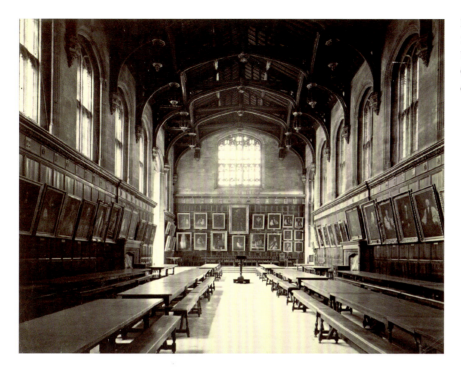

The embrace of an English medieval model of architecture, and of what it could communicate about academe, is also evident in the design of Procter Hall. Cram and West planned a hall modeled on Oxbridge dining halls, such as the one at Christ Church, Oxford (fig. 17).[53] Cram's letters to West demonstrate that he saw the College as a masterpiece not only of his career but also of Gothic Revival architecture in the United States. Not content to leave the details to his junior partners, he "personally tried to study and determine almost every detail of the plans, the elevations and the sections. Nothing has gone through that was not primarily my own work. . . . I have taken enormous personal pride in this particular building, and have tried to make it not only the best thing we ourselves have ever done, but the most personal as well, and also, if it might be, the best example of Collegiate Gothic ever done in this country."[54]

Such effusive language belies the messy and contentious design process, which often found Cram at odds with his patrons. Cram's desire for the best resulted in designs for buildings that were far more costly than what the University had budgeted—by as much as $212,057, according to a July 1911 estimate from the trustees' secretary—and many of the letters between West, Thompson, Pyne, and Cram that are preserved in the archives discuss ways to reduce costs and to complete the project within budget.[55]

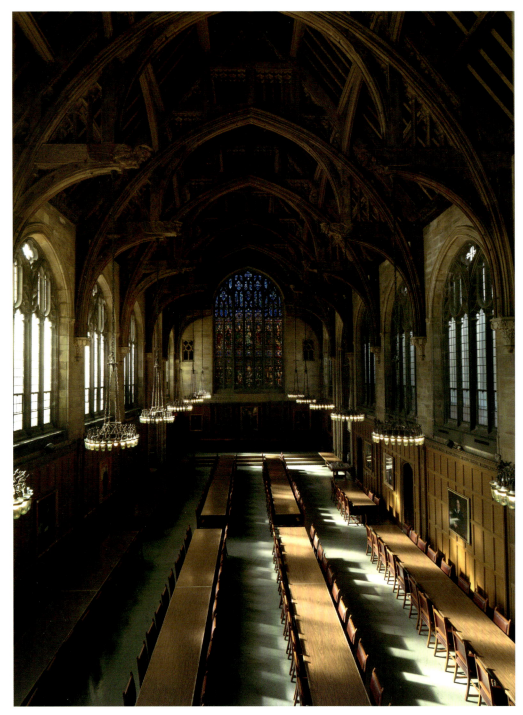

Figure 18. Graduate College, Princeton University, interior of Procter Hall.

In addition to the skyrocketing costs, division of control over design proved to be another major issue for Cram and his employers. At the beginning of the project, there seems to have been concern on the part of West and other committee members about the details of what West termed Cram's "florid" design aesthetic. Specifically, on several occasions West had to deny Cram's request to decorate the building with coats of arms or other insignia unrelated to Princeton and thus unsuited to its academic buildings. In a letter to Procter, West wrote: "In general, I think [the dining hall] is going to be superb. The two points of difficulty now ahead of us are the windows and Mr. Cram's inordinate desire for heraldic ornament. . . . The two dangers we have with Mr. Cram are lack of scale and simplicity, and also excessive and meaningless ornament."[56]

One element in the struggle for control was the selection of the artist for the monumental stained-glass window for the western wall of Procter Hall (fig. 18). To access the hall, one enters through a set of doors at the east and passes through a small antechamber underneath the organ loft, which is separated from the main space by an elaborately carved screen. Upon passing through this screen, one is immediately presented with a full view of the window. The repeating cusped arches that form the hammer-beam ceiling have a telescoping effect, simultaneously framing the upper arch of the window and propelling the visitor forward. The two parallel lines of chandeliers and the long dining tables reinforce the longitudinal aspect of the room, which terminates at the window. The stone tracery, designed by Cram's firm and already in place before the first design for the glass was submitted, recalls the tracery of so-called Perpendicular Gothic windows of the mid-fourteenth century in England, such as the one in the Christ Church dining hall. Unlike English Gothic tracery of the first half of the fourteenth century (also known as the Decorated Style), which employed S-curved ogival arches and other sinuous forms that mimic teardrops or flames, Perpendicular tracery utilized strong vertical lines to separate the window into rectangular compartments.[57] In Procter Hall, the stone mullions of the western window divide the area into three main zones. The lower and middle registers are composed of arcades of trilobed and cusped arches, respectively, while the upper register uses lozenge-shaped forms to break up the plane of the window and suggest a canopy-like form above the scene.

Although the architecture and window tracery directly referred to fourteenth-century English precedents, Cram expected the glass to evoke thirteenth-century examples from France or England, the era that he thought represented the apex of stained-glass production.

Cram had a short list of stained-glass artists whom he liked and trusted, and his active support through commissions helped them become among the most sought-after artisans in their field. His favorite stained-glass artist was Charles J. Connick Jr. (1875–1945), who was able to establish his own studio in Boston in 1913 largely based on the exposure and commissions he received through Cram.[58]

Cram assumed that he would be in charge of selecting the artist and gave Connick the assignment to create a design based on the theme of the Seven Liberal Arts. Unbeknownst to Cram, West wrote to Procter in February 1911 that he was making "inquiries as to the best artist for the windows, and I hope to get some names for your consideration in a few days."[59] By June, he had identified a potential candidate and wrote to Procter that he had recently been visited by William Willet (1869–1921), a Pittsburgh-based stained-glass artist. Willet had received acclaim for his windows at Calvary Church in Pittsburgh and for the chapel at West Point, buildings designed by Cram. West was pleased by Willet's ideas and invited him to submit at his own expense one or two color studies, as well as a small demonstration piece in glass.[60] Willet created a small stained-glass window of Saint Gregory for West's and Procter's approval, and by April 1912, he was already working on a watercolor design for a window on the theme of the Seven Liberal Arts.[61]

Willet began his career as a portrait artist and muralist in New York before training in the art of stained-glass design. He studied with the renowned American painter William Merritt Chase and later served for two years as art director for John La Farge's studio while the artist was abroad in Japan in the 1880s. In 1897, he and his wife Anne (also known as Annie) moved to Pittsburgh, where William served as art director for the studio of stained-glass artist Ludwig Grosse. The Willets founded their own studio, the Willet Stained Glass Company, in 1899.[62]

Although Willet admired La Farge as a "true artist," he was fundamentally opposed to the use of opalescent glass as well as to La Farge's pictorial approach to window design. It was only by studying the glass of the great medieval cathedrals, Willet believed, that American stained-glass makers would rise to the level of the work of the European studios. Willet had traveled to Europe and had been entranced by the thirteenth-century windows at Chartres Cathedral, which he called "the Holy of Holies of Stained Glass." He believed that medieval stained glass, such as that of Chartres, was the model that modern artists should follow, and that "legitimate stained glass should be nothing more or less than a flat, formalistic, transparent

section of the wall which supports it; unobstrusive (*sic*) and forming an integral part of the architectural whole."[63]

In addition to the windows of Chartres and the other great cathedrals of France and England that Willet visited on his travels, the other major artistic influence on his style was the work of the Pre-Raphaelite painters, such as Dante Gabriel Rossetti and Edward Burne-Jones. In "The Stained Glass Adventures of William Willet," Willet praised Pre-Raphaelites as artists who returned to medieval methods but were not copyists.[64] In the firm's *Book of Results*, a marketing publication, the Willets referred to stained glass as "that ancient and most imperishable of the arts," making clear their goal of returning to the working methods of their medieval predecessors.[65]

It does not appear that West informed Cram at this point of his decision to hire Willet. In a letter to Dean West in April 1912, Cram continued to argue the case for giving the commission to Connick: "As you know, I have been going ahead, more or less on my own hook, in this matter, having Connick work out a scheme in accordance with the ideas I had talked over with you. . . . I think it extremely fine in every way. The general scheme is of course that we have agreed upon together, and as far as I know Connick really comes nearer being the kind of man who could do the work after the old and genuine fashion than any other person I know."[66]

Regardless of Cram's personal recommendation of Connick, West decided to meet with Willet in June 1912 to review a preliminary design for the window (fig. 19). Willet's design depicts personifications of the Seven Liberal Arts in an outdoor setting in the upper register, while the lower register's central lancets depict Christ in the Temple, flanked by four historical and mythological figures that refer to the theme of the Liberal Arts. Willet imagined the tracery as a screen for the scene behind it, which continues across all seven upper lancets but is divided into smaller vignettes in the lower lancets. Rather than indicate specific colors of glass, Willet rendered the figures as carefully shaded black-and-white drawings against a background wash of blues and greens; no indication was made of the lead lines that would hold together the individual pieces of glass.

The Seven Liberal Arts—grammar (*lingua*), rhetoric (*ratio*), logic (*dialectica*), arithmetic (*numerus*), geometry (*angulus*), astronomy (*astra*), and music (*tonus*)—formed the core of a humanistic educational program dating back to Classical antiquity and systematized in western Europe in the Middle Ages. Grammar, rhetoric, and logic formed the *trivium* (Latin

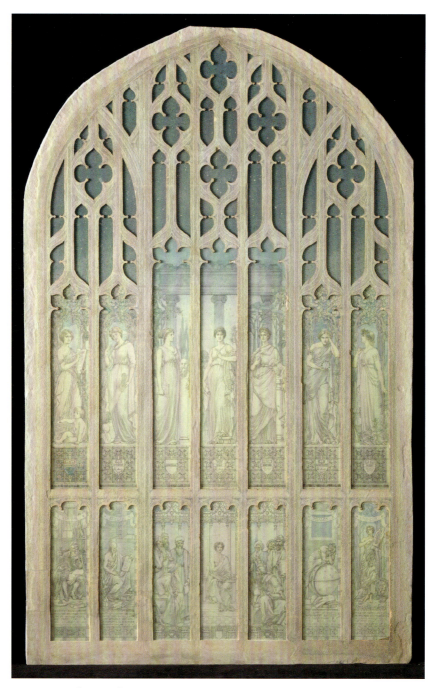

Figure 19. William Willet, American, 1869–1921: design for Seven Liberal Arts window, 1912. Watercolor on paper, 95 x 59 cm. Willet Stained Glass Co. Archives, Willet Hauser Architectural Glass, Philadelphia.

for "the three ways"), the foundation of a medieval liberal arts education. This was followed by the study of the *quadrivium*: arithmetic, geometry, astronomy, and music.

The Classical heritage of the Liberal Arts is a key inspiration for the design of the top register. The Seven Liberal Arts are personified as seven women clad in Greek dress, some with wreaths in their hair. They stand in a lush arbor under a starry night sky, with a Classical arcade in the background. Each figure holds the attributes of her art and stands above a base decorated with a shield, upon which her name is inscribed. Logic, the principal figure positioned at the center of the composition, holds the epistles of Saint Paul, "her foot planted firmly on the books of the law and the prophets, [as] she leans for support against the Tree of Life."[67] To her right is Rhetoric, holding a sculpted image of Plato and a copy of his *Dialogues*. To her left is Grammar, with a bust of Homer.

The three central women stand directly in front of a Classical structure meant to represent the ruins of the Erechtheum, an ancient Greek temple on the Acropolis in Athens.[68] The Erechtheum (or Erechtheion) is perhaps best known for the six draped female figures (caryatids), anthropomorphic columns on the south porch, known as the Porch of the Caryatids (fig. 20).[69] Although the window depicted another side of the building, the one with Ionic columns, the placement of the three women in chitons directly in front of the three columns recalls the Porch of the Caryatids, linking the design with one of the major artistic monuments of Athenian society and with the Classical *trivium*.

Flanking the three arts of the *trivium* are the four supporting arts of the *quadrivium*, each framed by a bower of vines that fills the upper portion of the tracery. To the right of Grammar are Astronomy, holding a wreath of stars, and Music, who is to be understood as listening to the sound of birds singing.[70] To the left of Rhetoric are Geometry, holding a honeycomb and a compass, with a sphere, cube, and rule at her feet, and Arithmetic, holding a tablet and a pen and with a child holding an abacus seated at her feet.

In the seven small lancets in the lower register, the theme of knowledge is interpreted with a specifically Christian perspective and a slightly more medievalizing aesthetic. Directly below the *trivium* in the central three lancets is the scene of Christ in the Temple. Christ, depicted as a toga-clad youth, sits directly below Logic and is flanked by heavily robed, turbaned rabbis. The Classical architecture of the upper register has given way to more medievalizing niches and canopies, although this structure does not continue in the side panels. Each side panel depicts a historical or mythical philosopher or scientist connected with the Art pictured above: Newton (arithmetic), Euclid (geometry), Thales (astronomy), and Orpheus (music).

The scenes in the upper and lower registers illustrate the theme of the enduring value of education and the ancient and medieval heritage of modern institutions of higher learning, placing the new Graduate College within a grand history. The theme of education is also suggested by the motto selected by Dean West and carved on the stone tracery below the window: "et qui ad iustitiam erudiunt multos, quasi stellae in perpetuas aeternitates" ("and they that instruct many to justice, as stars for all eternity," a quote from Daniel 12:3, written here on the Willet design in its entirety as: "They that be wise shall shine as the brightness of the firmament and they that turn many to righteousness as the stars for ever and ever").

In the document that accompanied the proposed design and a contract for $20,000 the Willets hoped the University would sign, the artists cited as precedent a window in "Jesus College, Cambridge, designed and executed by Mr. Burne Jones and Mr. William Morris, where the upper part of the window is occupied by a row of sibyls, the lower part being scriptural groups in the predellas."[71] The Willets' proposal referred to a set of four windows in the chapel of Jesus College, Cambridge, which were designed by Sir Edward Burne-Jones and executed by William Morris's firm between 1873 and 1877 (fig. 21). As in Willet's design, each window is divided into two registers. The upper register of three lancets depicts

one of the four evangelists flanked by two sibyls, while the lower register depicts three scenes from the life of Christ. The figures and the scenes are labeled with inscriptions or legends contained within white scrolls. Although the windows are not similar, the mention of the Burne-Jones design as an inspiration is understandable, for Willet admired the work of the Pre-Raphaelites and was working with a subject from antiquity.[72]

Dean West requested some significant changes to the design to bring it into alignment with the medieval theme and with the Collegiate Gothic building. These included the removal of the Erechtheum and any Classical references; a more "Gothic" arrangement of the draperies; the conversion from English to Latin of the motto on the base of the window; and the expansion of the scene of Christ in the Temple to cover all seven lancets (thus omitting the figures of Newton, Euclid, Thales, and Orpheus).[73] West nevertheless seems to have been pleased with the overall design, for he wrote to both Cram and Connick to inform them that Cooper Procter had selected William Willet to execute the stained-glass window for Procter Hall.[74]

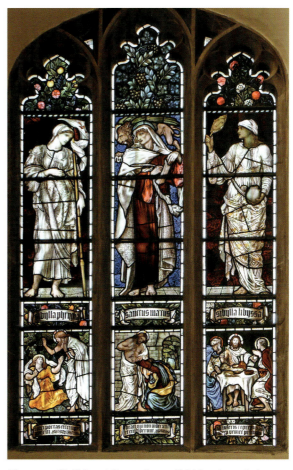

Figure 21. Sir Edward Burne-Jones, British, 1833–1898, made by William Morris & Co.: Saint Mark window, Jesus College chapel, Cambridge, 1873–77. Leaded glass.

Cram's initial fears over his potential loss of artistic control over the project had been realized, and he was incensed by this turn of events. Not only had the decision regarding the window been made without his approval as the University's supervising architect, the artist whom he had personally recommended (and had even directed to begin work on the project) had been rejected.[75] Moreover, Cram and Willet seem to have actively disliked

each other, and each man sent letters to West detailing the grievances he had with the other.[76] Cram did not see Willet's design until June 25; at that point, he wrote to him stating that he could not approve the design and that Hibben, West, and Procter endorsed his recommendation to request an entirely new design. The contract that the Willets had brought with them to Princeton was left unsigned, and they were told that they would not receive a signed contract until they had prepared a new design and a sample section of one of the lower lancets.

Cram's biggest objection to Willet's design concerned what he considered elements of Renaissance or modern American glass design, including the modeling of the figures and draperies, the inclusion of Classical elements, the suggestion of perspective, and the continuation of the design across the window plane (what he referred to as a "pictorial" treatment). These elements were in direct contradiction to the paradigm of English and French stained glass of the thirteenth and fourteenth centuries. Cram counseled: "Every pictorial element must be eliminated from the window, and it must become a great flat decoration, there is no place in it for perspective, and little place for modeling, beyond the strongest and simplest indications in the flesh and draperies; . . . the models in my opinion wisest to follow are the windows of the clerestory at Chartres, but the utmost care must be taken to avoid any effect of archaeological copying, any straining after archaism. The whole fundamental principle is the spirit of French 13th and English 14th centuries, in methods of design, color composition and leading." If Willet did not find inspiration in the windows at Chartres, Cram also recommended the windows at York Minster as possible models.[77]

Cram, along with many early-twentieth-century stained-glass artists, cited Chartres as a primary inspiration for modern glass windows. The cathedral is unusual because its medieval glazing has survived into the twenty-first century almost intact. One example of the clerestory-level windows to which Cram referred is the series of five lancet windows underneath the rose window in the south transept (fig. 22).[78] These windows feature five monumental standing figures beneath architectural canopies: Saint Luke on the shoulders of the Old Testament prophet Jeremiah; Saint Matthew on the shoulders of the Old Testament prophet Isaiah; the Virgin Mary and the Christ Child; Saint John on the shoulders of the Old Testament prophet Ezekiel; and Saint Mark on the shoulders of the Old Testament prophet Daniel. In the lower register, kneeling donor figures from the family of the Count of Dreux

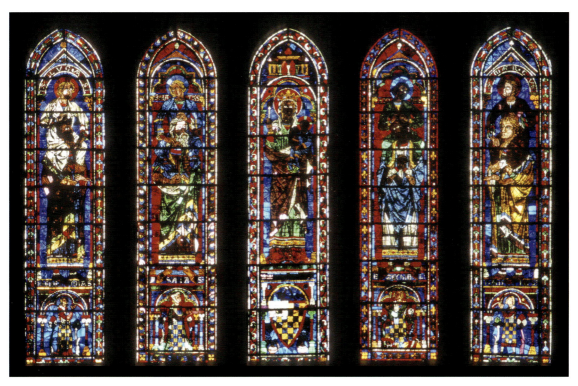

Figure 22. French, ca. 1221–1230: Cathedral of Notre-Dame, Chartres, France, south transept lancets.

are sheltered beneath trilobed arches supported on columns with foliate capitals. Each lancet is bordered by geometric or stylized foliate ornaments in shades of blue and yellow, mirroring the colors of the Dreux family arms in the center lancet's lower panel. The glass used is mostly in primary shades of blues and reds, with accents of green, purple, yellow, brown, and white. The white allows light to penetrate what is otherwise a deeply hued window, made so in part by the blue diaper-work background. The lead lines form part of the design, serving as outlines of figures or drapery folds.

The juxtaposition of this window with Willet's design for the Procter Hall window highlights the radically different ways that Willet and Cram looked to Chartres for inspiration. Willet claimed Chartres as a model, yet his design is more akin to the Aesthetic glass of his former teacher, John La Farge, than to any medieval precedent, even though he had repudiated La Farge's technique in his own writings. Cram and his protégé Connick were diametrically opposed, in both writing and practice, to the modern stained-glass industry as

represented by La Farge and Tiffany. In his book *Adventures in Light and Color*, Connick lambasted the modern American art-glass industry, which he believed had "buried the stained glass craft under an avalanche of mawkish prettiness and sweet ugliness, so that it was lost for years as it had never been lost before."[79] For Connick, La Farge was at root a painter, not a glass craftsman, and consequently he did not know how to design windows that would allow sufficient light to penetrate the glass. Connick considered Chartres to be the epitome of medieval glass and specifically singled out the twelfth-century Tree of Jesse window in the west façade as the height of medieval symbolism in light and color. For Procter Hall, Cram also desired a window that was suggestive of Chartres but did not copy it, and he particularly pointed to the leading and coloring effects as elements to be studied.

The back-and-forth between Cram and Willet appears to have disquieted West, whose primary goal was to secure a design that would please his patron, not to adhere to the architectural maxims of Ralph Adams Cram. He disagreed with some of Cram's criticisms, especially Cram's insistence on a flat, decorative character. He wrote to Cram: "What I fear most is the danger of a flat, repressed, constrained, cramping effect, and I feel this all the more, because the Dining Hall is a secular building and should not be subjected to the rigor of treatment which is proper in a purely ecclesiastical building. I am, therefore, strongly in favor of having Mr. Willet go ahead, because I believe you think him a fine artist, and because I believe he can produce a window which will, at least measurably, meet your objections."[80] He confided to Procter that "the difficulty and danger in Mr. Cram's criticisms, in the opinion of some of the best experts in this country, is that he is governed by an intense ecclesiastical bias which leads to a stiffness and repression both in the design and execution of stained-glass windows. He takes very extreme positions."[81]

West's encouragement notwithstanding, the Willets were frustrated by what they saw as Cram's machinations to have them removed from the project. In a letter to Procter dated July 2, 1912, Willet shared some of these frustrations, noting that his firm had set aside other work to focus on the Procter Hall window and that they were not willing to assume the entire financial risk of preparing another design and sample without a signed contract in hand. He concluded: "Mr. Cram seems determined to do your windows himself—he so informed me when I consulted him about Procter Hall last November, and he will never approve our design."[82] The Willets eventually set aside their reservations about the project and agreed to prepare a revised design for submission to the committee.

Their design was not immediately forthcoming, and Cram took advantage of the delay to encourage Connick to submit his design to the committee. Willet's revised design arrived in the third week of November, followed a week later by Connick's design, and it was decided that the two designs would be referred to a committee of two or three architects for an outside opinion. The committee returned an opinion in favor of Connick, a result that dismayed West, who feared that his control of the overall design of the new school—*his* school—was slipping out of his hands in favor of the brash and egotistical supervising architect.[83] Rather than accept the committee's opinion, West took matters into his own hands and appealed directly to his patron, making sure to point out all the negative aspects of Connick's design and his close relationship with Cram. He wrote: "Mr. Connick's scheme of a window does not belong in a fifteenth century dining hall, but in a thirteenth century cathedral. Moreover, I am thoroughly satisfied that his window will be too dark. Besides all this, Mr. Willet is amenable to suggestion and Mr. Connick is simply a passive agent in Mr. Cram's hands and not an independent artist in this matter."[84]

West prevailed, and the committee eventually decided in favor of the Willets' revised design (fig. 23), which bears little resemblance to the first wash drawing. All Classical elements have been removed in favor of an overarching "Gothic" milieu that evokes elements of both English and French Gothic design from the thirteenth through fifteenth centuries. The figures of the Seven Liberal Arts have traded their Greek dress for Tudoresque costumes, strengthening the connection between the glass and the English Gothic tracery of the window itself. Reds and blues, reminiscent of the windows at Chartres, dominate the color scheme although secondary and tertiary colors are used as accents. Other changes include the eradication of any sense of depth or perspective; the replacement of background scenery in favor of patterned ("diapered") backgrounds; the removal of the four historical figures in the lower register; and the expansion of the lower scene of Christ in the Temple to cover all seven of the lower lancets.

The figure of the boy Christ seems to have given Willet the most difficulty during the design process. Willet's memorandum summarizing the changes requested by the committee after their meeting on July 13 indicated that the committee desired a more "strong and masculine" figure than the boyish teen he had drawn. Willet's design process for the revised figure can be traced through surviving sketches that were compiled in a book by his wife.[85] This sketchbook covers multiple projects and includes sketches for many portions of the

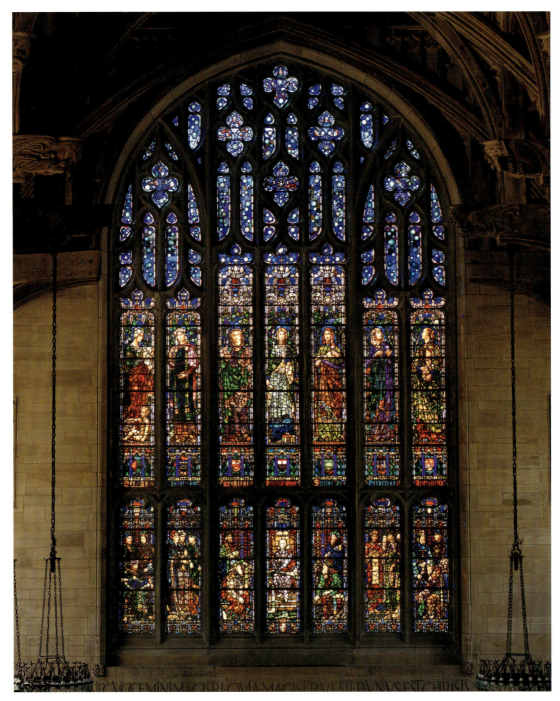

Figure 23. William Willet, American, 1869–1921: the Great West Window, Procter Hall, Graduate College, Princeton University, 1912–13.

Figure 24. William Willet, American, 1869–1921: "Sketches Principally for Stained Glass" (unpublished sketchbook, no date), folio 7. Art Department, Free Library of Philadelphia.

Procter Hall window, including the faces of most of the personifications of the Liberal Arts, some of the rabbis from the scene of Christ in the Temple, and studies for the revised figure of Christ.

For the youthful Christ figure, Willet's sketchbook includes three pages with multiple drawings: some of the faces appear more feminine, others more masculine; some gaze directly out at the viewer while others cast their gaze up at the heavens (fig. 24). One even has an alternate option for the upper portion of the face pasted over a sketch below. Willet must have sent West an intermediary design with a revised figure based on these sketches, for the dean wrote to him in November that the "figure you have drawn is too mature, insistent and even a little dapper." West requested a figure that conveyed "serene innocence . . . and a certain touch of divinity, mystery and spirituality."[86] In the final design, Christ is neither the young boy of the initial design nor the older, masculine figure in the sketchbooks, but appears to be somewhere in between (although the Willets' descriptive text submitted with the design indicates that the figure was taken from a twelve-year-old model).[87]

Whereas the initial design engaged with typology—the equation of historical figures with personifications of the Liberal Arts—the revised design creates an analogy between university learning (the Liberal Arts, and specifically, Logic) and Christian teaching. As summarized by the Willets, the Liberal Arts symbolize "the organization of learning in the first Christian schools, just as the lower window symbolizes Christ as the inspiration of Christian teaching."[88] With the removal of the Classical backdrop and the ancillary figures flanking the lower register, the design was clarified into two distinct scenes connected along a vertical axis: the teaching of Christ below and the Liberal Arts, led by Logic, above. Like the figure of Christ directly below her, Logic faces the viewer. Whereas Christ is enthroned and holds a scroll, she stands erect, one foot placed upon the "Book of Life," that is, the Bible. Above is a starry sky, a visual representation of the inscription below, which promises that "they that instruct many to justice, [are] as stars for all eternity."

Willet's design choices for the scene of Christ in the Temple seem particularly calculated to encourage viewers to identify with the scene and its message. As described in the Willets' text, the scene takes place toward evening—the exact time that the students would be gathering together to eat, and also the time of day when the window would be illuminated by the setting sun. The figure of Christ serves as a potential point of identification for the graduate students, a group that at the time was wholly comprised of young men. Although the text states that Christ is twelve years old, in fact he appears a bit older, perhaps a teenager, and thus not much younger than the students who would be dining in the hall.

In addition to creating a design that would resonate with the audience, the Willets were also interested in the affective qualities of the colors of the glass. The first design used ruby, green, and gold in the central panel of Christ in the Temple, cooler tints of lavender, purple, gray, and green in the upper level of lancets, and a final "crescendo pitch in the deep blues of the starry firmament in the upper traceries."[89] In the descriptive text that accompanied the first design, the Willets referred to the "vibrations" of the deep blue, which would be "absorbed by the shadow of the Gothic ceiling."[90]

The Willets continued to refer to the resonant qualities of color in their description of the final window design. They found these qualities in the type of glass they chose as well as in their working method. Unlike some modern glass artists, who painted or enameled glass to create different colors, the Willets created the myriad colors of their windows by

superimposing layers of glass upon each other. This method, they wrote, "set in vibration those waves of color" that gave life to the stone walls of a Gothic cathedral such as Chartres.[91] The Willets also indicated the symbolic nature of the colors chosen for the garb of each of the Liberal Arts: violet and gold for Arithmetic; blue, steel, and emerald for Geometry; purple and ruby for Grammar; sap greens for Logic; light purple, red, and olive for Rhetoric; cold purple, blue, and gray for Astronomy; and green and gold for Music. The sky was to remain a deep, "sonorous . . . blue of the unfathomed Heavens."[92]

In another document about the window written by the Willets for Princeton, they added musical metaphors to their discussion of color and light: "To understand this window, one must think of music expressed in permanent form—prepared and waiting for God's sunlight to evoke from its myriad mosaics the harmony of a color symphony."[93] Later, they wrote of the "crashing symbols" of the reds and blues. Whether they intended to write "cymbals" is not known, but the use of the homophone is fitting in this context.

The Willets' reference to their window as "music expressed in permanent form" evokes popular nineteenth-century ideas regarding the connection between music and architecture. Although the idea of architecture as frozen music is usually attributed to Madame de Staël or to Goethe, it was used earlier by Friedrich Wilhelm Joseph Schelling, who stated in his *Philosophie der Kunst* (1802–3) that "architecture in general is frozen music."[94] In the *North American Review* in 1868, Ralph Waldo Emerson noted that Madame de Staël's comment that "architecture is frozen music" could be traced back to Goethe and ultimately to "Vitruvius's rule, that 'the architect must not only understand drawing, but music.'"[95] A survey of nineteenth-century newspaper articles finds the phrase invoked in descriptions of the cathedrals in Cologne and Milan, the American ice-skating rink in Paris, the United States Capitol, and the New York Times Building, to cite only five examples.[96] The topos had gained widespread currency.

Ralph Adams Cram also made statements regarding the connection between stained glass, music, and spirituality. In an article written in 1924 for *Arts and Decoration*, he explained that stained glass was an art form developed by and for Christianity, and that it held a "peculiar spiritual power." He continued: "All arts have this faculty, but somehow the new luminous spaces of pulsating color worked more potently in this direction than any others, with the possible exception of music. Indeed there was something akin to music in this new art which retained certain of the pictorial forms but seemed to blend with them the

inexplicable potency of music."[97] The evocation of powerful pulsations is similar to the Willets' description of the vibrational qualities of stained glass.

Dean West and the Willets shared a desire for a window that would solicit an affective response on the part of the viewer, and it seems to have been fulfilled from the moment the window was installed in November 1913. The window inspired at least two men to compose poems: Harvey Maitland Watts, one-time director of the Moore Institute of Art in Philadelphia; and Thomas Hopkins English, a Princeton graduate student (see Appendix). Watts, by this time an art critic and editor for the Philadelphia *Public Ledger*, sent Willet a copy of a sonnet he had published in the newspaper after seeing the window in 1914; he declared it "finer than anything I saw in Oxford last year."[98] Tom English, a member of the Class of 1918, returned to Princeton to matriculate in the Graduate College after serving in the military during World War I. Upon seeing the window, he too was moved to write a sonnet, which was published in *Scribner's* in August 1920. A copy of the poem was sent to Willet, who then invited the student to his home. English met and fell in love with the Willets' daughter Rachel, one of the models for the Seven Liberal Arts, and the couple later married—a sweet dénouement to the oft-contentious circumstances surrounding the window's creation.[99]

The saga of Procter Hall taught Ralph Adams Cram a valuable lesson regarding donors and stained-glass commissions, and for the University Chapel, his final project for Princeton, he made sure to exert complete artistic control over the entire project. Although the Graduate College complex was the most extensive Collegiate Gothic project Cram completed for Princeton, the University Chapel provided a much larger canvas to realize his goal of a total work of art in the Gothic Revival mode. The University Chapel can thus be seen as the epitome of Cram's personal vision of what the Gothic Revival should be, in ethos and appearance, as well as the culmination of a Gothic Revival building campaign begun in the nineteenth century.

The University Chapel: A Medieval Building in the Modern World
Cram's 1907 plan for the University campus had recommended tearing down offending buildings and moving others that stood in the way of creating the desired quads. Although the University embraced many of the ideas in his plan, it never seriously considered demolishing any of the old buildings that Cram felt were in an inappropriate style. With the

loss of Marquand Chapel, Cram gained a golden opportunity to design one of the most important buildings on the campus.

Cram was not alone in his belief that there might be a silver lining to the devastation wrought by the fire. Three days after the disaster, the author of an article in the *Daily Princetonian* opined that the fire might have a positive influence on Princeton's future development, suggesting that "the architectural beauty of the campus will be very much increased" and that the new chapel could be built in the Collegiate Gothic style that had already overtaken campus.[100] It soon became clear that the chapel would not be rebuilt for some time owing to lack of funds; nevertheless, the Board of Trustees and the University administration began to think about the appearance of the future chapel. Cram was asked to draw up plans for a proposed building in the Collegiate Gothic style; these were published in 1921 to great acclaim. The *Daily Princetonian* reported that President Hibben declared, "The new chapel will fulfill the best of Gothic traditions and will mark the crowning of an architectural development which began when ex-President Wilson held the chair of Princeton."[101]

Many of the original proposal drawings for the chapel survive, providing a window into Cram's design process. Cram was responsible for the overall idea of the building, but he relied on his associates to develop the detailed perspective drawings and all the decorative elements. He first sketched his main idea and blocked out the plan and elevation, adding thumbnail perspective drawings in the margins.[102] He then passed on these drawings to one of the junior partners—Frank Cleveland, Chester Godfrey, or Alexander E. Hoyle (1882–1967)—who created detailed perspective drawings of the building, often from multiple viewpoints.[103] Once Cram selected the option he wished to pursue, the partner was responsible for the details of the design, including the sculpture and woodwork. In the case of the University Chapel, this task fell to Alex Hoyle, who joined the firm in 1908 and made partner in 1914.[104]

Cram's ideal was a chapel that would evoke the college chapels of Oxford and Cambridge without copying them exactly. Hoyle worked up at least two options for the western front, both in the style of fourteenth-century English Gothic architecture. Both designs feature a single arched entry portal below a monumental stained-glass window, flanked by shallow buttresses, but they differ in the decorative details, notably the entry portal, the elaboration of the shallow buttresses, the tracery in the large stained-glass window, and the design of the gable. In the first option, Hoyle included niches topped with crocketed gables,

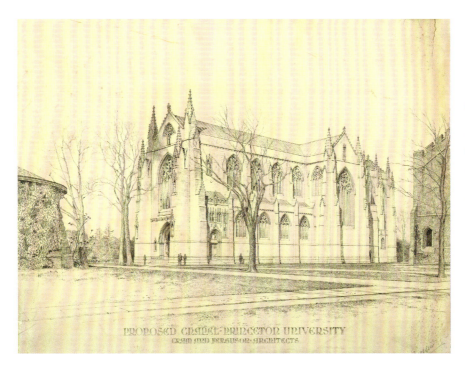

Figure 25. Alexander E. Hoyle, American, 1882–1967, for Cram and Ferguson, architects, Boston, fl. 1915–1941: proposed design for Princeton University Chapel, 1921. Ink on board. University Archives, Department of Rare Books and Special Collections, Princeton University Library.

and he inserted sculptures into each niche (fig. 25). The tracery was in the French style, with three quatrefoils above six lancet windows. The upper gable was pierced with a single traceried opening featuring three trilobes and ornamented with crosses along the roofline. The inclusion of gabled niches for sculpture, the trilobed tracery in the gable, and the cross-shaped finials along the roofline all refer to the eastern end of the cathedral at Carlisle in England, constructed during the fourteenth century (fig. 26). The overall shape and dimensions of the western front, as well as the stepped-out massing of the side buttresses, are also reminiscent of the skeleton of the eastern end of Gisborough priory, another fourteenth-century structure (fig. 27).[105]

For unknown reasons, this design was discarded in favor of a second option, which kept the major features of the first design while changing the decorative details (fig. 28). The second design changed the window tracery to a hybrid of English and French designs, with ogive-arched lancets topped by sexfoils (six-lobed shapes) encircled by roundels. The multiple gabled niches were removed and the buttresses were streamlined. The portal was given more elaborate moldings and was surmounted by a balcony (one can see a figure waving from this balcony in the watercolor drawing). Finally, the detailing of the gable was

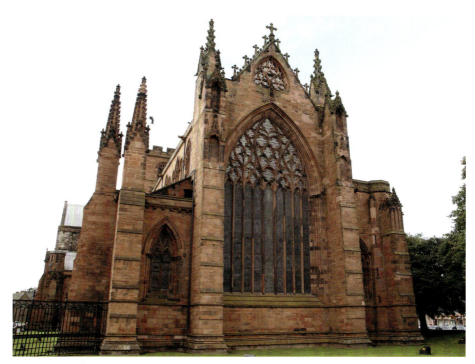

Figure 26. English, 14th century: Carlisle Cathedral, Carlisle, England, east end.

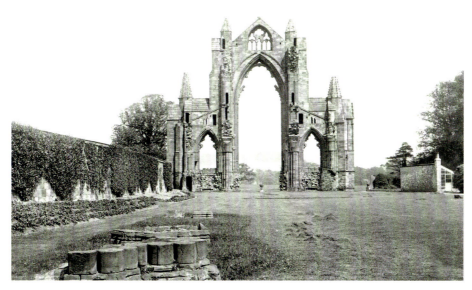

Figure 27. English, 14th century: Gisborough Priory, Guisborough, England, east end, ca. 1885.

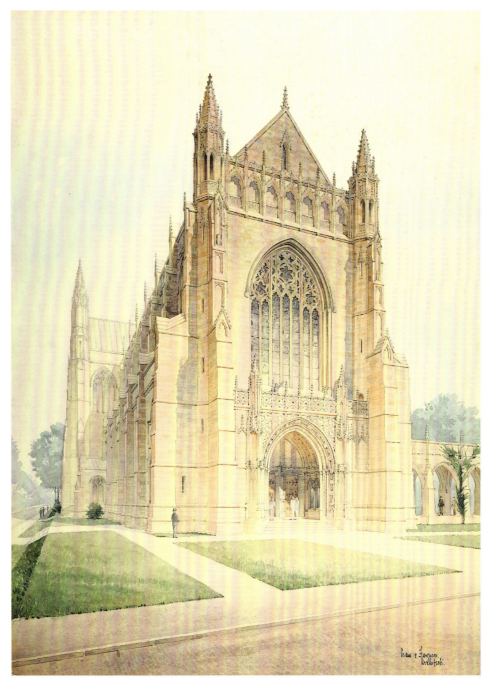

Figure 28. Cram and Ferguson, architects, Boston, fl. 1915–1941: proposed exterior of Princeton University Chapel, undated. Watercolor on wove paper, 94 x 68.6 cm. University Archives, Department of Rare Books and Special Collections, Princeton University Library.

changed—instead of a single traceried opening, a seven-arched arcade was inserted and all the crosses were removed in favor of a single small finial.

The English-French hybrid continued in the plan, elevation, and vaulting structure of the building. The plan, which features a flattened east end, is reminiscent of English Gothic cathedrals rather than French cathedrals, which usually exhibit a series of radiating chapels that create a rounded east end. The interior elevation and the vaulting, however, are more like French precedents, with the use of a single color of stone, emphasis on the repetitive nature of the bay system, and quadripartite ribbed vaulting. This was another change from the original proposal, which featured tierceron vaults springing from a central ridge rib, a vaulting scheme usually associated with English Gothic buildings from the late thirteenth and fourteenth centuries (fig. 29).

Because Cram was out of the country when Hoyle completed his proposal drawings, there is a written record of Cram's reactions (remarks that normally would have been made verbally in the studio).[106] Cram wrote that he thought the drawing a masterpiece and recommended a few changes, among them to increase the number of divisions in the upper blind

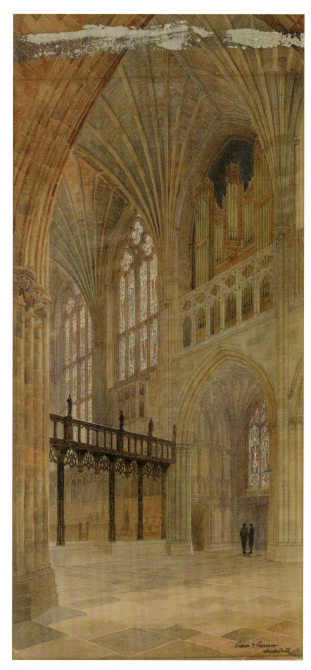

Figure 29. Cram and Ferguson, architects, Boston, fl. 1915–1941: Princeton University Chapel, interior, 1921. Watercolor on wove paper, 69.7 x 36.2 cm. Campus Collections, Princeton University (PP363).

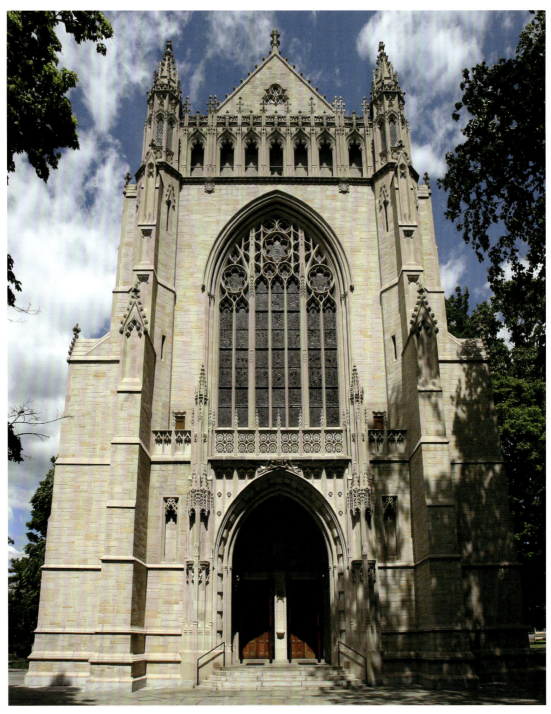

Figure 30. Cram and Ferguson, architects, Boston, fl. 1915–1941: Princeton University Chapel, west exterior.

arcade to nine, to crocket the gable with a larger and more significant finial, and to bring the panels in the buttresses under the first gables down to the lower offset.[107] Hoyle did make a few changes, although they did not follow Cram's directions exactly. He left the arcade with seven openings but changed the window opening in the gable above it to a different shape. He lengthened the panels in the buttresses and also changed the tracery detail in the balcony above the portal. The major change was the removal of an arcaded cloister walkway on the south side of the building, which does not appear in any of the later designs or detailed plans for the building. Even with these changes, however, the final design of the western exterior building is remarkably similar to the proposal drawing (fig. 30).

The creation of the new chapel presented a challenge that went beyond architectural style: how could the timeless nature of the Collegiate Gothic style be reconciled with the problems of the modern world, a world that had recently experienced the trauma of the Great War? Writing in 1921, President Hibben noted that "we who were in Princeton during the period of the World War, particularly after the spring of 1917, will always think of the Marquand Chapel as a place where the realities of life and death became startlingly vivid and worship there became a sacrament of consecration for our young men who were assembled within its walls for the last words of prayer and benediction before they set out upon the great adventure to engage in the world conflict."[108]

The loss of the many students who perished in the war was still fresh in the University's consciousness. Bronze stars had been affixed outside the windows of dormitory rooms that had housed students later killed in the war, and on February 21, 1920, just a few months before the fire, the University had remodeled the entry vestibule of Nassau Hall to create a memorial to students who had died in military combat. Designed by the architectural firm of Day and Klauder, Memorial Hall features marble-clad walls with inset panels listing the names of Princeton students who died in past wars, including 152 casualties from World War I.[109]

It was important to the University administration, therefore, that the new chapel not only serve as an example of Collegiate Gothic architecture at its finest but also that it commemorate what had been lost when Marquand Chapel burned down. This sense of loss—for a lost building as well as for lost human life—was to influence the design and creation of the stained-glass windows in the chapel, particularly those in the north transept arm, christened the Marquand Transept (fig. 31).

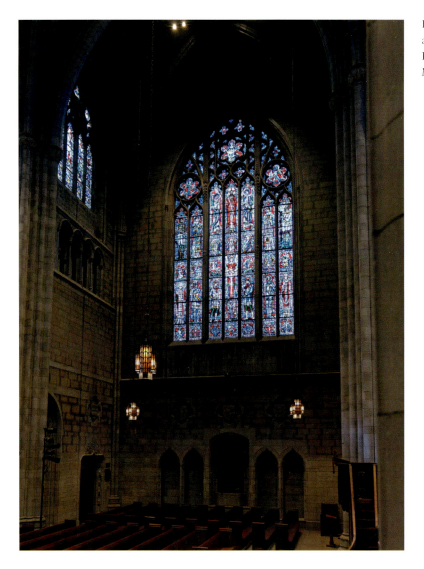

Figure 31. Cram and Ferguson, architects, Boston, fl. 1915–1941: Princeton University Chapel, Marquand Transept.

The program of stained glass for the entire chapel included four great windows in the north, south, east, and west; nine windows along the nave arcade; eleven windows in the clerestory of the nave; six additional windows in the choir; and additional windows in the transept arms.[110] The concept for the program as a whole, as well as for each individual window, was worked out by Albert M. Friend Jr., a faculty member in the Department of Art and Archaeology, in consultation with Hibben and Cram.[111] Once Friend had sketched a rough concept for a particular window, the details of the composition were finalized in

consultation with Cram, the stained-glass artist responsible for that window, and in some cases, the donor.

As noted earlier, Cram rejected Hibben's request to re-create the lost Marquand Chapel windows, although he was agreeable to the commissioning of new designs based loosely on the themes of the lost windows. In an undated letter to Hibben, Friend recapitulated the subjects for the Marquand Transept windows that the president felt were essential: "David and Jonathan for the Marquand window in the clerestory of the N. Transept. Perfection through suffering for the Garrett window in the same. Praise for the Dodge window in the clere[story] of the N. Transept."[112]

The Marquand memorial window, with its theme of friendship, was to maintain the figures of Jonathan and David; however, the Garrett and Dodge windows, which had been more theological in nature, were to change significantly. This was in keeping with the overall scheme for the windows, which Friend stated was not theological, but rather philosophical. He wrote to Hibben: "The chapel is not a Roman Catholic cath[edral] or even an Episcopal one so such things as sacraments, saints, etc. should have no place in it. The institution of learning in which teaching and the building of character through knowledge of the truth are the essentials."[113] The windows were to communicate a humanistic approach to Christian learning; therefore, the focus on saints and angels in the Garrett and Dodge windows would have to be discarded.

The first window in the Marquand Transept to be commissioned, perhaps because it was the largest and most costly of the three, was the Garrett window, also known as the Great North Window. For this window, Cram selected the Boston firm of Reynolds, Francis and Rohnstock. Joseph Reynolds Jr. (1886–1972) was the designer and director of the firm, William M. Francis (1870–1954) was the glass painter, and J. Henry Rohnstock (1879–1956) was the glazier. All three men had trained with Charles Connick Jr. before opening their own studio in 1921.[114]

The theme of the Garrett window is the promise of salvation for those who endure suffering—an appropriate subject for a chapel whose purpose was in part the commemoration of the losses of the past decade.[115] Friend's initial approach to the window seems to have disregarded his own insistence that the window not be theological in nature, for it focused exclusively on biblical typology that expounded upon the theme of suffering. A sketch by Friend of these early ideas depicts a window centered on a juxtaposition of the image of

Figure 32. Sketch by Professor Albert M. Friend of design for north transept window, Princeton University Chapel. University Archives, Department of Rare Books and Special Collections, Princeton University.

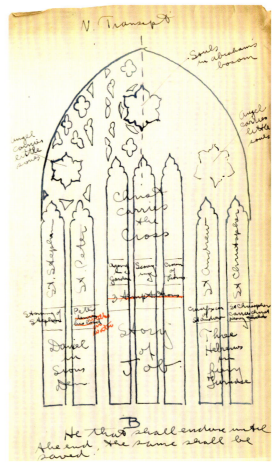

Figure 33. Sketch by Professor Albert M. Friend of revised design for north transept window, Princeton University Chapel. University Archives, Department of Rare Books and Special Collections, Princeton University.

Christ carrying the cross with an image of an Old Testament precursor, Job (fig. 32). Christ is flanked by four saints; below, smaller panels illustrate scenes from each man's life. At the bottom, four subsidiary panels illustrate four Old Testament scenes of suffering: the Israelites in the wilderness, the trials of the prophets, Daniel in the lion's den, and the three Hebrews in the fiery furnace. A second sketch consolidated the ideas laid out in the first to create a more focused composition (fig. 33). The central axis and top panels were retained, but the

four bottom scenes were condensed into two: Daniel in the lion's den and the Hebrews in the fiery furnace. Although there is no documentation to suggest why, Friend eventually abandoned this approach in favor of a scheme that incorporated historical figures and discarded all narrative scenes.

Although Friend was the official iconographer for the stained-glass program, Cram presented an alternate proposal that placed a greater emphasis on the role of war in promoting Christian society and specifically evoked the most recent war, something that Friend omitted in his initial scheme. Cram's proposal kept the central figure of Christ as well as the flanking figures of saints, but he replaced the narrative scenes at the bottom (which he thought would be too difficult to see from the ground level) with additional monumental figures drawn from medieval and modern history, including Godfrey de Bouillon and Don John of Austria, the first and last of the great crusaders; and Saint Louis of France and King Arthur of England, representatives of the good Christian soldier-king. He also added Saint Joan of Arc, who had been beatified in 1909 and canonized in 1920, and had become a popular figure during the World War for her divinely inspired resistance to injustice.[116] Other references to the World War included the figures of an Allied soldier and Edith Cavell, a British nurse who helped Allied soldiers escape from German-occupied Belgium (and who was later shot by the Germans for her actions). The two other figures added by Cram were examples of Christians who had endured personal suffering in order to save others: Father Damien, a Catholic missionary to a leper colony in Hawaii; and John Eliot, an English Puritan missionary to Native Americans in the Massachusetts Bay Colony.

Perhaps Cram's references to war, both medieval and modern, were his way of making sense of the senseless. Cram believed that the recent war (as well as industrialism and the decrease in religious observance, among other things) was an indication that Western civilization was reaching the end of one era and was poised to begin another. It was his fervent hope that this new era would return to the ideals of the Middle Ages through a Gothic Revival in architecture. In his book *Heart of Europe*, Cram described the great Gothic cathedral at Reims, which had been destroyed by German bombs, as a martyr in a great battle between Christianity (i.e., the Allied forces) and the devil (i.e., the Germans). He contrasted this modern era of chaos and anti-Christian spirit with the Europe of the Middle Ages, a period when the continent, "in spite of its bickering and fightings and jealousies and plots and counterplots . . . was really more united, more a working whole . . . than ever it

has been since. One religion and one philosophy did for the fluctuant states what the Reformation, democracy, and 'enlightenment' could only undo, and in this vanishing art, which, after all, is the truest history man can record, we find the dynamic force, the creative power, of a culture and a civilization that took little count of artificial barriers between perfectly artificial nations, but included all in the greatest and most beneficent syntheses Europe has ever known."[117] Cram echoed these sentiments in a speech he gave in August 1921 at the Harvard chapter of Phi Beta Kappa, in which he stated that the thirteenth through fifteenth centuries were the apex of Christian society and that a return to this era through reference to its architecture would restore modern Western civilization to its former glory.[118]

If Cram had an agenda to pursue in the design of the stained-glass windows, so too did the Princeton administration. Hibben and Friend were less interested in the restoration of Western civilization than in creating a beautiful chapel that would encourage reticent students to attend services more often. The windows had to be easily understood by nonspecialists, and their design had to be timeless in order to speak to the Princeton community as a whole. Friend's final design thus made significant changes to Cram's proposal, simultaneously softening allusions to the recent war and strengthening connections to the University and its community (fig. 34).

At the top is the figure of Christ as Ecce Homo flanked by the archangels Gabriel and Raphael, who were retained from the original Garrett window design. To the left and right are four saints: Sebastian, Stephen, Lawrence, and Christopher. Below each saint is a scene relating to his martyrdom (or, in the case of Christopher, a scene of the saint carrying the boy Christ across a river). Below is a register of historical figures and saints: Cardinal Mercier, Chevalier Bayard, Saint George, Saint Theodore, Saint Joan of Arc, and Saint Thomas à Becket. The lowest register contains symbolic emblems of Christ (the peacock, a symbol of immortality; the cup of suffering; the scourge and Crown of Thorns, both instruments of the Passion; the *Agnus Dei*, or lamb of God; a lion, symbol of courage; and the phoenix rising from its ashes, symbol of the Resurrection).

Serving as intermediary between these intersecting layers is the archangel Michael, who is shown twice: once as a larger figure holding a flaming sword and again as a smaller figure below, weighing the souls of the departed. Michael is the pivot around whom the whole window revolves, and it was very important to Friend that the image of Michael weighing the souls be depicted below the full-length figure of Michael with the sword.[119] Those whose faith

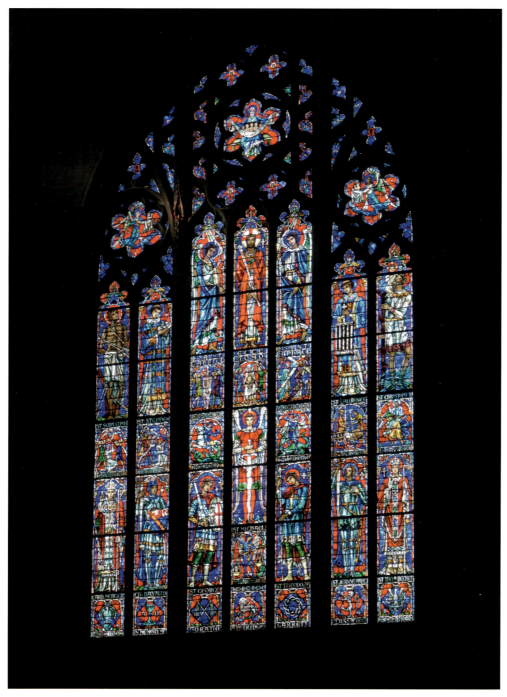

Figure 34. Reynolds, Francis and Rohnstock, Boston: the Great North Window (the Garrett memorial window), Princeton University Chapel.

can endure even the greatest suffering and are judged favorably receive their just reward at the very top of the window: two angels carry souls to the figure of Abraham, who gathers them to his bosom in the central oculus. The message of the window is reiterated in the inscription carved into the stone sill: "He that shall endure unto the end, the same shall be saved."[120]

Although the window does not copy any specific medieval model, individual sections do seem to be influenced by medieval sources, both French and English. For example, the frontal and three-quarter standing figures are comparable to the figures of the lancets at Chartres, as are the combination of large panels with standing figures above smaller panels with scenes/figures framed by arches (see fig. 22). Given that Cram and his protégé Connick both recommended Chartres as a prime example of medieval glass, it is quite possible that Cram specifically requested Reynolds to look to Chartres for inspiration. Conversely, Reynolds, who had trained with Connick, may have looked to Chartres as a model without being asked. Mary Shepard has noted a general similarity between the figure of Saint Joan of Arc and the sculpted figures of Saints Theodore and George (after 1224) on the jambs of the left portal (the "Portal of the Martyrs") of the south transept of the cathedral, suggesting that Reynolds may have taken inspiration from the entire building, not only its glass (fig. 35).[121] Similar to the Chartres sculptures of warrior saints, Saint Joan is depicted as a slim, standing figure, with chin-length bobbed hair parted in the middle. Her drapery falls in parallel folds, not unlike the tunics worn by Saints George and Theodore. It would certainly have been

appropriate for Reynolds to look to images of military martyr saints for his depiction of a female figure in the same category.

The tracery of the window is a hybrid of English and French models, with a combination of rows of lancets topped by three sexfoils—in keeping with the rest of the building, which married English and French influences in the plan, elevation, and vaulting structure. Yet the composition does not copy French or English precedents, in which monumental figures are arranged in rows of lancets, sometimes beneath a rose window. Here, the figures are both stacked and staggered—that is, each lancet contains two monumental figures, one stacked on top of the other, and the outer four lancets are placed at a slightly lower register than the central three ones. The composition thus is read neither from side-to-side nor from bottom-to-top, as is usually the case with Gothic stained glass, but in a sort of triangular pattern from outer edge to interior and then up toward the central figure of Christ.

In the final design, Cram's many references to English history and the World War were loosened, and the connections to the Princeton community were strengthened. There remains a single English figure, Saint Thomas à Becket, and only one figure who refers to the recent war, Cardinal Mercier, a vocal resister of the German occupation of Belgium. More importantly, Mercier and another figure, the Chevalier Bayard, had specific Princeton connections. Bayard, a French soldier of the late fifteenth and early sixteenth centuries, was claimed as an ancestor by an important New Jersey family with ties to the town and the University.[122] Mercier traveled to Princeton to receive an honorary doctorate of law in 1919, when President Hibben hailed him as an exemplar of patriotism and endurance.[123] He died in January 1926—not long before Cram, Friend, and their colleagues began to think about the stained-glass windows.

To be sure, war still plays a part in the design—three of the saints in the bottom row (George, Theodore, and Joan of Arc) are military saints—yet the connection is not to the most recent war but to the role of the military in the service of God. Saints George and Theodore both battled dragon-like creatures, symbols of the devil, while Joan of Arc was called by God to go to war to save her country. The figures of warrior saints thus symbolize the active or worldly Christian life and serve as the counterpoint to the Duffield memorial window in the south transept, which depicts the contemplative or scholarly Christian life.

Two other windows joined the Garrett window in the north transept to commemorate the windows that were lost in the Marquand Chapel fire. One of these, the so-called

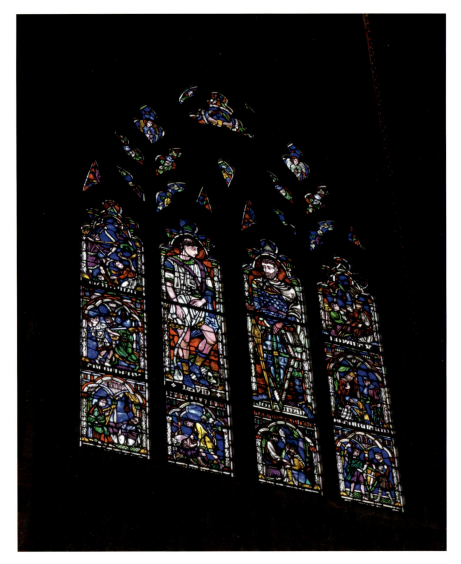

Figure 36. Oliver Smith, American, 1896–1980: the Marquand memorial window, the so-called Friendship window, in the north transept of the Princeton University Chapel.

Friendship window (fig. 36) by the stained-glass artist Oliver Smith (1896–1980), hews much more closely to its lost predecessor—the Marquand memorial window—than either the new Garrett or Dodge window. Cram commissioned Smith in the summer of 1927 to create this window, writing to Albert Friend that Smith had done an "admirable small window" for the church of Saint Mary's in Detroit, also a building designed by Cram.[124]

Unlike the two other windows, the Marquand window retained its basic subject matter— that is, the figures of David and Jonathan. But unlike Francis Lathrop's original window,

which presented the two monumental figures flanking an inscription, the new window includes scenes drawn from the lives of these two friends. The figures are thus placed in a larger narrative context, something largely missing from any of the original windows in Marquand Chapel but found quite frequently in medieval stained glass.

Like most of his contemporaries who worked in stained glass, Smith traveled to Europe early in his career to study the great medieval masterpieces still in situ. After his graduation from the Rhode Island School of Design, he worked for seven months in Charles Connick's studio before departing for Europe. There he spent a year and a half, visiting the great cathedrals in England and France and studying mosaics and "primitive" paintings in Italy.[125]

Smith returned to the United States eager to find a studio where he could create glass like the windows he had seen in thirteenth-century cathedrals. Based on the recommendation of Joseph Reynolds, his friend and former colleague at the Connick studio, Smith wrote in June 1922 to Raymond Pitcairn of Bryn Athyn, Pennsylvania. Pitcairn was responsible for the design and construction of a major Gothic Revival building rising amidst the rolling hills of the eastern Pennsylvania countryside, the Bryn Athyn Cathedral (built between 1913 and 1928). The cathedral was financed by Pitcairn's father, John Pitcairn, an industrialist and member of the Swedenborgian church, also known as the New Church. Cram was initially hired to design the building, but Pitcairn, desirous of controlling both the design and the construction process himself and dismayed at Cram's frequent absences from the site, fired him and undertook the oversight alone. Pitcairn also collected authentic works of medieval stained glass and sculpture to serve as examples for the craftsmen he hired to construct and decorate the church.[126]

Smith enclosed in his letter some sketches of the works he had seen in Europe, and by 1923, Pitcairn had hired him to replicate a stained-glass panel in the Worcester Art Museum (figs. 37 and 38). This panel, made in the first decade of the thirteenth century for the nave of the Cathedral of Notre-Dame in Rouen, is a companion piece to a set of panels Pitcairn had purchased in the early 1920s. The panels depict the Seven Sleepers of Ephesus, a legend first recorded in the West by Saint Gregory of Tours in the sixth century.[127] The legend tells of seven Christian youths who fled religious persecution during the reign of the Roman emperor Decius (ca. A.D. 250) by hiding inside a cave on the outskirts of Ephesus (in modern-day Turkey). According to the legend, the youths fell asleep for over a hundred years, finally awakening during the reign of the Byzantine emperor Theodosius II.

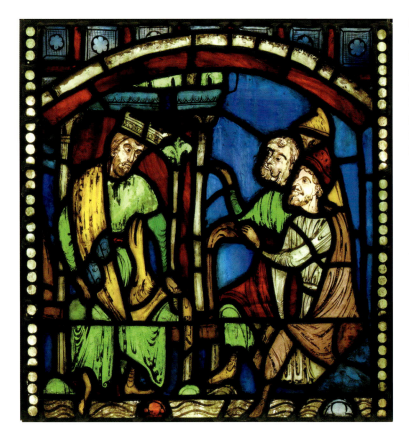

Figure 37. Oliver Smith, American, 1896–1980: episode from *The Legend of the Seven Sleepers of Ephesus* (Rouen Cathedral, ca. 1205, in fig. 38). Leaded and stained glass, 62.2 x 59.7 cm. Glencairn Museum, Bryn Athyn Historic District, Pennsylvania (03.SG.339).

The Worcester panel that Smith copied depicts two messengers announcing the miracle of the seven sleepers to Theodosius II, who sits on his throne, dumbfounded by the news. There is no record of the reason Pitcairn wished to have a copy made of this panel—perhaps he wanted to complete his set, or perhaps he simply wished to be able to compare his panels with the Worcester panel. The panel was on display in the museum's galleries at the time of Smith's visit, so he had to stand on a stepladder to study the panel and complete his copy.[128] Such working conditions must have been arduous yet exciting for the young artist, for he was able to observe the intricacies of the glass much more closely than had been possible when he was visiting the European cathedrals. He spent considerable time looking very closely, for he reported back to Pitcairn that the colors of the Worcester glass were different from the colors in the Glencairn panels.

A comparison of Smith's replica panel with the narrative scenes in the David and Jonathan window reveals the artist's interest in re-creating both the compositional structure and the

Figure 38. French, ca. 1205: episode from *The Legend of the Seven Sleepers of Ephesus*. Stained glass, 63.3 x 59.2 cm. Collection of the Worcester Art Museum, museum purchase, 1921 (1921.60).

colors used in medieval glass of the early thirteenth century, as well as his general knowledge of thirteenth-century art gained during his European travels. Compositionally, the Rouen scene Smith copied is divided into two zones united underneath what now appears as an arched canopy. This "canopy" is actually the remainder of the original medallion encircling the scene; when the panels were cut down in the 1270s for reuse in new chapels inserted between the nave buttresses, the rest of the medallion was sheared off.[129] On the left, Theodosius sits on his throne and listens to the report from the two messengers. He is set apart from his visitors by the columnar support of his throne and the red background. To the right, the messengers kneel and gesticulate against a brilliant blue background. The color palette is based on the primary colors—red, yellow, and blue—with a judicious use of green and accents of white and brown.

As on the Worcester panel, a canopy frames each narrative scene in the David and Jonathan window, and many of the scenes are divided into two parts. This division is

accomplished through one of two methods: the use of an architectural feature (such as in the scene at the bottom left, where David soothes Saul with his harp) or a change in color (such as the scene directly below the figure of Jonathan, where two figures against a blue background kneel before an enthroned king in front of a green curtain). The color palette in the David and Jonathan window, similar to that of the thirteenth-century Worcester panel, includes emerald green, canary yellow, ruby red, and ultramarine blue, inspired by the famous blue glass at Chartres.

Unlike the apparent canopies on the Worcester panel, the canopies in the David and Jonathan window are actual architectural features supported by two columns. Similar canopies are found in the lancets of the south transept at Chartres, where the donor figures are depicted beneath trilobed arches. Yet such forms are unusual in narrative scenes in medieval windows, in which geometric shapes, such as circles or quatrefoils, were usually employed as framing and containing devices. Architectural framing devices are also used in the so-called primitive panel paintings of late-thirteenth- and early-fourteenth-century Italy, as well as in thirteenth-century French sculpture and manuscript illumination, examples of which Smith must have seen during his tour of medieval sites in England, France, and Italy. The trilobed arch, in particular, is found in a number of monumental representations of the Coronation of the Virgin, for example, above the north portal of the west façade of the cathedral at Chartres (fig. 39), one of Smith's own artistic pilgrimage stops (and, as previously noted, a favorite source of inspiration of his mentor, Charles Connick).

The composition and coloring of the Friendship window thus suggest that Smith had a range of models at his disposal, from his trip to Europe as well as his time spent in Bryn Athyn working for Raymond Pitcairn. He appears to have been comfortable selecting certain elements that were historically accurate components of thirteenth-century glass and combining these with other elements that were more general conventions in art of the period, including sculpture and painting.

Likewise, the Garrett memorial window by Reynolds, Francis and Rohnstock is a twentieth-century reinterpretation of a thirteenth-century art form, although in this case the modern material takes the form of figures included in the design itself. Whereas Smith's panel depicts only biblical stories, the Garrett memorial window includes a range of historical figures from the Middle Ages as well as the modern era. Saint Thomas à Becket, the twelfth-century archbishop of Canterbury, at the far right, is similar to Cardinal Mercier, the

Figure 39. French, ca. 1205–10: *Coronation of the Virgin*, Cathedral of Notre-Dame, Chartres, France.

early-twentieth-century archbishop of Mechelen, at the far left. The inscriptions below each are the only personal identifying features that enable a viewer to determine who he is, and by extension, when he lived. Modern and historical figures are rendered equal by the medievalizing language of the Gothic Revival stained glass.

Together, the Garrett and Marquand memorial windows in the University Chapel encapsulate the approach to the Gothic Revival preached by Cram and supported by the Princeton University administration in the 1920s. Cram sought to create new forms that might have grown organically out of the art and architecture of the Middle Ages but that did not slavishly copy the originals. This approach was different from the one adopted by the College of New Jersey when it first commissioned "Gothic Revival" buildings in the 1870s and 1880s. As reflected in the three stained-glass projects highlighted in this essay—the Marquand Chapel memorial windows, the Great West Window in the Graduate College, and the windows in the Marquand Transept in the University Chapel—the very meaning of Gothic had undergone a transformation during this time. "Gothic" had changed from a catch-all term that referred to almost any style that seemed old and exotic to a designation that pinpointed a precise moment in history and geography—the thirteenth through fifteenth centuries, particularly in France and England—as interpreted through the eyes of modern artists and architects.

Cram's vision of a world renewed by a Gothic Revival never materialized. In fact, the University Chapel was the last true twentieth-century Gothic Revival building constructed on the Princeton campus, and even then it could have been seen as a relic of a bygone era in architectural design. By January 1930, the date of the dedication of the four main choir windows in the chapel, the Empire State Building was under construction in New York City, Frank Lloyd Wright was designing homes in his Organic style, and the Swiss architect Le Corbusier had already completed his Villa Savoye. Not even the great Ralph Adams Cram could stem the tide of Modernism that was sweeping across America and Europe.

The Gothic Revival buildings on the Princeton campus, and in particular those built in the Collegiate Gothic style of the late 1890s through 1930, nevertheless continue to exert a powerful force on the imaginations of Princeton students and alumni. In his 1999 feature article in the *Princeton Alumni Weekly* (*PAW*), Catesby Leigh, Class of 1979, rejected the minimalist architecture of the modern period and yearned for a return to the "traditional styles" of the campus—that is, the Collegiate Gothic of Cram and contemporary architects such as Princeton's own Demetri Porphyrios, Graduate School Class of 1980, architect of Whitman College. Leigh argued in favor of "ancient architectural conventions": "Those architectural conventions exist, above all, for the sake of beauty. And beautiful forms have an emotional resonance that corresponds, however mysteriously, to the highest human intentions, our sense of 'ought.'"[130]

The emotional resonance of architectural forms—and specifically the Collegiate Gothic forms of the late nineteenth and early twentieth centuries—was a defining feature of the debate sparked by Leigh's article. Successive issues of the *PAW* were filled with letters by alumni as well as working architects passionately arguing for or against Leigh's proposal. The debate was renewed in 2002 when plans for a new residential college in the Collegiate Gothic style were approved by the University (fig. 40). Whitman College, named for benefactor Meg Whitman and designed by Demetri Porphyrios, rose at the same time as Frank Gehry's undulating Lewis Library on the other side of campus. Again, many alumni and students were in favor of Whitman College, while others, including many in the architectural community, dismissed it entirely and instead embraced the Gehry aesthetic.

As many of the letters made clear, alumni and students often trace their strong sense of connection to the University to their experiences of its architecture. Modernist buildings are deemed "ugly," a "cacophony . . . egotistically jostling for notice," while the Collegiate

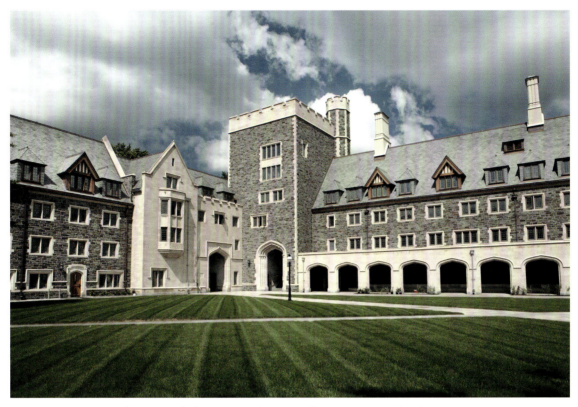

Figure 40. Demetri Porphyrios, Greek, born 1949: Whitman College, Princeton University, 2002–7.

Gothic buildings are praised as "beautiful" and "inspiring."[131] As noted by W. Barksdale Maynard, Class of 1988, in a recent *PAW* article on Princeton students' responses to the campus architecture, "Old buildings can transport them to a place where history becomes not just intellectual, but visceral."[132] From Marquand Chapel to Whitman College, criticism has often been bound up with emotion. Whether it has been concern over adopting a "popish" style or simply a style that was outmoded, campus architecture has continued to elicit a deep-seated emotional response on the part of the community, a response that would no doubt have felt familiar to Amory Blaine as he gazed out at the "spires and gargoyles" in the mist.

Notes

* *Book of Results of the Willet Stained Glass and Decorating Company of Philadelphia, Pennsylvania* (Philadelphia: Willet Stained Glass and Decorating Company, 1921), 5. The text, attributed by the Willets to "Hawthorne," appears to be a reference to chapter 33 in Nathaniel Hawthorne's *The Marble Faun*, although it is not a direct quotation. "It is the special excellence of pictured glass, that the light, which falls merely on the outside of other pictures, is here interfused throughout the work; it illuminates the design, and invests it with a living radiance; and in requital the unfading colors transmute the common daylight into a miracle of richness and glory in its passage through the heavenly substance of the blessed and angelic shapes which throng the high-arched window." See *The Marble Faun, or the Romance of Monte Beni*, vol. 2 (Boston: Ticknor and Fields, 1860), 95. My thanks to Professor William Gleason in the Department of English, Princeton University, for his assistance in tracking down this reference.

1. "Big Fire Destroys Marquand Chapel and Dickinson Hall," *Daily Princetonian*, May 15, 1920, 1. The present Dickinson Hall, connected with the University Chapel by the Rothschild Arch, replaced the lecture and examination building that burned in 1920.

2. "Worst Fire Ever Seen in Princeton Says Fire Chief," *Daily Princetonian*, May 18, 1920, 4. President Hibben also spoke of the loss in a statement following the fire: "Aside from the financial loss, the destruction of Marquand Chapel with its memorial windows and tablets, and the associations of past years, brings to all of our hearts an overwhelming sense of something of great value which has gone out of our lives and can never be brought back" (*Princeton Alumni Weekly*, May 26, 1920).

3. Ralph Adams Cram (hereafter referred to as RAC) to John Grier Hibben (hereafter referred to as JGH), May 3, 1926, Department of Grounds and Buildings Subject Files, box 2, folder 10, University Archives, Department of Rare Books and Special Collections, Princeton University Library.

4. Alice Cooney Frelinghuysen, "Duyckinck to Tiffany: New York Stained Glass, 1650–1920," in *The Art of Collaboration: Stained-Glass Conservation in the Twenty-First Century*, ed. Mary B. Shepard, Lisa Pilosi, and Sebastian Strobl (Turnhout: Harvey Miller Publications for the American Corpus Vitrearum, 2010), 20.

5. James McCosh, *Twenty Years of Princeton College, Being a Farewell Address, Delivered June 20th, 1888* (New York: Charles Scribner's Sons, 1888), 10.

6. This chapel, which came to be known as the "Old Chapel," was designed by the Philadelphia architect John Notman and was the first purpose-built chapel on the Princeton campus.

7. Pranks dating back to 1800 were recalled in a 1936 article in the student newspaper. See "Students of 1800, Irked at Two Daily Chapels, Pelt Tutors with Brickbats and Combustibles," *Daily Princetonian*, December 10, 1936.

8. McCosh, *Twenty Years of Princeton College*, 15.

9. Sara Bush, "The Princeton Chapels" (unpublished paper, April 29, 1994), Robert Judson Clark Papers, box 1, folder "Chapels" (Bush's research), University Archives, Department of Rare Books and Special Collections, Princeton University Library. McCosh reported: "To prevent confusion and disorder, we need a new chapel as soon as it can be provided. It is understood that a large portion of the money donated by Mr. Marquand is to go for this purpose." See "President's Report," December 17, 1873, Board of

Trustees Minutes and Records, vol. 5, 333, University Archives, Department of Rare Books and Special Collections, Princeton University Library.

10. Marquand wrote to McCosh in June 1880 that he had given orders to build the chapel and left the site selection up to the Board of Trustees (although the site would eventually be chosen by Marquand himself). See Henry G. Marquand to James McCosh, June 17, 1880. Recorded in the minutes for June 22, 1880, Board of Trustees Minutes and Records, vol. 6, 184–85.

11. Sarah Talbot O'Connor, "Henry Gurdon Marquand: Art Appreciation in Nineteenth-Century America" (B.A. thesis, Princeton University, 1989), 1.

12. McCosh quickly became alarmed by Allan Marquand's un-Calvinistic approach to the teaching of logic and offered him a position as the College's first lecturer in art history the following year. He was appointed as professor of art and archaeology, a position endowed by the estate of his deceased uncle, Frederick, in 1883. For the early years of the Department of Art and Archaeology and the Museum, see Marilyn Aronberg Lavin, *The Eye of the Tiger: The Founding and Development of the Department of Art and Archaeology, 1883–1920* (Princeton: Princeton University Art Museum, 1983).

13. These included three for the sons of William Henry Vanderbilt: Marble House, in Newport, Rhode Island, built in 1892 for William Kissam Vanderbilt; The Breakers, also built in Newport in 1892, for Cornelius Vanderbilt II; and Biltmore Estate, George Washington Vanderbilt II's château in Asheville, North Carolina, built between 1889 and 1895.

14. Some of Hunt's other Princeton buildings have since been demolished. See Virginia M. Green, "The Princeton Architecture of Richard Morris Hunt" (B.A. thesis, Princeton University, 1973), vi.

15. Linden Gate was featured in *Artistic Houses, Being a Series of Interior Views of a Number of the Most Beautiful and Celebrated Homes in the United States*, vol. 1 (New York: D. Appleton and Company, 1883–84), 85–86. It was destroyed by fire in 1973 and razed to make way for new development. See also Daniëlle O. Kisluk-Grosheide, "The Marquand Mansion," *Metropolitan Museum Journal* 29 (1994): 151–81.

16. Allan Marquand to Henry G. Marquand, November 25, 1879, Allan Marquand Papers, box 15, folder 13, Department of Rare Books and Special Collections, Princeton University Library.

17. Green, "The Princeton Architecture of Richard Morris Hunt," 20.

18. Richard Morris Hunt, "The Church Architecture We Need," *American Architect and Building News* 2, no. 100 (November 24, 1877): 376.

19. Richard Morris Hunt, "The Church Architecture We Need," *American Architect and Building News* 2, no. 101 (December 1, 1877): 384.

20. Paul R. Baker, *Richard Morris Hunt* (Cambridge, Mass.: MIT Press, 1980), 34.

21. Allan Marquand to Henry G. Marquand, November 25, 1879.

22. July 1847, Board of Trustees Minutes and Records, vol. 3, 483–84.

23. A quote from Luke 2:14 was cut out of the metal in Gothic script: "GLORY to GOD in THE HIGHEST, on EARTH PEACE, GOOD WILL TOWARD MEN."

24. See "Restored Statue of Pres. McCosh To Be Placed in Chapel Transept," *Daily Princetonian*, May 16, 1929, 1.

25. Louis was the brother of Augustus; he changed the spelling of his last name to differentiate himself from his older (and more famous) brother. The Joseph Henry tablet was cracked by the heat of the fire, and the rock slab to which the Guyot plaque was attached did not survive. The plaque itself did survive and is now installed in Guyot Hall.

26. "The New Chapel," *Daily Princetonian*, October 21, 1881, 78–79.

27. "Topics at Princeton College; Completion of Marquand Chapel—Programme of Commencement Exercises," *New-York Tribune*, May 21, 1882, 5.

28. Harry William Desmond, *Stately Homes in America from Colonial Times to the Present Day* (New York: D. Appleton and Company, 1903); "The Splendid Marquand Mansion and Its Future," *New York Times*, April 16, 1905, X8; Kisluk-Grosheide, "The Marquand Mansion."

29. For Aesthetic movement stained glass, see Frelinghuysen, "Duyckinck to Tiffany: New York Stained Glass, 1650–1920," as well as Doreen Bolger Burke, ed., *In Pursuit of Beauty: Americans and the Aesthetic Movement* (New York: The Metropolitan Museum of Art, 1986).

30. See H. Barbara Weinberg, *The Decorative Work of John La Farge* (New York: Garland Press, 1977), 363–64, and Julie L. Sloan and James L. Yarnall, "John La Farge's Patent for the American Opalescent Window," *Journal of Stained Glass* 28 (2004): 31–45.

31. This window is also discussed in Frelinghuysen, "Duyckinck to Tiffany: New York Stained Glass, 1650–1920," 26.

32. See Martha Joanna Lamb, *The Homes of America* (New York: D. Appleton and Company, 1879), 203; also Kisluk-Grosheide, "The Marquand Mansion."

33. Tiffany first established his firm in 1881 as Louis C. Tiffany & Company, Associated Artists. In 1883, he dissolved Associated Artists and renamed his firm Louis C. Tiffany & Company. By 1887, the name was changed again to Tiffany Glass Company, and in 1892, it was renamed Tiffany Glass & Decorating Company. In 1902, the firm was renamed Tiffany Studios.

34. "Topics at Princeton College," *New-York Tribune*, May 21, 1882, 5.

35. Elizabeth Johnston De Rosa, "Louis Comfort Tiffany and the Development of Religious Landscape Memorial Windows" (Ph.D. diss., Columbia University, 1995), 23–24.

36. For a contemporary account, see "Memorials in the Marquand Chapel. The Interior Decorations of the Chapel and Their Donors," *Daily Princetonian*, April 5, 1898, 1.

37. "A Handsome Gift to Princeton," *New-York Tribune*, December 22, 1889, 7.

38. Hamilton Easter Field, introductory note in Anderson Art Galleries, "Paintings and Studio Property of the Late Francis Lathrop of New York City," auction catalogue, April 4–6, 1911, New York.

39. Ibid.

40. Frelinghuysen, "Duyckinck to Tiffany: New York Stained Glass, 1650–1920," 28.

41. "A Handsome Gift to Princeton," *New-York Tribune*, December 22, 1889, 7.

42. The exhibition took place in the museum's former location, Memorial Hall in Fairmount Park, Philadelphia. Artists were solicited to enter works for the following categories: pottery, porcelain, glassware, stained glass, terracotta, tile, and mosaic work. Lathrop entered several works in the stained-glass category, which had four separate subclasses; his David and Jonathan windows won the gold medal for "Exhibit of Figure or Ornamental Windows for Ecclesiastical Purposes." See series "Initiatives," subseries "Exhibitions, American Art Industries

(1889)," Board of Trustees Records, boxes 44–45; and Scrapbook 6, series "Memorial Hall and School," Special Format Records, The Philadelphia Museum of Art, Archives. For a contemporary account, see "A Gold Medal Window," *New York Times*, December 23, 1889, 5.

43. For a contemporary account, see "Educational," *New York Observer and Chronicle*, January 10, 1895, 56.

44. *Princeton College Bulletin*, June 1895, 59.

45. "A Fine Memorial Window," *Baltimore Sun*, January 17, 1898, 10.

46. Diane C. Wright, "Frederick Wilson: 50 Years of Stained Glass Design," *Journal of Glass Studies* 51 (2009): 199.

47. "A Fine Memorial Window."

48. Wright, "Frederick Wilson: 50 Years of Stained Glass Design," 206.

49. McCosh, *Twenty Years of Princeton College*, 13.

50. Allan Marquand, "On the Campus. Princeton University," *Cosmopolitan* 8 (1889): 738.

51. See Willard Thorp et. al., *The Princeton Graduate School: A History*, rev. ed. (Princeton: Princeton University Press, 2000), and W. Barksdale Maynard, *Woodrow Wilson: Princeton to the Presidency* (New Haven, Conn.: Yale University Press, 2008).

52. The final factor in clinching the deal for West was a $10 million bequest made by alumnus Isaac C. Wyman, Class of 1848, whose will named West as the sole executor of his estate and stipulated that the money could be used to build a graduate college only if the site was near that of the Revolutionary War's Battle of Princeton, in which his father had fought. See Maynard, *Woodrow Wilson*, 234.

53. For more on West's interest in English Gothic architecture, see "Observes Features of European Universities and Incorporates Them In Graduate School," *Daily Princetonian*, February 22, 1928, 20.

54. RAC to Moses Taylor Pyne, June 2, 1911, Graduate School Records, box 15, folder 4, University Archives, Department of Rare Books and Special Collections, Princeton University Library.

55. See letters in Graduate School Records, box 15, folder 4.

56. Andrew Fleming West (hereafter referred to as AFW) to William Cooper Procter (hereafter referred to as WCP), February 8, 1911, Graduate School Records, box 15, folder 3.

57. In France, these sinuous forms (known as the *mouchette*, a curved, dagger-like shape, and *soufflet*, a leaf or teardrop shape) became popular in the late fourteenth century, a period in architecture referred to as Flamboyant Gothic.

58. Connick dedicated his 1937 biography/treatise on the art of stained glass, *Adventures in Light and Color*, to "Ralph Adams Cram who trusts, encourages, and defends adventures in Light and Color today." He listed many of his commissions in this book. See *Adventures in Light and Color* (New York: Random House, 1937).

59. AFW to WCP, February 8, 1911, Graduate School Records, box 15, folder 3.

60. AFW to WCP, June 14, 1911, Graduate School Records, box 15, folder 4.

61. William Willet (hereafter referred to as WW) to AFW, March 22, 1912, Graduate School Records, box 15, folder 6.

62. Anne Lee Willet and William Willet, "The Stained Glass Adventure of William Willet," Henry Lee Willet papers, reel P5, Archives of American Art, Smithsonian Institution. Annie was an artist in her own right and was actively involved in both the creative and business sides of the company.

63. "The Art of the Glass-Workers—the Week's Review," *The (Philadelphia) Public Ledger*, January 24, 1915, n.p.

64. Anne Lee Willet and William Willet, "The Stained Glass Adventure of William Willet." In his youth, Cram was also a fan of the Pre-Raphaelites; a letter to the editor about the first Pre-Raphaelite exhibition at the Art Museum on Copley Square, Boston, helped him to get his first job as an art critic. See Ralph Adams Cram, *My Life in Architecture* (Boston: Little, Brown and Company, 1936), 7–10.

65. *Book of Results of the Willet Stained Glass and Decorating Company*, 5.

66. RAC to AFW, April 26, 1912, Graduate School Records, box 15, folder 6.

67. Anne Lee Willet and William Willet, "The Great West Window of Proctor (*sic*) Hall of the Post Graduate School of Princeton University" (unpublished paper, June 9, 1912), 3, Graduate School Records, box 15, folder 7.

68. Ibid.

69. The six figures now in situ are copies. One original is in the British Museum, and the other five are in the Acropolis Museum.

70. Anne Lee Willet and William Willet, "The Great West Window," 3.

71. Ibid., 4.

72. Mary Shepard has suggested another intriguing possible influence: Sir Joshua Reynolds's design for the Great West Window in the antechapel of New College, Oxford (painted by Thomas Jarvis between 1778 and 1785). The window depicts the Seven Virtues, who are posed on pedestals and dressed in a fashion not unlike the depiction of the Seven Liberal Arts in Willet's design.

73. The Willet Stained Glass and Decorating Company, "Report of Conference, June 13, 1912, Covering modifications of Design No. 3520—for the Great West Window—Procter Hall, Princeton, N.J." (unpublished and undated paper), 4, Graduate School Records, box 15, folder 7.

74. "I think this a wise decision, although I realize that you would probably prefer to select some other artist, yet your strong endorsement of Willet's work at West Point and in the Calvary Church at Pittsburg (*sic*) has naturally had great weight" (AFW to Charles J. Connick Jr., June 18, 1912, and AFW to RAC, June 16, 1912, Graduate School Records, box 15, folder 7).

75. "The circumstances surrounding this matter are incomprehensible and (in our experience) unprecedented. . . . I consider that both my firm as Architects, and I myself as Supervising Architect, have been treated with grave injustice and extreme discourtesy" (RAC to AFW, June 19, 1912, Graduate School Records, box 15, folder 7).

76. Letters between WW and AFW and RAC and AFW refer to past projects and each man's frustrations with the other. WW accused RAC of deceit and trickery in his dealings with him, and of making false claims regarding how much control he had actually had over the Willets' work at buildings he had designed. RAC criticized WW's work, which he saw as uneven and inconsistent. See letters from WW to AFW, June 22, 1912; RAC to WW and WW to AFW, June 26, 1912; and RAC to WW, July 8, 1912, Graduate School Records, box 15, folders 7 and 8.

77. RAC to WW, June 26, 1912, Graduate School Records, box 15, folder 7.

78. The cathedral is currently undertaking a full conservation program for its windows; in the future, what now appears as dark glass in the south transept lancets will be returned to its original color and brightness.

79. Connick, *Adventures in Light and Color*, 104.

80. AFW to RAC, June 26, 1912, Graduate School Records, box 15, folder 7.

81. AFW to WCP, June 26, 1912, Graduate School Records, box 15, folder 7.

82. Copy of letter from WW to WCP, July 2, 1912, Graduate School Records box 15, folder 8.

83. The committee members suggested that if West and Procter were not comfortable giving the west window commission to Connick based on a small sample of his work, then he should be given one of the smaller windows. This came to fruition the following year, when West received an offer from Mr. and Mrs. Russell W. Moore for a stained-glass window to occupy the tall bay window on the south side of the hall. Connick received this commission and created a window with the theme of the search for the Holy Grail. See letter and attached report from Frank Miles Day and M. B. Medary Jr. to the Graduate School Committee, December 13, 1912, Graduate School Records, box 15, folder 10, and AFW to WCP, April 19, 1913, Graduate School Records, box 16, folder 2.

84. AFW to WCP, December 16, 1912, Graduate School Records, box 15, folder 10.

85. William Willet, "Sketches Principally for Stained Glass" (unpublished sketchbook, no date), Art Department, Free Library of Philadelphia.

86. AFW to WW, November 4, 1912, Graduate School Records, box 15, folder 10.

87. William and Annie Lee Willet, "A Brief Description of Submitted Design and Executed Glass Panel for Memorial Window. Procter Hall. Graduate School. Princeton University. Princeton, New Jersey. Subject: The Seven Liberal Arts" (no date), Graduate School Records, box 16, folder 1.

88. William Willet, "The Great West Window, Procter Hall, Graduate School" (two-page pamphlet in unpublished scrapbook, 1913), Art Department, Free Library of Philadelphia.

89. Willet, "The Great West Window of Proctor (*sic*) Hall," 4.

90. Ibid.

91. Willet, "A Brief Description," 4.

92. Ibid., 6.

93. Anne Lee Willet and William Willet, *The Great West Window. Procter Hall. Graduate School. Princeton, N.J.* (n.p., n.d.), 1. A copy of this publication, most likely produced by the Willets themselves, is in the Seeley G. Mudd Manuscript Library, Princeton University.

94. Friedrich Schelling, *Philosophy of Art*, trans. and ed. Douglas W. Stott (Minneapolis: University of Minnesota Press, 1989), 165. Madame de Staël: "La vue d'un tel monument est comme une musique continuelle et fixée." See *Corinne, ou l'Italie* (1807; New York: Leavitt et Compagnie, 1849), 61. Goethe: "I have found, among my papers . . . a leaf, in which I call architecture frozen music." See *Conversations with Goethe in the Last Years of His Life*, trans. S. M. Fuller (Boston: Hilliard, Gray, and Company, 1839), 282.

95. Ralph Waldo Emerson, *Nature* (Boston: James Monroe and Company, 1849), 41; and "Quotation and Originality," *North American Review*, April 1868, 547. Emerson is referring to book one of Vitruvius's *De architectura*: "Let (the architect) be educated, skilful with the pencil, instructed in geometry, know much history, have followed the philosophers with attention, understand music, have some knowledge of medicine, know the opinions of the jurists, and be acquainted with astronomy and the theories of the heavens." See *The Ten Books on Architecture*, trans. Morris Hickey Morgan (Cambridge, Mass.: Harvard University Press, 1930), 5–6.

96. "Lecture on Artists," *New York Daily Times*, January 19, 1856, 2; "Local Matters: Peabody Institute Lectures—Progress of the Human Race," *The (Baltimore) Sun*, November 17, 1871, 4; Anna Ritchie, "The Old World: The American Rink in Paris," *San Francisco Chronicle*, May 15, 1870, 4; "Improvements at the Capital," *New-York Tribune*, June 15, 1872, 4; "A Lesson in Architecture," *New York Times*, January 31, 1889, 4.

97. Ralph Adams Cram, "Stained Glass: An Art Restored," *Arts and Decoration* 20, no. 4 (February 1924): 11.

98. Harvey Maitland Watts to WW, June 11, 1914, in William Willet, unpublished scrapbook, Art Department, Free Library of Philadelphia.

99. Sally Forth, "Mrs. Thomas English Is Subject of Interesting Newspaper Story," *Atlanta Constitution*, January 5, 1937, 13. Thomas English received his B.A. in 1918 and his Ph.D. in 1924, both from Princeton's Department of English. He was a member of the faculty of the Department of English at Emory University, from 1925 until his retirement in 1964.

100. "The Effect of the Fire," *Daily Princetonian*, May 17, 1920, 2.

101. "Chapel Will Be Built on Site of Marquand," *Daily Princetonian*, November 17, 1921, 3.

102. The design process is discussed in detail in Douglass Shand-Tucci, *Ralph Adams Cram: An Architect's Four Quests. Medieval, Modernist, American, Ecumenical* (Amherst: University of Massachusetts Press, 2005), 271–308.

103. Ralph Adams Cram's firm went through several permutations during the first three decades of the twentieth century. Cram had founded the firm in 1887 with his partner Charles Wentworth. In 1897, they took on a third partner, Bertram Goodhue, and the firm was renamed Cram, Wentworth and Goodhue. Wentworth died in 1899; the firm took another partner, Frank Ferguson, and was renamed Cram, Goodhue and Ferguson. Goodhue left the firm in 1910, and the name was changed to Cram and Ferguson. Ferguson died in 1926, but the firm's name remained the same.

104. "Architect A. E. Hoyle, 87; Hub Services Tomorrow," *Boston Globe*, January 5, 1967, 83; Douglass Shand-Tucci, *Built in Boston: City and Suburb, 1800–2000* (Amherst: University of Massachusetts Press, 1999), 163.

105. "The Architects' Description of the Chapel Designs," *Princeton Alumni Weekly*, November 23, 1921, 179–81.

106. Douglass Shand-Tucci, *Ralph Adams Cram, American Medievalist* (Boston: Boston Public Library, 1975), 33.

107. Transcription of letter from RAC to Alexander E. Hoyle, March 5, 1921, Princeton University Chapel, Architectural Project Correspondence, 1925(?), Cram and Ferguson Collection, Fine Arts Department, Boston Public Library.

108. John Grier Hibben, "The Proposed New Chapel," *Princeton Alumni Weekly*, November 23, 1921, 175.

109. In 1921 the school also established 149 scholarships in memory of the deceased. See *Princeton Alumni Weekly*, February 9, 1921, 403. For Memorial Hall, see Alexander Leitch, *A Princeton Companion* (Princeton: Princeton University Press, 1978), 332–33.

110. The cost of the windows depended on a number of factors, including their size, elaborateness, and the skill of the artist(s). The north and south transept windows each cost $25,000, while the Great West Window, by Nicola d'Ascenzo, cost $25,776. The five choir windows, all by Charles Connick Jr., cost a total of $104,500. Individual clerestory or aisle windows cost between $5000 and $7500. See "Princeton Chapel" (listing of costs of stained-glass windows, May 12, 1932), Princeton University, Architectural Project Correspondence, May 1932, Cram and Ferguson Collection, Fine Arts Department, Boston Public Library.

111. Friend's role in the creation of the stained-glass program has been discussed most recently by Matthew J. Milliner, whose article on Friend and the University Chapel focuses primarily on the windows in the choir and the Great East Window. See "Primus inter pares: Albert C. (*sic*) Friend and the Argument of the Princeton University Chapel," *Princeton University Library Chronicle* 70, no. 3 (Spring 2009): 471–517.

112. Albert M. Friend (hereafter referred to as AMF) to JGH, undated, Dean of Religious Life and Chapel Records, box 9, folder "Chapel Windows," University Archives, Department of Rare Books and Special Collections, Princeton University Library.

113. Ibid.

114. See Biographical Material, Joseph Reynolds Papers, roll 1468, Archives of American Art, Smithsonian Institution. In addition to the Garrett window, the firm was also hired to create a window for the south transept arm, given by Edward D. Duffield, president of Prudential Insurance Company of Newark, New Jersey, and a member of the Class of 1892.

115. Friend referred to the theme as "perfection through suffering." See AMF to JGH, undated, Dean of Religious Life and Chapel Records, box 9, folder "Chapel Windows."

116. My thanks to Mary Shepard for pointing out this connection.

117. Ralph Adams Cram, *Heart of Europe* (New York: Charles Scribner's Sons, 1915), 5, 13.

118. "Dr. Cram Preaches a 'Gothic Revival' in America," *Current Opinion*, August 1921, 204.

119. "In the predella beneath (Michael), there must be represented Michael weighing the souls. For the sake of the meaning of the whole window, this last detail is to me essential" (AMF to Joseph Reynolds, June 15, 1927, Dean of Religious Life and Chapel Records, box 9, folder "Chapel Windows").

120. Matthew 24:13.

121. Mary Shepard, e-mail message to author, May 17, 2011.

122. The Bayards trace their genealogy to a group of French Huguenots who first fled to Holland and then to New Amsterdam to avoid religious persecution. Samuel J. Bayard, Class of 1820, was a prominent nineteenth-century jurist. His daughter Caroline Bayard married Professor Albert B. Dod of Princeton; their daughter Susan married Richard Stockton, also an alumnus of Princeton and a well-respected lawyer in New Jersey. See *Genealogical and Personal Memorial of Mercer County, New Jersey*, vol. 2, ed. Francis Bazley Lee (New York: Lewis Publishing Company, 1907).

123. "Princeton Honors Cardinal Mercier," *New York Times*, September 30, 1919. "Patriotism and Endurance" was the title of a pastoral written by Mercier in late 1914.

124. RAC to AMF, August 12, 1927, Dean of Religious Life and Chapel Records, box 10.

125. Oliver Smith (hereafter referred to as OS) to Raymond Pitcairn (hereafter referred to as RP), June 12, 1923, Oliver Smith Papers, folder 2, The Glencairn Museum, Bryn Athyn, Pennsylvania. Smith's studio brochure listed England, France, Holland, and Italy on his itinerary in 1921–22. He and his wife visited the cathedrals of Poiters, Bourges, Troyes, Angers, Sens, and Chartres in France, and Canterbury in England. My thanks to Smith's granddaughter, Laurie Engel, for this information.

126. For more on the Pitcairns and the Glencairn collection, see Jane Hayward et. al., *Radiance and Reflection: Medieval Art from the Raymond Pitcairn Collection* (New York: The Metropolitan Museum of Art, 1982).

127. The panels were originally part of a larger group of thirty-six scenes in a window in Rouen. Pitcairn purchased three of the panels at the Sotheby's sale of the Lawrence collection in New York in 1921 and a fourth from the dealer Lambert in Paris in 1923 (Glencairn 03.SG.52, 03.SG.49, 03.SG.51); the Glencairn Foundation later gave the fourth panel to The Cloisters Collection (1980.263.4). See Hayward et al., *Radiance and Reflection*, cat. no. 56, and Michael W. Cothren, "The Seven Sleepers and the Seven Kneelers: Prolegomena to a Study of the 'Belles Verrières' of the Cathedral of Rouen," *Gesta* 25, no. 2 (1986): 203–26.

128. OS to RP, March 31, 1923, Oliver Smith Papers, folder 2.

129. Hayward et al., *Radiance and Reflection*, 150.

130. Catesby Leigh, "Must the Minimum be the Maximum?" *Princeton Alumni Weekly*, May 19, 1999, accessed March 31, 2011, http://www.princeton.edu/paw/archive_old/index.html.

131. "Letters," *Princeton Alumni Weekly*, September 8, 1999, and July 7, 1999, accessed March 31, 2011, http://www.princeton.edu/paw/archive_old/index.html. The arguments made for and against the Gothic Revival architecture of the twenty-first century mirror some of the arguments made for and against the Chapel in 1922. See "The Proposed New Chapel," *Princeton Alumni Weekly*, January 18, 1922, 311–12.

132. W. Barksdale Maynard, "Something Old, Something New," *Princeton Alumni Weekly*, February 13, 2008, accessed March 31, 2011, www.princeton.edu/paw/archive_old/index.html.

Appendix

"Before the Western Window,
The Graduate School, Princeton"

By Harvey Maitland Watts

Published in the *Philadelphia Ledger*, June 8, 1914

Jewelled with glory at the set of sun,
The Great Tradition glows upon this pane
Failing which benison all else were vain,
Since men may ne'er forget what men have done;
Those mighty souls, who though their sands are run,
Abide within and consecrate this fane,
Whose walks shall never hear the cry of gain
Nor see the work of yesterdays undone.

Though of the present, how the cunning skill
Of mind and hand has mellowed all this pile
In reverent touch with a more reverent Past.
"'Tis good, Lord, to be here," since naught of ill
Invades these cloisters, only Wisdom's Guile—
Lo, as the prospect so the outlook vast.

"The Western Window,
Graduate College"

By Thomas Hopkins English

Published in *Scribner's*, August 1920

The glory of the blue and green and gold
Fades from the jeweled lancets, as the day
Puts on his dusky garment, and behold,
The figures from the window fade away.
Vanish the sister arts of Christian lore,
Vanish the reverend doctors of the Law;
Yet from the darkened panes shines as before
One Face that fills the soul with love and awe.
So, when the arts are dead, and systems fail,
Knowledge is dimmed, and wisdom's works decay,
Hidden all signs behind the obscuring veil,
From Thine own face will shine the saving ray—
Thou the Fixed Star that through the darkness vast
Wilt guide me to the throne of Truth at last.

Checklist of the Exhibition

Benjamin West, American,
1738–1820
The Woman Clothed with the Sun
Fleeth from the Persecution of the
Dragon, ca. 1797

Oil on paper laid down on panel
149 x 69 cm. (58 11/16 x 27 3/16 in.)
Museum purchase, Kathleen Compton
Sherrerd Fund for American Art (1996-62)

Alexander Jackson Davis,
American, 1803–1892
Glen Ellen: perspective,
elevation, plan, 1832–33

Watercolor, ink, and graphite on paper
55.2 x 39.7 cm. (21 3/4 x 15 5/8 in.)
The Metropolitan Museum of Art, Harris
Brisbane Dick Fund, 1924 (24.66.17)

John Britton, British, 1771–1857
Graphical and Literary Illustrations
of Fonthill Abbey, Wiltshire; with
Heraldical and Genealogical Notices
of the Beckford Family, 1823

31 x 24.8 cm. (12 3/16 x 9 3/4 in.)
Rare Book Collection, Marquand Library
of Art and Archaeology, Princeton
University

English Bible, ca. 1270–80
Manuscript

Tempera and ink on parchment
Open: ca. 24 x 34 cm. (9 7/16 x 13 3/8 in.)
Robert Garrett Collection of Medieval
and Renaissance Manuscripts, no. 28,
Manuscripts Division, Department of
Rare Books and Special Collections,
Princeton University Library. Gift of
Robert Garrett, Class of 1897

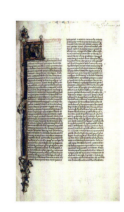

John Rutter, British, 1796–1851
Delineations of Fonthill and Its
Abbey, 1823

28 x 22 cm. (11 x 8 11/16 in.)
Rare Book Collection, Marquand Library
of Art and Archaeology, Princeton
University

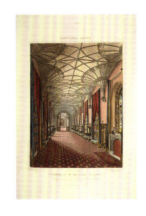

Jasper Francis Cropsey,
American, 1823–1900
Morning, 1854

Oil on canvas
44 x 32 cm. (17 5/16 x 12 5/8 in.)
Gift of Stuart P. Feld, Class of 1957,
and Mrs. Feld (y1984-31)

Jasper Francis Cropsey, American,
1823–1900
Evening, 1855

Oil on canvas
44 x 33 cm. (17 5/16 x 13 in.)
Gift of Stuart P. Feld, Class of 1957,
and Mrs. Feld (y1984-32)

Richard Morris Hunt, American,
1827–1895
Marquand Chapel (architectural
drawing of front elevation)

Ink on linen?
90.1 x 89.5 cm. (35 1/2 x 35 1/4 in.)
University Archives, Department of Rare
Books and Special Collections, Princeton
University Library

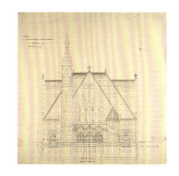

Unidentified American artist
Romantic Landscape, ca. 1850–75

Oil on canvas
91 x 122 cm. (35 13/16 x 48 1/16 in.)
Gift of Edward Duff Balken, Class of 1897
(y1958-95)

Richard Morris Hunt, American,
1827–1895
Marquand Chapel (architectural
drawing of side elevation)

Ink on linen?
90.8 x 101.6 cm. (35 3/4 x 40 3/4 in.)
University Archives, Department of Rare
Books and Special Collections, Princeton
University Library

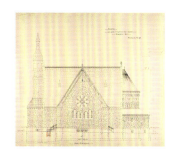

Lithographed by Thomas Hunter,
American, active 1875, after a
design by W. M. Radcliff
Princeton College, Princeton, N.J.,
1875

Lithograph
Ca. 61.6 x 81.6 cm. (23 1/4 x 32 1/8 in.)
Princetoniana Collection, Graphic Arts
Collection, Department of Rare Books
and Special Collections, Princeton
University Library

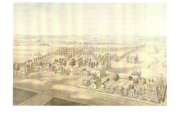

Francis Lathrop, American,
1849–1909
Jonathan (model for window in
old Marquand Chapel, burned
in 1920), 1889

Leaded opalescent glass
171 x 61.5 cm. (67 5/16 x 24 3/16 in.)
Gift of the Museum for the Arts of
Decoration, The Cooper Union for the
Advancement of Science and Art, New
York (y1958-112)

Frederic, Lord Leighton,
British, 1830–1896
After Vespers, 1871

Oil on canvas
111.5 x 71.5 cm. (43 7/8 x 28 1/8 in.)
Museum purchase (y1961-17)

Francis Lathrop, American,
1849–1909
David (model for window in old
Marquand Chapel, burned in
1920), 1889

Leaded opalescent glass
171 x 61.5 cm. (67 5/16 x 24 3/16 in.)
Gift of the Museum for the Arts of
Decoration, The Cooper Union for
the Advancement of Science and Art,
New York (y1958-113)

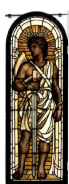

Augustus Saint-Gaudens,
American, 1848–1907
James McCosh (1811–1894), 1889

Bronze
47 x 25 x 26 cm. (18¹/₂ x 9¹³/₁₆ x 10¹/₄ in.)
Campus Collections, Princeton University
(PP35)

A(rthur) Page Brown, American,
1859–1896
Class of 1877 Biological
Laboratory: proposed exterior,
1887

Watercolor on paper
Ca. 45.7 x 50.8 cm. (18 x 20 in.)
University Archives, Department of Rare
Books and Special Collections, Princeton
University Library

Attributed to John La Farge,
American, 1835–1910
Summer and Winter (design for
stained-glass window)

Watercolor, pen and brown ink, brush
and black ink on cream wove paper
30.8 x 10.3 cm. (12¹/₈ x 4¹/₁₆ in.)
Gift of Frank Jewett Mather Jr. (x1976-26)

A(rthur) Page Brown, American,
1859–1896
Sketchbook and scrapbook,
1880–93

Manuscript
32.5 x 40.6 x 5 cm.
(12¹³/₁₆ x 16 x 1¹⁵/₁₆ in.)
The Winterthur Library, Delaware
(folio 67)

Unknown American artist
Princeton College (drawn from
photographs, published in
Harper's Weekly, June 18, 1887)

Color engraving
38.7 x 51.5 cm. (15¹/₄ x 22¹/₄ in.)
Princetoniana Collection, Graphic Arts
Collection, Department of Rare Books
and Special Collections, Princeton
University Library

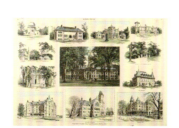

British, Nottingham School
Coronation of the Virgin, second
half of the 15th century

Alabaster with traces of polychromy
39.5 x 29.5 cm. (15⁹/₁₆ x 11⁵/₈ in.)
Gift of Allan Marquand, Class of 1874
(y48)

A(rthur) Page Brown, American,
1859–1896
Art Museum, Princeton College:
front elevation, 1886

Pen, black ink, and watercolor on
tracing paper
68.4 x 80 cm. (26¹⁵/₁₆ x 31¹/₂ in.)
Gift of A. Page Brown (x1963-33)

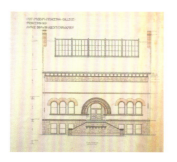

Possibly Italian
Casket, ca. 1450

Bone and ebony
17 x 30 x 18 cm.
(6¹¹/₁₆ x 11¹³/₁₆ x 7¹/₁₆ in.)
Gift of Allan Marquand, Class of 1874,
in 1917 (y49)

John F. Kyes and Charles
Herbert Woodbury
Published by George S. Harris
and Sons
*Aerial View of Princeton University
Campus*, 1895

Lithograph
36.8 x 66 cm. (14¹/₂ x 26 in.)
Princetoniana Collection, Graphic Arts
Collection, Department of Rare Books
and Special Collections, Princeton
University Library

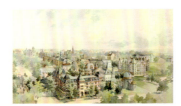

After a watercolor by Richard
Rummell, American, 1848–1924
Commissioned and published by
Littig and Company
Princeton University, 1906

Colored photogravure
67.3 x 101.6 cm. (26¹/₂ x 40 in.)
Princetoniana Collection, Graphic Arts
Collection, Department of Rare Books
and Special Collections, Princeton
University Library

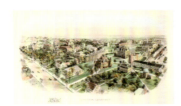

Alexander Jackson Davis,
American, 1803–1892
Villa for Robert Donaldson,
Fishkill Landing, New York
(perspective and plans), 1834

Watercolor
33 x 25.4 cm. (13 x 10 in.)
The Metropolitan Museum of Art, Harris
Brisbane Dick Fund, 1924 (24.66.865)

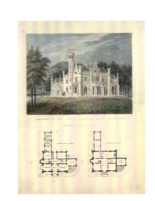

William Appleton Potter,
American, 1842–1909
Suggested addition for Library
(with a chapel-like structure), 1898

Graphite on paper
46.3 x 75.2 cm. (18¹/₄ x 29⁵/₈ in.)
University Archives, Department of
Rare Books and Special Collections,
Princeton University Library

William Appleton Potter,
American, 1842–1909
Suggested addition for Library
(showing a modified Chancellor
Green), 1896

Graphite on paper
Ca. 53.3 x 76.2 cm. (21 x 30 in.)
University Archives, Department of Rare
Books and Special Collections, Princeton
University Library

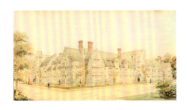

William Willet, American,
1869–1921
Design for stained-glass window
in Procter Hall, Graduate
College, July 1912

Watercolor on paper
95 x 59 cm. (37³/₈ x 23¹/₄ in.)
Willet Stained Glass Co. Archives, Willet
Hauser Architectural Glass, Philadelphia

Day & Klauder, architects,
Philadelphia (fl. 1911–1927)
Holder Hall: perspectival view
of southeast façade, undated

Watercolor on paper
39.5 x 75.9 cm. (15⁹/₁₆ x 29⁷/₈ in.)
University Archives, Department of
Rare Books and Special Collections,
Princeton University Library

Day & Klauder, architects,
Philadelphia (fl. 1911–1927)
Dormitories and dining halls,
undated

Diazo print
Ca. 25.4 x 81.3 cm. (10 x 32 in.)
University Archives, Department of
Rare Books and Special Collections,
Princeton University Library

Charles Zeller Klauder, for Day
& Klauder, architects,
Philadelphia (fl. 1911–1927)
Tower from South Court,
undated

Red crayon on paper
38.6 x 32.4 cm. (15³⁄₁₆ x 12³⁄₄ in.)
University Archives, Department of Rare
Books and Special Collections, Princeton
University Library

After a watercolor by Richard
Rummell, American, 1848–1924
Commissioned and published by
Littig and Company
Princeton University, ca. 1920

Colored photogravure
65.7 x 101.2 cm. (25⁷⁄₈ x 39⁷⁄₈ in.)
Princetoniana Collection, Graphic Arts
Collection, Department of Rare Books
and Special Collections, Princeton
University Library

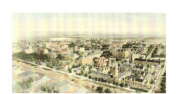

Cram and Ferguson, architects,
Boston (fl. 1915–1941)
Proposed exterior of Princeton
University Chapel, undated

Watercolor on wove paper
94 x 68.6 cm. (37 x 27 in.)
University Archives, Department of
Rare Books and Special Collections,
Princeton University Library

Cram and Ferguson, architects,
Boston (fl. 1915–1941)
Interior of Princeton University
Chapel, undated

Watercolor on wove paper
69.7 x 36.2 cm. (27⁷⁄₁₆ x 14¹⁄₄ in.)
Campus Collections, Princeton University
(PP363)

Cram and Ferguson, architects,
Boston (fl. 1915–1941)
Proposed exterior of chapel, 1923

Graphite on paper
Ca. 67.3 x 86.4 cm. (26¹⁄₂ x 34 in.)
University Archives, Department of
Rare Books and Special Collections,
Princeton University Library

Oliver Smith, American,
1896–1980
Episode from *The Legend of the
Seven Sleepers* (copy after original
from Rouen Cathedral, ca. 1205),
1923

Leaded and stained glass
62.2 x 59.7 cm. (24¹⁄₂ x 23¹⁄₂ in.)
Glencairn Museum, Bryn Athyn Historic
District, Pennsylvania (03.SG.339)

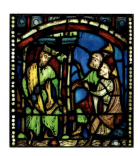

Durandus of Saint-Pourçain
*Commentary on the Sentences of
Peter Lombard*, 1336

Manuscript; 2 vols.
open: ca. 45 x 28.3 cm.
(17¹¹⁄₁₆ x 11¹⁄₈ in.)
Robert Garrett Collection of Medieval
and Renaissance Manuscripts, no. 83,
Manuscripts Division, Department of
Rare Books and Special Collections,
Princeton University Library.
Gift of Robert Garrett, Class of 1897

French, Burgundian?
Angel, late 15th century

Stone with traces of polychromy
and gilding
60 x 37.5 x 15.2 cm. (23⁵⁄₈ x 14³⁄₄ x 6 in.)
Museum purchase (y45)

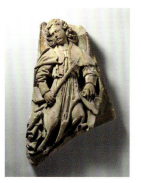

French?
Madonna and Child, ca. 1325

Wood with polychromy
56 x 18.7 x 10.2 cm. (22 1/16 x 7 3/8 x 4 in.)
Museum purchase, Carl Otto von
Kienbusch Jr. Memorial Collection Fund
(y5)

Italian, Friuli
Madonna and Child, ca. 1500

Wood with polychromy and gilding
102 x 48 x 33 cm. (40 3/16 x 18 7/8 x 13 in.)
Gift of Mrs. P. C. Nye (y52)

Selected Bibliography

SECONDARY SOURCES

Addison, Agnes. "Early American Gothic." *Romanticism in America. Papers Contributed to a Symposium Held at the Baltimore Museum of Art, May 13, 14, 15, 1940,* 118–37. Baltimore: The Johns Hopkins University Press, 1940.

———. *Romanticism and the Gothic Revival.* New York: Richard R. Smith, 1938.

Aldrich, Megan. *Gothic Revival.* London: Phaidon, 1994.

Andrews, Wayne. *American Gothic: Its Origins, Its Trials, Its Triumphs.* New York: Vintage Books, 1975.

Aslin, Elizabeth. *The Aesthetic Movement: Prelude to Art Nouveau.* London: Elek, 1969.

Baker, Paul R. *Richard Morris Hunt.* Cambridge, Mass.: MIT Press, 1980.

Bennett, Adelaide, Jean F. Preston, and William P. Stoneman. *A Summary Guide to Western Medieval and Renaissance Manuscripts at Princeton University.* Princeton: Princeton University Library, 1991.

Bright, Michael. *Cities Built to Music: Aesthetic Theories of the Victorian Gothic Revival.* Columbus: Ohio State University Press, 1984.

Brooks, Chris. *The Gothic Revival.* London: Phaidon Press, 1999.

Brown, Cathy J. "Victorian Architecture on the Princeton Campus: 1868–1888: An Exhibition at the Princeton University Art Museum, 11 May–13 June 1976." B.A. thesis, Princeton University, 1976.

Brush, Kathryn. "The Capitals from Moutiers-Saint-Jean (Harvard University Museums) and the Carving of Medieval Art Study in America after World War I." In *Medieval Art and Architecture after the Middle Ages,* ed. Janet T. Marquardt and Alyce A. Jordan, 298–311. Newcastle-upon-Tyne: Cambridge Scholars Publishing, 2009.

———. *The Shaping of Art History: Wilhelm Vöge, Adolph Goldschmidt, and the Study of Medieval Art.* Cambridge: Cambridge University Press, 1996.

Burke, Doreen Bolger, ed. *In Pursuit of Beauty: Americans and the Aesthetic Movement.* New York: The Metropolitan Museum of Art, 1986.

Bush, Sara E. "The Architectural History of the Art Museum." *Record of the Art Museum, Princeton University* 55, nos. 1/2 (1996): 77–106.

Bush, Sara E., and P. C. Kemeny. "The Princeton University Chapels. An Architectural and Religious History." *Princeton University Library Chronicle* 60 (Spring 1999): 317–52.

Clark, Burton R. *The Research Foundations of Graduate Education: Germany, Britain, France, United States, Japan.* Berkeley: University of California Press, 1993.

Clark, Kenneth. *The Gothic Revival: An Essay in the History of Taste.* New York: Charles Scribner's Sons, 1929.

Clark, Michael D. "Ralph Adams Cram and the Americanization of the Middle Ages." *Journal of American Studies* 23 (August 1989): 195–213.

Cothren, Michael W. "The Seven Sleepers and the Seven Kneelers: Prolegomena to a Study of the 'Belles Verrières' of the Cathedral of Rouen." *Gesta* 25, no. 2 (1986): 203–26.

Curran, Kathleen. "The Romanesque Revival, Mural Painting, and Protestant Patronage in America." *Art Bulletin* 80, no. 4 (1999): 693–722.

———. *The Romanesque Revival: Religion, Politics, and Transnational Exchange.* University Park: Pennsylvania State University Press, 2003.

De Rosa, Elizabeth Johnston. "Louis Comfort Tiffany and the Development of Religious Landscape Memorial Windows." Ph.D. diss., Columbia University, 1995.

Duke, Alex. *Importing Oxbridge: English Residential Colleges and American Universities.* New Haven, Conn.: Yale University Press, 1996.

Egbert, Donald Drew. "The Architecture and the Setting." In *The Modern Princeton*, ed. Charles Osgood et al. Princeton: Princeton University Press, 1947.

Emery, Elizabeth. "The Martyred Cathedral: American Attitudes toward Notre-Dame de Reims during the First World War." In *Medieval Art and Architecture after the Middle Ages*, ed. Janet T. Marquardt and Alyce A. Jordan, 312–39. Newcastle-upon-Tyne: Cambridge Scholars Publishing, 2009.

Finch, Edith. *Carey Thomas of Bryn Mawr.* New York: Harper, 1947.

Fleming, Robin. "Picturesque History and the Medieval in Nineteenth-Century America." *American Historical Review* 100 (October 1995): 1061–94.

Frankl, Paul. *The Gothic: Literary Sources and Interpretations through Eight Centuries.* Princeton: Princeton University Press, 1960.

Frelinghuysen, Alice Cooney. "Duyckinck to Tiffany: New York Stained Glass, 1650–1920." In *The Art of Collaboration: Stained-Glass Conservation in the Twenty-First Century*, ed. Mary B. Shepard, Lisa Pilosi, and Sebastian Strobl, 19–33. Turnhout: Harvey Miller Publications for the American Corpus Vitrearum, 2010.

Green, Virginia M. "The Princeton Architecture of Richard Morris Hunt." B.A. thesis, Princeton University, 1973.

Hamilton-Phillips, Martha. "Benjamin West and William Beckford: Some Projects for Fonthill." *Metropolitan Museum Journal* 15 (1980): 157–74.

Hayward, Jane, et al. *Radiance and Reflection: Medieval Art from the Raymond Pitcairn Collection.* New York: The Metropolitan Museum of Art, 1982.

Kenney, Alice P., and Leslie J. Workman. "Ruins, Romance and Reality: Medievalism in Anglo-American Imagination and Taste, 1750–1840." *Winterthur Portfolio* 10 (1975): 131–63.

Kidney, Walter C. *The Architecture of Choice: Eclecticism in America, 1880–1930.* New York: George Braziller, 1974.

Kisluk-Grosheide, Daniëlle. "The Marquand Mansion." *Metropolitan Museum Journal* 29 (1994): 151–81.

Kusserow, Karl, ed. *Inner Sanctum: Memory and Meaning in Princeton's Faculty Room at Nassau Hall.* Princeton: Princeton University Art Museum, 2010.

Lambourne, Lionel. *The Aesthetic Movement.* London: Phaidon Press, 1996.

Landau, Sarah Bradford. *Edward T. and William A. Potter: American Victorian Architects.* New York: Garland, 1979.

Lanford, Sarah Drummond. "A Gothic Epitome: Ralph Adams Cram as Princeton's Architect." *Princeton University Library Chronicle* 43 (Spring 1982): 184–220.

Lavin, Marilyn Aronberg. *The Eye of the Tiger: The Founding and Development of the Department of Art and Archaeology, 1883.* Princeton: Princeton University Art Museum, 1983.

Lears, T. J. Jackson. *No Place of Grace: Antimodernism and the Transformation of American Culture, 1880–1920.* Chicago: University of Chicago Press, 1981.

Leitch, Alexander. *A Princeton Companion.* Princeton: Princeton University Press, 1978.

Loth, Calder, and Julius Trousdale Sadler Jr. *The Only Proper Style: Gothic Architecture in America.* Boston: New York Graphic Society, 1975.

Maynard, W. Barksdale. *Architecture in the United States, 1800–1850.* New Haven, Conn.: Yale University Press, 2002.

———. *Woodrow Wilson: Princeton to the Presidency.* New Haven, Conn.: Yale University Press, 2008.

Milliner, Matthew. "Primus inter pares: Albert C. (*sic*) Friend and the Argument of the Princeton University Chapel." *Princeton University Library Chronicle* 70, no. 3 (Spring 2009): 471–517.

Morey, Charles Rufus. "Mediaeval Art and America." *Journal of the Warburg and Courtauld Institutes* 7 (1944): 1–6.

Muccigrosso, Robert. *American Gothic: The Mind and Art of Ralph Adams Cram*. Washington, D.C.: University Press of America, 1979.

Nelson, Robert L. "Art and Religion: Ships Passing in the Night?" In *Reluctant Partners: Art and Religion in Dialogue*, 100–120. New York: American Bible Society, 2004.

O'Connor, Sarah Talbott. "Henry Gurdon Marquand: Art Appreciation in Nineteenth-Century America." B.A. thesis, Princeton University, 1989.

Osgood, Charles, et al. *The Modern Princeton*. Princeton: Princeton University Press, 1947.

Peck, Amelia, ed. *Alexander Jackson Davis, American Architect, 1803–1892*. New York: The Metropolitan Museum of Art, 1992.

———. "Alexander Jackson Davis (1803–1892)." In *Heilbrunn Timeline of Art History*. New York: The Metropolitan Museum of Art, last modified May 10, 2011, accessed May 23, 2011, http://www.metmuseum.org/toah/works-of-art/24.66.17.

Rosasco, Betsy. "The Teaching of Art and the Museum Tradition: Joseph Henry to Allan Marquand." *Record of the Princeton University Art Museum* 55, nos. 1/2 (1996): 7–52.

Ross, Barbara T. "The Prints and Drawings Collection: The Early Years." *Record of the Princeton University Art Museum* 55, nos. 1/2 (1996): 135–55.

Shand-Tucci, Douglass. *Ralph Adams Cram: American Medievalist*. Boston: Boston Public Library, 1975.

———. *Ralph Adams Cram: Life and Architecture*. Vol. 1, *Boston Bohemia, 1800–1900*. Amherst: University of Massachusetts Press, 1995.

Sloan, Julie L., and James L. Yarnall. "John La Farge's Patent for the American Opalescent Window." *Journal of Stained Glass* 28 (2004): 31–45.

Smith, Elizabeth Bradford. *Medieval Art in America: Patterns of Collecting, 1800–1940*. University Park: Pennsylvania State University Press, 1996.

Smith, Ryan K. *Gothic Arches, Latin Crosses: Anti-Catholicism and American Church Designs in the Nineteenth Century*. Chapel Hill: University of North Carolina Press, 2006.

Smyth, Craig Hugh. "The Princeton Department in the Time of Morey." In *The Early Years of Art History in the United States: Notes and Essays on Departments, Teaching and Scholars*, edited by Craig Hugh Smyth and Peter M. Lukehart, 37–42. Princeton: Department of Art and Archaeology, Princeton University, 1993.

Stewardson, William Emlyn. "Cope and Stewardson, the Architects of a Philadelphia Renascence." B.A. thesis, Princeton University, 1960.

Thorp, Willard, et al. *The Princeton Graduate School: A History*. Rev. ed. Princeton: Princeton University Press, 2000.

Turner, Paul Venable. *Campus: An American Planning Tradition*. 2nd ed. Cambridge, Mass.: MIT Press, 1995.

"The Very Best Women's College There Is": M. Carey Thomas and the Making of the Bryn Mawr Campus, last modified September, 2001, accessed March 21, 2011, http://www.brynmawr.edu/library/exhibits/thomas/gothic.html

Voorsanger, Catherine Hoover, and John K. Howat, eds. *Art and the Empire City: New York, 1825–1861*. New York: The Metropolitan Museum of Art, 2000.

Weinberger, H. Barbara. *The Decorative Work of John La Farge*. New York: Garland Press, 1977.

Williams, Peter W. "The Medieval Heritage in American Religious Architecture." In *Medievalism in American Culture*, ed. Bernard Rosenthal and Paul E. Szarmach, 171–92. Binghamton, N.Y.: Medieval & Renaissance Texts and Studies, 1989.

Williamson III, David, et al. *Princeton Campus: An Interactive Computer History, 1746–1996*. Last modified 1996. http://etcweb.princeton.edu/Campus/text_PyneLib.html.

Wilson, Richard Guy. "Architecture and the Reinterpretation of the Past in the American Renaissance." *Winterthur Portfolio* 18 (Spring 1983): 69–87.

Wodehouse, Lawrence. "William Appleton Potter, Principal 'Pasticheur' of Henry Hobson Richardson." *Journal of the Society of Architectural Historians* 32 (May 1973): 175–92.

Wright, Diane C. "Frederick Wilson: 50 Years of Stained Glass Design." *Journal of Glass Studies* 51 (2009): 198–214.

PRIMARY SOURCES

"Dr. Cram Preaches a "Gothic Revival" in America." *Current Opinion*, August 1921, 204–6.

"The Art of the Glass-Workers—the Week's Review." *(Philadelphia) Public Ledger*, January 24, 1915.

Artistic Houses, Being a Series of Interior Views of a Number of the Most Beautiful and Celebrated Homes in the United States. Vol. 1. New York: D. Appleton and Company, 1883–84.

Baker, Ray Stannard. *Woodrow Wilson: Life and Letters.* Vol. 2, *Princeton, 1890–1910.* Garden City, N.Y.: Doubleday Books, 1927; New York: Greenwood Press, 1968.

Book of Results of the Willet Stained Glass and Decorating Company of Philadelphia, Pennsylvania. Philadelphia: Willet Stained Glass and Decorating Company, 1921.

Butler, Howard Crosby. "McCormick Hall and the School of Architecture." *Princeton Alumni Weekly*, November 2, 1921, 99–102.

———. "Princeton. A Typical American University Town and Its Beautiful Architecture." *Indoors and Out*, December 1905.

Connick, Charles J., Jr. *Adventures in Light and Color.* New York: Random House, 1937.

Daily Princetonian (multiple articles cited; see endnotes).

Desmond, Harry William. *Stately Homes in America from Colonial Times to the Present Day.* New York: D. Appleton and Company, 1903.

Fitzgerald, F. Scott. *This Side of Paradise.* New York: Charles Scribner's Sons, 1920; Random House, 2001.

Hastings, Thomas. "The Evolution of Style in Modern Architecture." *North American Review*, February 1910, 197–99.

Hunt, Richard Morris. "The Church Architecture That We Need. I-I." *American Architect and Building News* 2, no. 100 (November 24, 1877): 374–76.

———. "The Church Architecture That We Need. I-II." *American Architect and Building News* 2, no. 101 (December 1, 1877): 384–85.

King, Clarence. "Style and the Monument." *North American Review*, November 1885, 443–53.

Klauder, Charles Z., and Herbert C. Wise. *College Architecture in America and Its Part in the Development of the Campus.* New York: Charles Scribner's Sons, 1929.

Lamb, Martha Joanna. *The Homes of America.* New York: D. Appleton and Company, 1879.

McCosh, James. *Twenty Years of Princeton College, Being a Farewell Address, Delivered June 20th, 1888.* New York: Charles Scribner's Sons, 1888.

Memorial Book of the Sesquicentennial Celebration of the Founding of the College of New Jersey and of the Ceremonies Inaugurating Princeton University. New York: Charles Scribner's Sons, 1898.

Nichols, J. B. *Historical Notices of Fonthill Abbey, Wiltshire.* London: Nichols and Son, 1836.

Paintings and Studio Property of the Late Francis Lathrop of New York City. Auction catalogue. Anderson Galleries, Inc., April 4–6, 1911.

Potter, Frank Hunter. *The Alonzo Potter Family.* Concord, N.H.: Rumford Press, 1923.

Prime, William C., and George B. McClellan. *Suggestions on the Establishment of a Department of Art Instruction in the College of New Jersey.* Princeton, 1882.

Princeton Alumni Weekly, The (multiple articles cited; see endnotes).

Pugin, Augustus Welby Northmore. *Contrasts: or, A Parallel between the Noble Edifices of the Middle Ages, and Corresponding Buildings of the Present Day, Shewing the Present Decay of Taste*. 2nd ed. London: C. Dolman, 1841.

———. *Designs for Gold and Silver Smiths*. London: Ackermann & Co., 1836.

———. *Gothic Furniture: In the Style of the 15th Century*. London: Ackermann & Co., 1835.

Ruskin, John. *The Stones of Venice*, ed. J. G. Links. Cambridge, Mass.: Da Capo Press, 1960.

Schuyler, Montgomery. "Architecture of American Colleges: III. Princeton." *Architectural Record* 27 (February 1910): 129–60.

Warner, Charles Dudley. "Editor's Study." *Harper's New Monthly Magazine*, February 1897, 481–86.

West, Andrew Fleming. "The New University Library at Princeton." *Harper's Weekly*, June 12, 1897, 591–92.

———. *The Graduate College of Princeton: With Some Reflections on the Humanizing of Learning*. Princeton: Princeton University Press, 1913.

Willet, William, and Anne Lee Willet. *Stained Glass*. 2 vols. Philadelphia: Free Library of Philadelphia, 1942. Unpublished scrapbook.

MANUSCRIPT AND ARCHIVAL COLLECTIONS

Allan Marquand Papers, Department of Rare Books and Special Collections, Princeton University Library.

Board of Trustees Minutes and Records, University Archives, Department of Rare Books and Special Collections, Princeton University Library.

Board of Trustees Records and Special Format Records, The Philadelphia Museum of Art, Archives.

Charles J. Connick Jr. Papers, Fine Arts Department, Boston Public Library.

Department of Art and Archaeology Records, University Archives, Department of Rare Books and Special Collections, Princeton University Library.

Department of Grounds and Buildings Subject Files, University Archives, Department of Rare Books and Special Collections, Princeton University Library.

Department of Grounds and Buildings Technical Correspondence Records, University Archives, Department of Rare Books and Special Collections, Princeton University Library.

Graduate School Records, University Archives, Department of Rare Books and Special Collections, Princeton University Library.

Historical Photograph Collection, Grounds and Buildings Series, University Archives, Department of Rare Books and Special Collections, Princeton University Library.

Jessie Wilson Sayre Papers, Public Policy Papers, Department of Rare Books and Special Collections, Princeton University Library.

Joseph Reynolds Papers, Archives of American Art, Smithsonian Institution, Washington, D.C.

Office of Physical Planning Records, University Archives, Department of Rare Books and Special Collections, Princeton University Library.

Office of the Dean of Religious Life and the Chapel Records, University Archives, Department of Rare Books and Special Collections, Princeton University Library.

Oliver Smith Papers, Glencairn Museum, Bryn Athyn, Pennsylvania.

Princeton Memorabilia Collection, University Archives, Department of Rare Books and Special Collections, Princeton University Library.

Robert Judson Clark Papers, University Archives, Department of Rare Books and Special Collections, Princeton University Library.

Willet Stained Glass Archives, Willet Hauser Architectural Glass, Philadelphia, Pennsylvania.

William Willet and Anne Lee Willet Papers. In Henry Lee Willet Papers, Archives of American Art, Smithsonian Institution, Washington, D.C.

SELECTED PRIMARY SOURCES BY RALPH ADAMS CRAM

"The Influence of France upon American Architecture." *American Architect and Building News* 66, no. 1248 (November 25, 1899): 65–66.

"The Work of Frank Miles Day and His Brother." *Architectural Record* 15 (May 1904): 397–421.

"The Work of Messrs. Cope & Stewardson." *Architectural Record* 16 (November 1904): 407–38.

"Princeton Architecture." *American Architect* 96 (July 21, 1909): 21–30.

"Architecture as an Expression of Religion." *American Architect* 98 (December 28, 1910): 209–14, 216–20.

"Recent University Architecture in the United States." *American Architect* 101 (June 26, 1912): 285–88.

Heart of Europe. New York: Charles Scribner's Sons, 1915.

"Holder and the Halls. An Appreciation." *Architecture* 37, no. 2 (February 1918): 29–32.

"Stained Glass: An Art Restored. America's Position in Bringing about a Renaissance of This Phase of Architectural Beauty." *Arts and Decoration*, February 1924, 11–13, 50.

"The Value of Precedent in the Practice of Architecture." *American Architect* 126 (December 17, 1924): 567–69.

My Life in Architecture. Boston: Little, Brown & Co., 1936.

Ralph Adams Cram Papers, Fine Arts Department, Boston Public Library.

Photography Credits

INTRODUCTION:
SPIRES AND GARGOYLES

Fig. 1. Brian M. Wilson.
Fig. 5. © The Metropolitan Museum of Art/
Art Resource, NY.

PRINCETON AND THE CHANGING
FACE OF GOTHIC

Fig. 1. Bruce Aleksander & Dennis Milam. Reproduced
by permission.
Fig. 2. Jeff Evans.
Fig. 3. Photo courtesy of Union College
Communications.
Fig. 4. Johanna G. Seasonwein.
Fig. 5. Jeff Evans.
Fig. 8. © The Metropolitan Museum of Art/
Art Resource, NY.
Fig. 9. Jeff Evans.
Fig. 10. Holly Hayes/Art History Images. Reproduced
by permission.
Fig. 11. Bryn Mawr College Library, Special Collections.
Reproduced by permission.
Fig. 12. Vanni/Art Resource, NY.
Fig. 14. Bryn Mawr College Library, Special Collections.
Reproduced by permission.
Fig. 15. Jeff Evans.
Fig. 16. Denise Applewhite.
Fig. 17. Vanni/Art Resource, NY.
Fig. 18. Bruce M. White.

"THAT ANCIENT AND MOST
IMPERISHABLE OF THE ARTS"

Fig. 5. Princeton Theological Seminary Photograph
Collection. Reproduced by permission.
Fig. 6. DeA Picture Library/Art Resource, NY.
Fig. 7. Vanni/Art Resource, NY.
Fig. 11. © The Metropolitan Museum of Art/Art
Resource, NY.
Fig. 13. Bruce M. White.
Fig. 16. The Montreal Museum of Fine Arts,
Christine Guest.
Fig. 17. Courtesy of the Division of Rare and Manuscript
Collections, Cornell University Library.
Figs. 18, 19. Bruce M. White.
Fig. 20. JenniKate Wallace. Reproduced by permission.
Fig. 21. Reverend Stephen Day. Reproduced by
permission.
Fig. 22. Gordon Plumb. Reproduced by permission.
Fig. 23. Bruce M. White.
Fig. 24. Art Department, Free Library of Philadelphia.
Reproduced by permission.
Fig. 26. Simon Pleasants. Reproduced by permission.
Fig. 27. The Francis Frith Collection/Art Resource, NY.
Fig. 29. Bruce M. White.
Fig. 30. Denise Applewhite.
Figs. 31, 34, 36, 37. Bruce M. White.
Fig. 38. Worcester Art Museum, Worcester, Massachusetts.
Reproduced by permission.
Fig. 39. Johanna G. Seasonwein.
Fig. 40. Denise Applewhite.

Cover. Bruce M. White.